Underlying Vibrations

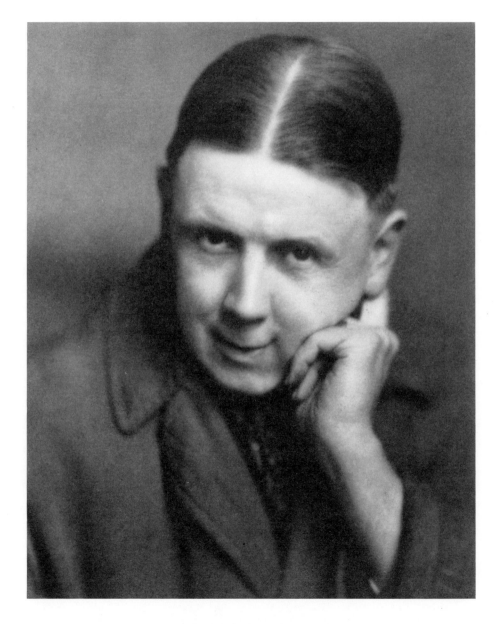

Figure 1. *Self-portrait, John Vanderpant, CIRCA 1928.*

Underlying Vibrations

The Photography and Life of John Vanderpant

Sheryl Salloum

Sheryl Salloum

HORSDAL & SCHUBART

Horsdal & Schubart Publishers Ltd.
Victoria, BC, Canada

Cover: "Liquid Rhythm," by John Vanderpant, *circa* 1934.

This book is set in Lapidary 333 Book Text.

Printed and bound in Canada by Kromar Printing Limited,
Winnipeg.

Canadian Cataloguing in Publication Data

Salloum, Sheryl, 1950-
Underlying vibrations

Includes bibliographical references and index.
ISBN 0-920663-40-0

1. Vanderpant, John, 1884-1939. 2. Photographers—British
Columbia—Vancouver—Biography. 3. Vancouver (B.C.)—
Biography. 4. Photography—British Columbia—Vancouver. I. Title

TR140.V36S24 1995 770'.92 C95-910853-X

CONTENTS

Acknowledgements
Introduction

CHAPTER ONE - RESTLESS, ENERGETIC BEGINNINGS 1
CHAPTER TWO - A VISION "BEYOND APPEARANCES" 6
CHAPTER THREE - BUILDING A PERMANENT FOUNDATION 13
CHAPTER FOUR - NEW DIRECTIONS 23
CHAPTER FIVE - VIBRATING CONTACTS 32
CHAPTER SIX - LIGHTING THE "UNMAPPED WAYS" 46
CHAPTER SEVEN - "CRY AND CRY AND CRY AGAIN" 62

Underlying Vibrations: A Portfolio

Index to the Plates 73
Notes to Vanderpant's Photographs among the Figures 75
Footnotes 77
Selected Bibliography 91
Index 95

ACKNOWLEDGEMENTS

I AM HONOURED THAT Anna Vanderpant Ackroyd and Catharina Vanderpant Shelly gave me access to John Vanderpant's prints, negatives, lantern slides, papers, and memorabilia. I am grateful for their patience, our many discussions, and their always cheerful responses to my queries. Special thanks are extended to Catharin Ackroyd for her continuing support; to Barbara Mitchell and Sheila Watson for their interest; and to Dr. Sherrill Grace who felt that this book should be written, and who encouraged me to do so.

While I was not fortunate in receiving support from funding agencies, I garnered a wealth of cooperation from individuals and institutions. Invaluable assistance was provided by the National Archives of Canada and particular appreciation is extended to Joan Schwartz, Melissa Rombout, and Anne Goddard. Thanks also to Charles C. Hill and the staff of the National Gallery of Canada, Ian Thom and the staff of the Vancouver Art Gallery, the Burnaby Art Gallery, the Vancouver City Archives, Laurie Robertson and Special Collections at the Vancouver Public Library, the B.C. Archives and Records Service, Patricia Bovey and the Art Gallery of Greater Victoria, Archie Miller and the New Westminster Historic Centre and Museum (Archives), the Victoria City Archives, the Alberta Archives, the Alberta Legislature Library, Roger Boulet and the Edmonton Art Gallery, the Special Collections libraries at the University of British Columbia and the University of Manitoba, Dorothy Farr and the Agnes Etherington Art Centre at Queen's University, Dr. Ingeborg Th. Leijerzapf and the Prentenkabinet at the University of Leiden, and Pam Roberts and the Royal Photographic Society of Great Britain.

The contributions of those who graciously granted me interviews and/or permission to reprint correspondence or recollections are greatly appreciated. Special thanks to Pindy Barford, Jessie Binning, Vito Cianci, John Helders, Lottie Kaiser, Anne le Nobel, Ruth Levenston, John C. Lort, Tony Lort, Elizabeth Partridge and The Imogen Cunningham Trust, Irene Hoffar Reid, Frank Taylor, Cole Weston, The Centre for Creative Photography at the University of Arizona, Isabell Wintemute, and Peter Varley, who made F.H. Varley's correspondence available and allowed me to quote from his published recollection, "John Vanderpant: A Memory." Warm thanks are also extended to Edward Cavell, Sheila Drummond, Ariane Isler De Jongh, Dr. Jack Parnell, and John VandenBrink, for their valuable input.

Cheers to Marlyn Horsdal for her careful editing, and to her and Michael Schubart for undertaking the publication of this work.

Deepest thanks to my family for their ever-loving support.

Sheryl Salloum
Vancouver, 1995

INTRODUCTION

IN THE PERIOD between the two world wars a unique light glowed on the west coast of British Columbia. Energized by the photographic pursuits and artistic interests of a Dutch Canadian by the name of John Vanderpant, that beacon radiated across Canada and throughout international art circles: he was "a major influence on Canadian photography in the 1920s and 1930s."[1] Vanderpant's black-and-white prints are distinctive, and his images convey the physical, emotional, and symbolic characteristics of his subjects: what he referred to as their "underlying vibration."[2]

There were many stimulants to Vanderpant's work, and a primary one was the desire to explore mystical interests. He often chose his compositions and symbols with the intention of conveying spiritual meanings so as to "change thought about things." This aspiration to communicate what he termed "visionary wisdom"[3] prompted him to explore his medium imaginatively.

After its invention in 1839, photography evolved rapidly. As cameras, lenses, papers, developing and printing techniques became more sophisticated and accessible, the medium grew in popularity with professionals and amateurs alike. The question arose as to whether or not photography was an art, and the debate raged for decades; so, too, did arguments over photographic styles. Vanderpant always championed the cause of artistic photography. Over the years he developed a style based upon "the beauty of its [photography's] inherent qualities—the playing with forms—tones—gradations," and a desire to convey ideas so as to "exalt and elevate."[4]

Born towards the end of the Victorian era, Vanderpant was both an old-world gentleman and an innovator. His life was marked by contrasts: a creative individual, he was fettered by financial difficulties; a proponent of artistic freedom, he lived by a strict personal code; isolated on the west coast of Canada, a cultural backwater in the 1920s and '30s, he not only achieved international recognition but struggled to make avant-garde art and music available in the Vancouver area. Even Vanderpant's output was divided into two categories: the work he did to earn a living, mostly portraiture, and the work that nourished his creative drive, his art photography. His imaginative energies were also divided between his camera work and advocating the fine arts. His extraordinary patronage helped to make Canadian culture "richly-textured, diversified, and spontaneous" in the 1920s and '30s.[5] Vanderpant was also a writer and worked in two genres, prose and poetry. (He published many articles, and his personal papers contain unpublished manuscripts, notebooks, lectures, and a collection of published and unpublished poems. Although he was fluent in the English language, Vanderpant's writings show that his spelling and usage were sometimes incorrect. Moreover, his manuscripts and letters are often in draft form and occasionally contain errors that may have been corrected in the final versions. Because the errors are not consistent, and to ensure that the material is understandable, the author has chosen to correct confusing or incorrect spellings and usage. Unless otherwise indicated, the spellings and usage of Vanderpant's poetry and published writings have not been changed.)

Contrasts were technically and philosophically significant to Vanderpant's work. He described photography as "entirely a process of gradation between white and black; pictorially it is more a balancing of contrasting or blending spaces." Thematic opposites are often reflected in his compositions: up versus down, horizontal versus vertical, large versus small, animate versus inanimate, nature versus technology, and permanence versus impermanence, to name a few. They represent

Vanderpant's desire to communicate "mood or ideal by understandable form, which becomes vital through its relation to other forms." He attempted to convey universal values or qualities through the study of commonplace forms.

The vitality of Vanderpant's prints was matched by the vigorous contributions he made to the cultural development of western Canada. He always gave support and encouragement to his contemporaries. Intrigued by modern trends in the fine arts, he sought to share his interests with others. Vanderpant did so through his photographs, exhibitions at his studio gallery, his involvement with arts institutions, and his lectures and articles on photography and art. He believed that the artistic and cultural pursuits of a country shape its overall attitudes and achievements. Vanderpant was convinced that he had a role to play in the development of Canadian art, and in endeavouring to fulfill that role he became a powerful proponent of all the fine arts.

Vanderpant's most productive period spanned a brief 20 years, from 1919 to 1939, and he died feeling that he had only accomplished "some space." That description is accurate in terms of time, but not in terms of impact. His work is a highlight in the history of Canadian photography, and his personal contributions to the artistic development of Canada, most notably on the west coast, were exceptional.

A man of medium height, Vanderpant had a wry sense of humour and a slight Dutch accent. He enjoyed spectator sports and motoring about the countryside. His eyes, which were "dreamy in repose," could "meet one with the directness and simplicity of a child." A vivacious man, his face would light up "with animation and enthusiasm."[6] He was generous and compassionate. A pacifist, teetotaller, humanitarian, and a man of deep spirituality, Vanderpant tried to live and work according to the principles of what he called "divine law." Peter Varley, son of the painter F.H. Varley, describes Vanderpant as having had a "body and person [that] radiated calm vitality; his form rounded and full, like sculpture—a solid head set low to his shoulders, thinning brushed back hair, eyes golden brown, compassionate and ready for laughter, slender-fingered hands stained with cigars and developers, but warm and light in touch. ... My memory can't find his voice clearly, he spoke so much with his eyes."[7] Vanderpant also spoke through his writings and his photography.

CHAPTER ONE

RESTLESS, ENERGETIC BEGINNINGS

JAN (JOHN) VANDERPANT was born in Alkmaar, Holland, on 11 January 1884. He was the son of Jan van der Pant, a tobacconist and importer of moderate income, and Catharina Sophia Ezerman. Little is known of his youth, except that he had a younger sister, Catharina, and that he attended primary and high school in Alkmaar. From his father he seems to have acquired the knowledge and organizational skills necessary for operating a business. In his youth he also developed a passion for photography and music.[1]

The 14th "Jan" in succession, he was expected to enter into his father's business. He did so for a time, but his interests were more diverse. He studied at the University of Amsterdam, and was enrolled in the Literary Faculty of the University of Leiden from 1905 to 1912.[2] His main interests were poetry, religion, and the development of languages.

In those years Vanderpant was exposed to an exciting variety of philosophies and artists, and the experience was to enhance and solidify his interests in the arts. Vanderpant described the impact of his university days in a 1934 letter to Eric Brown, a Christian Scientist and the first Director of the National Gallery of Canada:

> I always was surrounded by artists, by painters. I published a volume of poetry and numerous literary articles … [was]

drenched in the spirit of music, [and] I visited most of the European art centers. I studied the history of languages, their development from Greek and Latin … into the languages of Western Europe. I studied literature, was [a] newspaper critic, was actively attached for a season to Ro[o]y[a]ards the most artistic stage leader in Holland. I really have been blessed with every contact, which helped prepare … [me] for a deeper insight of the meaning of it all.[3]

Vanderpant's fervour for the arts developed into a longing, harboured throughout his life, to be a painter or a symphony conductor. As a young man he had also considered becoming a minister,[4] showing that religion was an aspect of his "deeper insight."

Vanderpant's need for imaginative expression found an early outlet in the writing of poetry. From 1907 to 1910 he published a number of poems in Dutch literary magazines, and a book of poems entitled *Verzen*. In 1908 he published a short story, "Haar Verdriet," and in January of the same year the Dutch journal *Nederland in Rijp* published his first photograph, a winter scene titled "Haarlem," as part of "200 Fotos Van de Wonder." The reading and writing of verse was to become a satisfying pastime, while photography was to become his vocation.

In 1910 Vanderpant met Catharina over de Linden. A striking, elegant woman, she was impressed with him because "she thought that any man who could write poetry must be special."[5] Catharina shared Vanderpant's enthusiasm for theology and the arts, and they married on 6 July 1911. She later became a Christian Scientist and, while Vanderpant never formally joined the church, its teachings were to inspire him over the years.

In 1910, while still registered at the University of Leiden, Vanderpant worked as a photojournalist for the Dutch magazine *Op de Hoogte*. The articles he prepared between 1910 and 1913, on countries such as Italy, Portugal, Holland, and Canada, show that he could capture the spirit of lands and peoples. His accompanying prints indicate a talent for composition and an ability to communicate the vitality of his subjects. While some views tend to merely record, many reveal everyday people and scenes in evocative images. Vanderpant's ability to convey character in photographic portraits is also evident in his early work.[6]

In 1911 Vanderpant and Catharina emigrated to Canada and travelled from Quebec to Alberta. For the next two years he published a series of photo-illustrated articles in Holland's newspapers and journals on the viability of Canada as a new homeland for Dutch farmers; three of these articles were signed CANUCK.[7] One of his articles conveys his view that Canada was a country "with a great future." More importantly, the article indicates Vanderpant's growing need to find a nurturing environment: one that would allow him financial security, intellectual inspiration, and the opportunity to escape the Dutch concern "for the preservation and refinement of what existed before." He described Canada as a land where "individual energy is rewarded" and where one

has more freedom to follow his initiative without taking any great risks, more so than in any country in Western Europe, where a large number of the population is compelled by circumstance and is forced to desperately hang on to an employment situation once they have obtained it.[8]

According to his daughters, Vanderpant was attracted by "the beauty of the land, and by the expanse of the country and its

Figure 2. *Catharina and John in southern Alberta. The exact location and date are not known.*

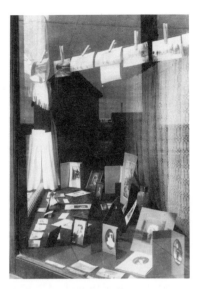

Figure 3. *The display window of Vanderpant's first studio, Okotoks, Alberta,* CIRCA *1913.*

resulting sense of freedom. Canada was not bound by the European restrictions of tradition; that appealed to him."

The Canadian government was encouraging immigration, and in 1912 it employed Vanderpant to lecture to audiences in Holland on the appeal of Canada. Later that year, Vanderpant and Catharina settled in Okotoks, Alberta; there he opened a photography studio. The town was a booming ranching, sawmilling and transportation centre in the foothills of the Rocky Mountains. The expanse of prairie with the towering mountains in the distance was a view that particularly appealed to Vanderpant.

Although he appears to have been intrigued with photography from the time he was a teenager, Vanderpant stated that he never intended to be a photographer; he came to use "the camera as a medium of self-expression because for a time language could not do it and painting could not maintain us."[9] Photography was a field that allowed him to work creatively while earning a living, and he had experience with the medium from his work as a photojournalist. Vanderpant had no formal training, but from the beginning his innate talent was recognized: not only were his images used in *Op de Hoogte*, but a number were reproduced on the magazine's covers.

Twelve examples of Vanderpant's early Canadian photographs, dated 1912, were used in a Board of Trade booklet entitled, *Watch It Grow! Okotoks: The Centre of a Rich Grain Growing and Mixed Farming Country*. While views such as the main street, the public school, an oil well, and the residential part of the town are functional, one image entitled "Okotoks: Along Sheep Creek—Night Impression" stands out. In the print Vanderpant manages to capture the alluring aspects of a moonlit vista. His concerns with the "play of light and shadow," textural and tonal qualities, and the mood and emotional impact of an image are evident in this early landscape study. This "Impression" also indicates Vanderpant's early interest in nature and its possibilities for reflecting the preternatural, an idea that was to become vital in his later work.

From the beginning, prairie life was to take its toll on the Vanderpants. Anna states that when pregnant with their first child, Catharina was

> homesick for her parents and the family doctor. Poor Mother: young, loving, intelligent, and homesick for the more sophisticated atmosphere of Europe as compared to the more primitive atmosphere of rural Alberta. So, Father sent her home to have me. He understood her loneliness and her concerns with what, to her, was a strange wilderness.

Although Catharina loved her husband, the thought of returning to the rugged isolation of Okotoks was not inviting. She did not do so until Anna was nine months old; then the prospect of World War I made it imperative for her to return before travel by ship was curtailed.

While Catharina was away, Vanderpant had to deal with his loneliness and a personal and financial disaster. On 18 February 1914 a fire ravaged a large section of Okotoks, including the block that contained Vanderpant's living quarters and studio. *The Okotoks Review* of 20 February reported that the "flames and the heat of the fire were tremendous," and the overall financial loss was estimated to be $60,000. More of the town might have been lost but Vanderpant alerted the townspeople, and volunteer fire fighters prevented the flames from spreading by covering "all the buildings within reach with a coat of ice." The paper also reported that the fire's origin was

> a complete mystery. It was first noticed smouldering ... between 1:30 and 2:00 o'clock ... [by a local restaurateur and his family] who proceeded to salvage their goods. ... After a while they woke up Van der Pant the photographer next door who immediately ... went out energetically spreading the alarm. When he came back it was too late to save any of his goods and his loss or most of it is directly due to the fact that he put the public interest before his own.

The result of Vanderpant's altruism was that he

> was left in the cold of that winter night with his pyjamas, shoes and coat, and his [portable] camera. Everything else was destroyed. During the fire he took photographs. From those he made post cards, which he sold to raise some of the money for a new start.[10]

The appreciative townspeople helped him by donating clothing, furniture, and a place to live.

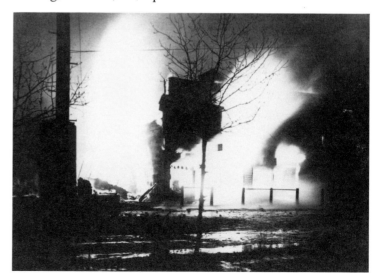

Figure 4. *One of Vanderpant's post cards of the Okotoks fire, February 1914.*

In 1916, the Vanderpants moved to Fort Macleod. Until 1919 the town was a divisional centre for the Royal Canadian Mounted Police and a distribution centre for the area's farmers and ranchers. Vanderpant opened a studio in Fort Macleod while maintaining the one in Okotoks. Soon, he opened another in Pincher Creek, a town which relied on wheat farming as its economic base; apparently, Vanderpant made an adequate living between the three businesses.[11]

As is often the case with immigrants, life in a new homeland was not initially easy for Vanderpant. An article in *Saturday Night* relates the story of his first professional portrait, that of his landlady,

> for whom he used an old tablecloth as a background. Although fully conversant with the English language upon coming to this country, he was then still somewhat bewildered about Canadian currency, and he recalls that the good lady kindly pointed out that he was charging only a fraction of what other photographers in the town were obtaining for similar work.[12]

Unfortunately, he did not have such good counsel regarding financial investments. His record books show that Vanderpant invested money in stocks but, according to his daughters, he lost money speculating in oil and real estate. He never again risked his earnings in so-called boom markets. This experience may also have caused him to adopt the Christian Science belief that success is not to be found in material things, but in what Vanderpant termed "spiritual abundance." He later wrote that

> the struggles and dramatic complications man experiences today and has experienced throughout the ages: wars, … sweeping plagues, economic ups and downs, his gamblings, his speculations … are the result of being without Scientific [or the Christian Science] basis of thought.[13]

On a practical level, Vanderpant had to provide more than "spiritual abundance" for his family. Financial survival meant travelling between his studios during the winter. Riding in a horse-drawn vehicle in temperatures of 20 to 40 degrees below zero, Fahrenheit, was not the only hardship Vanderpant had to bear.

Another personal tragedy was to mar the Vanderpants' life on the prairies. In 1915 they had a son but, while still an infant, John died of influenza. Adding to these trials, the Vanderpants suffered from cultural deprivation. In those days, rural Alberta did not have the galleries and concerts that they so enjoyed. Vanderpant lamented that "the loneliness of the land, the sparse habitation, the contrast between all he saw and his native Holland, nearly killed forever his sense of the artistic."[14] He viewed western Canada's lack of a vibrant artistic culture as its main disadvantage. Over time, Vanderpant came to feel that he could contribute to the country's cultural needs, and he did so by encouraging and supporting art and artists in his adopted homeland. This role was probably motivated by the metaphysical belief that the artist is a seeker and teacher of divine wisdom.

In 1917 a second daughter, Catharina (Carina), was born in Fort Macleod. A study of her, entitled "Eve Every Time" (Figure 5), was

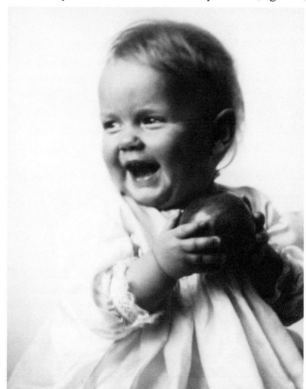

Figure 5. *"Eve Every Time" 1918.*

to win Vanderpant awards and medals from a number of international photographic salons. The print was published in *Photograms of the Year 1923*, a British journal which produced "an international collection of the year's best photographic work."[15] The study received further acclaim when it was exhibited at the 1924 London Salon. Interest was so strong that three London newspapers carried copies of the image, and a reproduction was published in that year's *Record of Photography*. The photograph was described as having "not only a good decorative pattern" but as also being "full of spontaneous life—a combination rarely achieved either in painting or photography. The lines of the dress are ... [distinct] with movement and contrast with the darker tones of the face, apple and hands."[16]

Vanderpant believed that humour was one of photography's "faculties." Whether or not an image was amusing, Vanderpant's drollery, enjoyment of slapstick, and fondness for puns are evident in numerous titles. "Eve Every Time" exemplifies how he used titles to extend or complement his viewpoint. What

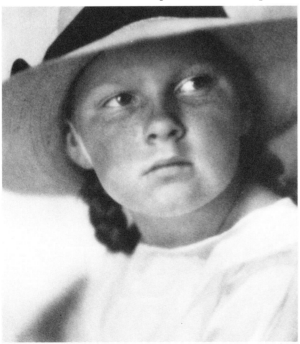

Figure 6. *Photographs of his family were a part of Vanderpant's early folio and were often exhibited. "Sunburned," a study of Anna, around 1918.*

would otherwise be a charming study of a laughing baby is subtly changed into an ironic statement by the print's title. Vanderpant used his images and titles as a means of "communion," with "the artist inviting, the onlooker accepting." He felt that an artist's work should cause the viewer to

> discover [the] meaning and personality which is behind every genuine work of art. It is always the reaction in, and expression of a strong personality. In its being created, it [art] is personally *felt* ... by a vibrating mind, rich in the knowledge of life and emotion, conflicts and comparison.

Simple images of the everyday world, made poignant through the highlighting of similar and divergent elements, were to become a hallmark of Vanderpant's art.

By 1919 Vanderpant was disheartened by the harsh climate, the long hours of travel, and the isolation of the Canadian prairies. In November, he decided to move his family to Hawaii. En route to Victoria, British Columbia, where they planned to book their passage, the Vanderpants had a stopover in Vancouver. They never left the area, and the next 20 years were to be Vanderpant's most productive.

CHAPTER TWO

A VISION "BEYOND APPEARANCES"

Figure 7. *Miss Irene Carpenter, New Westminster's May Queen, 1922;* NEW WESTMINSTER HISTORIC CENTRE AND MUSEUM (ARCHIVES), MAY DAY COLLECTION, #J.J. I.H. P730600.

VANDERPANT "FOUND THE coast of British Columbia to be of such beauty, and to hold such possibilities, that he decided to look for a photography studio. He found it on Columbia Street in New Westminster."[1] Situated just southeast of Vancouver, New Westminster was a large, freshwater port on the Fraser River, a lumber and salmon-canning centre, and the commercial hub of the rich farming area known as the Fraser Valley. The Canadian writer Sheila Watson, who was raised in New Westminster, recalls that the ambience of the "Royal City," as it had been dubbed by Queen Victoria, was "genteel."[2] Vanderpant was soon making a comfortable living from his portrait work, and he also had time to devote to artistic endeavours. Like his bountiful surroundings, Vanderpant was to thrive. He began with a more modern facility and a fuller understanding of Canadian currency and business practices than he had had in 1913.

Vanderpant was also an experienced photographer with an already distinctive style of portraiture. His study of Irene Carpenter (New Westminster's 1922 May Queen), exemplifies that style.[3] In this study, as in all his work, Vanderpant sought to go "beyond appearances," to depict "hidden" qualities. This aim was parallelled by the Christian Science belief that one has to "look beneath the surface of things" in order to truly comprehend that which is outwardly visible.[4] Vanderpant posed Carpenter so that her sombre stare, rather than her regalia, her

mental presence as compared to her physical, is the absorbing feature of the print. She conveys a maturity, a knowledge and fortitude, that is beyond her years. Entranced and entrancing, Carpenter looks to an inner or spiritual consciousness. Like her hands, one gloved and the other exposed, the girl's outer adornments and inner countenance are used to contrast and complement one another. Through the presentation of differing characteristics (child/woman, inner/outer, sombre/festive, covered/exposed, appearance/reality, and from a metaphysical perspective, matter/spirit), Vanderpant achieved an intriguing balance of relationships and an intense expression of character. The subtle lighting and soft focus accentuate the diaphanous and transcendent qualities of the print.

Vanderpant used lighting and pose to convey a "deep quality of essences," which was for him the definition of beauty. He

was not a regular churchgoer and he smoked cigars, a habit not accepted by Christian Scientists, but Anna noted that he "supported" his wife's dedication, and he espoused the teachings of that religion. The family subscribed to *The Christian Science Monitor*, the children were raised "to live the purpose of religion,"[5] and Vanderpant's writings reflect the Christian Science belief that the universe is governed by spiritual rather than physical laws. According to Christian Science, God or "Mind, or Spirit, is fundamental. The universe to which it introduces the learner is a universe of infinite spiritual consciousness."[6] This principle led Vanderpant to believe that "the great need of art today is to be reborn in the idea of purpose, so that inspiration may have its inspiring source." He maintained that the resulting "vision" would lead to "the entrance light to a universal renaissance which ... [was] in the process of unfolding—humanly—economically—artistically!" For him photography, like all the arts, was a medium for interpreting "vibrating" ideas which were "reflections of the Principle [God]."

An incident with a rival photographer helped to determine Vanderpant's business practices. Anna recalls that her father's "studio was up a long flight of stairs. On the stair riser Father had a sign, 'Columbia Studio.' Then another photographer came along and put up a sign that read 'Studio This Way'." The sign pointed to the other photographer's premises. Vanderpant deplored this type of business conduct; he criticized advertising ploys and "wrong concepts, ... wrong practice, and wrong results" in the photographic business. He stressed that "a substantial mental attitude, as a result of scientific thinking, [was] essential to progress," and that if one worked according to "the law of life," it would "enable one to do the right thing in the right way, in the right spirit and this is intelligence expressed in harmony with Creation." Vanderpant thought that photography should be run not so much as a commercial enterprise but as an art, and that in portraiture the person operating the camera ought to be giving a "personal vision of the sitter and his character." In so doing, he maintained that photographers would "preserve" the "intellectual character" and integrity of their profession.[7] He emphasized that the "only concept of competition for me is that we try to do a little better in the practice of

the Golden Rule." He held that spiritual beliefs would give him "a permanent foundation to be guided by, to build on." This approach to life and art was consistent throughout Vanderpant's life. He continued "to serve, not for selfishness' sake but to give satisfaction."[8]

Vanderpant contended that a photographer's work spoke for itself and that the quality of the work was its main advertisement. He did not agree with pressuring customers or in providing service according to the amount they had to spend.

> Do we realize how much joy our profession holds out to us if we practise it right, how much joy we can give to others by making the work as cheap and good and wholesome as we possibly can? ...
>
> ... I do not ask for any deposit in my studio. ... I have had very, very little loss. Even if I had some loss, I would rather lose a little bit of money and build on the right foundation than get all the coin that was coming to me and collect it on the wrong basis. ...
>
> ... I try to show gratitude for all the good I experience in my daily life. ... I consider myself ... more as a translator in life and it is my duty to try to see that I do ... things right.[9]

Figure 8. *Vanderpant in his Vancouver studio (n.d.).*

Throughout his career, Vanderpant maintained that commercial photographers should work according to a code of ethics. In 1934 he was elected to the Retail Merchants' Association of Canada. During the meeting, in which he was chosen president of the photographic division, the "establishment of a code of business ethics for [the] photographers of B.C. was discussed and approved." A copy of the code was sent to all of B.C.'s commercial photographers.[10]

Like the work of many artists in the last one hundred years, Vanderpant's reflected "a desire to express spiritual, utopian, or metaphysical ideals" that could not be conveyed "in traditional pictorial terms."[11] He attempted to look beyond mere representation in order to reveal other viewpoints. His delight in nature's beauties, the human character, and the everyday pleasures of life were intensified; a "joyous simplicity" became an aspect of his work.

Vanderpant's personal life also reflected a delight in homely pleasures such as piggybacking his children to bed and treating the family to a large tub of Italian ice cream. Among his favourite recreational activities were horseshoes, bowling, croquet, and bridge. Anna remembers that he "enjoyed bringing gifts home. He often brought Mother chocolates and flowers … and he used to bring home fresh baking as a present for the family." According to his daughters their home life "was special, very harmonious." They cannot recall a quarrel or a raised voice, "not even between us as sisters. We had a lovely environment."

When Anna asked to quit school at age 17, she was allowed to do so. She went to work in her father's studio and was later joined by Carina. Both were to become talented photographers in their own right.[12] Vanderpant held interesting views on education that were progressive for their day, and Anna and Carina's photographic training was based on those views. Vanderpant felt that children should be given "the consciousness of confidence. … All instruction … if progressive should be based not on interesting facts as realities, but as merely recognizable points in mental relationships."

Anna's favourite memory of her father is the way "he always listened and responded as if I were mature. I could ask him anything and receive an intelligent, warm response. I appreciated the quality of his attention and his thoughtful replies to my queries." Her instruction in the studio was much the same. She and Carina learned from observation, practice, and experimentation. They were "always allowed to try" and used Vanderpant's studio camera to take countless portraits of one another. When Vanderpant had finished photographing a sitter, his daughters were often allowed to take one or two further studies. Anna recalls that he would show them "the shutter positions, and we learned lighting by experimenting." The now-famous "Vanderpant" portrait of the acclaimed Canadian painter, J.W.G. Macdonald, was actually taken by Carina.[13] She remembers that her father's critiques were always subtle: "Rather than a negative comment, even when things were not right, he would say something encouraging. His words would give me a boost and I would keep trying." Her accomplishments were given quiet approval. The way in which her father recognized her as a photographer is vivid in Carina's memory: "I took a close-up of a woman's face, and when the print was mounted I showed it to him. He quietly said to Mother, 'She's made it.' That was my graduation diploma."

Vanderpant's reputation was soon bringing him customers from throughout the province and Washington and Oregon. Due to his success, he moved in 1924 to larger quarters in the Hamley Block, 657 Columbia Street. Three years later he made these comments on being a portrait photographer:

> I have always found that when I come to my studio open-minded, grateful for the opportunity to serve, I succeed in reflecting that warmth of feeling in my work, … and that, I think, is what makes it stand out from the work which is produced purely for financial returns. Even in my earliest efforts, when the technique was poor, the composition bad, and the portrait made by mere instinct, there seemed always to be that special appeal which I now realize is a response to the artist[']s mentality. …
>
> Of course, there is one point that must not be overlooked, and it is this: to make the technique of portrait-taking simple, a man must carry in his mind more knowledge, more experience, more understanding, than is required for any one sitting. … There is no more intellectual occupation than that of making real portraits.[14]

Through his "intellectual occupation," or "mental vision," Vanderpant sought to depict the intrinsic character of each personality. He used pose and lighting to achieve expressive images—what he called "living" prints.[15] This quality made his portraiture among the best in Canada during the 1920s and '30s. In the 1940s another new Canadian, Yousuf Karsh, would become one of the world's most celebrated portrait photographers. Like Vanderpant, Karsh strove to convey the internal essence of his patrons: what he termed their "inward power."[16]

While it is unlikely that Vanderpant influenced Karsh's style of portraiture, Karsh was, to some extent, influenced by Vanderpant and other prominent photographers of the 1930s in that he showed "an increasing interest … throughout … the 1930s in art photography" and "actively participated in the salon movement." Moreover, some images in a series of 18 nitrate negatives in the Karsh Collection, National Archives of Canada,

with the general title *Icicles* … suggest an awareness of and an interest in the dramatic, abstracted architectural views of Vanderpant. In one instance, the composition is sharply bisected by the strong diagonal thrust of the roofline, with the semi-circular forms of the upper-story eaves forming a rhythmic parade above the roofline, and the downward-pointing forms of the icicles defining the formal pattern below. … The perspective is formed by looking up-from-below along an oblique angle. … Also, a logical "reading" of the architectural space is denied to the viewer as both ground level and skyline are cropped from our view. This emphasis on two-dimensional pattern and surface contrast occurs infrequently in the oeuvre of Yousuf Karsh … and, in 1938, points to an acknowledgement of the brilliant modernist architectural studies by John Vanderpant."[17]

The similarities in the styles and philosophies of Karsh and Vanderpant are interesting. Karsh's early work, like most of Vanderpant's, was printed on matte silver papers that are no longer available. The fine-grained texture of the papers (Vanderpant used Kodak P.M.C. #8 and #12; Karsh used Opal V) provided a wide range of soft tones. Karsh's papers, however, gave him richer results than Vanderpant could achieve.

Figure 9. *"Abstract Study (Icicles)" 1938, Yousuf Karsh;* NATIONAL ARCHIVES OF CANADA PA 189182.

While both photographers did include visual contexts in their portraits, they often chose to take close-up and strongly modelled studies of their subjects. Their dramatic manipulation of light and shadow was used to capture the essence of sitters and to evoke emotional responses from viewers. From Garo, the Boston society portrait photographer with whom he apprenticed, Karsh learned the importance of seeing a subject "in terms of light, shadow, and form, and to understand that light is the photographer's greatest gift."[18] Vanderpant worked from the same premise. He bathed his customers in light, which he then eliminated or manipulated to create the desired effects. The impetus for much of Karsh's work "stems from a belief in the dignity, goodness, and genius of human beings."[19] The same can be said of Vanderpant's portraiture, but he also sought to capture their spiritual qualities: in the words of the transcendental poet, Walt Whitman, to "endow them with … glows and glories and … illustriousness."[20]

Vanderpant's commercial work was comprised of family portraits and prints for Christmas giving, for engagement notices, for the Vancouver society pages, for graduations, and the

like. The tastes and expectations of his clients afforded him only limited creativity. Little of his commercial photography was included in his artistic folio. As a result only a small number of portraits, as compared to the thousands he must have taken, are in the extant collections of his work.[21] A number are of special value because of the people he photographed: for example, the Canadian poet Bliss Carman (Plate 47), artist F.H. Varley (Figures 38, 39), and members of the Group of Seven and writer and painter Bertram Brooker in Toronto.

During Vanderpant's career, the portraits he did exhibit received much attention. In one, "A Son of the East" (Plate 16), light is reflected on portions of a man's face while the rest of his profile is obscured by shadow. His eye, which is barely visible, is lost to an internal rather than an external gaze. The pose implies inner knowledge or communion, and the title adds to the sense of majesty and suggests the qualities of a seer. The man's turban indicates that he is literally "a son of the east." On another level, the title and lighting suggest that he is a sun or the "son" of an eternal light: illumination is physically and symbolically radiating from his being. In terms of Christian Science, the portrait symbolizes the belief that "thought passes from God to man," and that humans are therefore "the spiritual, eternal reflection of God."[22]

In another, "Ebony Mask" (Plate 15), the face of a woman, delicately illuminated, fills the frame. The close-up which highlights her heart-shaped face, the warm sheen of her skin which is set off by the lighting, and her closed eyes which are at once barring and inviting, create an intensely rich image. Vanderpant's use of the word "mask," with its intimation of concealment enhances the image's sensuousness; its suggestion of a physical cover for the internal essence of the individual adds to the study's mystery. The pose, together with the lighting which seems to radiate both onto and from the woman, implies a rapturous state. In terms of Christian Science, the lighting symbolizes the belief that each individual "in the likeness of … [the] Maker, reflects the central light of being, the invisible God."[23] Both portraits are typical of those that Vanderpant exhibited: the poses, the striking use of lighting, and the suggestion of character and spiritual communion are used to form engaging interpretations of the subjects.

In 1929 the Indian writer and philosopher, Rabindranath Tagore, was in Vancouver to give a series of readings. According to Anna, Vanderpant made an appointment to meet with Tagore at his hotel room. "The secretary stipulated that Father could only stay for fifteen minutes and that Tagore did not want to be photographed. As it was, they talked for four and one half hours. They had a wonderful rapport." In all likelihood, that rapport was based on similar spiritual beliefs which included the conviction that the artist has a sacred role; that by living a life dedicated to beauty, love, and truth one reaches a higher state of grace; that "relationship is the fundamental truth of this world of appearance"; and that an artist must strive "to reveal the endless in unending surprises."[24]

During the visit Vanderpant took a number of informal photographs of Tagore. One of those studies (Plate 18) won Vanderpant much acclaim: the portrait highlights the piety and peaceful intensity of the Nobel-prize-winning poet. The study also demonstrates what Tagore described as man's "dualism— his existence within the range of obvious facts and his transcendence of it in a realm of deeper meaning."[25] Tagore does not look at but, rather, through the viewer. His gaze conveys a spiritual consciousness that is central to Christian Science and other mystical philosophies. Charles C. Hill notes that in the study of Tagore and that of Vera Weatherbie (Plate 17), a Vancouver art student, they "are not just interesting objects in the landscape of the room. They dominate the image, filling the frame, their gentleness emanating from the subtle contact between subject and photographer."[26] Vera's downcast eyes also suggest an inward gaze, a transcendent state. Her attire, a costume for the 1928 Christmas pageant of the Vancouver School of Decorative and Applied Arts, presents her as a Madonna figure, and Vanderpant's soft focus intensifies the ethereal qualities of the image.

Like other mystically inspired artists, Vanderpant used space "in new ways to underline a higher concern with the soul."[27] This is evident in most of his extant portraiture where dramatic close-ups, lighting, positioning, and backgrounds provide symbolic frameworks. In the study of the Hart House String Quartet (Figure 10), the four members are looking in different directions; yet they are linked through their closeness on a small

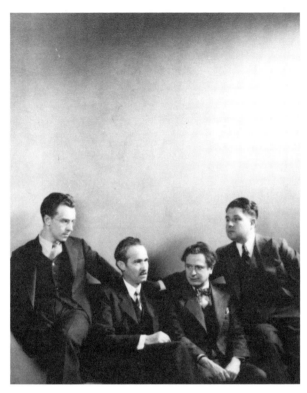

Figure 10. *The Hart House String Quartet, (n.d.); From left to right: Harry Adaskin, Géza de Kresz, Boris Hambourg, and Milton Blackstone.*

couch and the reaching, encircling arms of Harry Adaskin and Milton Blackstone. The study highlights the individuality of each member as well as their ability to merge their talents into a cohesive whole. Although the photograph was probably for promotion of the quartet, Vanderpant portrayed the group without instruments and posed them so that over half the print is devoted to an undecorated backdrop. Bright lighting individually illumines each of the musicians, as well as a large space above their heads. In this way, Vanderpant implies that the four are alight with talent and that they are inspired by, and radiate, a higher consciousness.

In "à la Garbo" (Plate 45), F.H. Varley's canvas, "The Cloud, Red Mountain," adds a sense of depth and movement to the background which, given Vanderpant's title, conveys the idea of a motion-picture screen. Vanderpant was concerned that the commercialism of the movie industry undermined its intellec-

tual achievements and standards. He stated that the "'star' development ... places personality, artistically prettified and glorified, above the dramatic ability ... of the star ... [and] the drama itself." His study excludes what he perceived to be the false ideals of Hollywood: the woman's attire and demeanour do not present her as a sexual icon; rather, she imparts a majesty and sense of purpose. She looks away from and beyond her viewing audience, and her concentration suggests that she is receiving direction or inspiration. The thrusting mountains and surging clouds behind her imply that the vital spirit of nature is part of her *élan*. Like an actor, she is conveying a role; but one that is sacred, not commercial. Vanderpant regarded this image as a prime example of his ability as a "camera man."[28]

One attempt to make a portrait more intriguing through the use of a backdrop had a humorous element. According to the client,

there was a large canvas ... in the style of Lawren Harris [in Vanderpant's studio] which he tilted on its side to make an interesting backdrop, and I was always undecided later whether to have myself, or the mountains, in a vertical position.[29]

Figure 11. *Vanderpant photographing his assistant, Zoe Kirk (n.d.). According to his daughters, the backdrop is a piece of fabric that their father found intriguing. The large painting on the left wall is F.H. Varley's, "The Immigrants." Vanderpant used the painting as a backdrop for a number of portraits.*

The practice of posing individuals beside or in front of paintings seems to have been a common feature of Vanderpant's. He may have done so to signify an affiliation with the arts, as illustrated by the pose of Eric Brown, then Director of the National Gallery of Canada, in front of F.H. Varley's painting "The Immigrants" (Plate 24); or he may have been suggesting the interrelatedness of the arts, illustrated by framing the musical composer Jean Coulthard with visual compositions (Figure 12); or in the case of A.Y. Jackson, Vanderpant may have been highlighting the connection of the painter to his artistic accomplishment (Plate 46).

Figure 13. *Anne le Nobel, CIRCA 1931.*

Vanderpant seems to have had a talent for charming his sitters. One, Anne le Nobel, recalls that she felt

> so comfortable with him. ... Perhaps it's the gift of a "genius" to make people relax and be themselves: he certainly had that facility. I remember that he tried innumerable poses, angles, and expressions, but all the while the conversation flowed. I also recall that he liked the combination of textures in my coat and hat.[30]

The portrait highlights the patterns and textures of le Nobel's outfit. Her wondering countenance contrasts with the sophistication of her dress, adding a dimension to the print that takes it beyond a literal representation.

No matter whom his subject or the limitations imposed, Vanderpant sought to express an aesthetic interpretation of his clients that would capture "the absolute qualities and values of living art" and that would "go beyond appearances into indisputable realities."

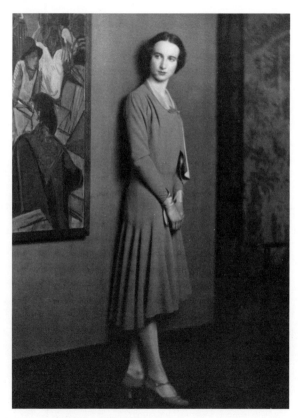

Figure 12. *Jean Coulthard (n.d.);* SPECIAL COLLECTIONS LIBRARY, U.B.C., THE JEAN COULTHARD ADAMS COLLECTION, BOX 13.

VANDERPANT'S ARTISTRY WAS enhanced when he moved to British Columbia because he came into contact with a number of other photographers and artists. With them he had a special communion: sharing ideas on art; discussing a variety of religious philosophies including Christian Science, theosophy, anthroposophy, and Oriental faiths; and considering spiritual influences on the creative imagination. Statements by Vanderpant and these artists, particularly Emily Carr, J.W.G. Macdonald, and F.H. Varley, indicate that they agreed with the tenets of theosophy: "Only that which is spiritual can be beautiful," and "the artist is the priest of 'beauty'."[1] Accordingly, Vanderpant aimed to present various interpretations of reality to his audience.

One individual who shared religious and artistic concerns with Vanderpant was the photographer Harry Upperton Knight. He made his living at his Fort Street studio in Victoria from 1917 to 1947. An article in a local paper described Knight as seeing things "as nobody else would. ... He uses a camera as an artist uses his paintbrush. You'd recognize the place in his photograph, but as though you were seeing it for the first time. ... [He has also] photographed hundreds of Victoria's eminent men."[2]

Vanderpant met Knight at a gathering of photographers in 1921. The two shared photographic, musical, and spiritual interests (Knight was a Christian Scientist), and the men and their families became good friends. More importantly, Knight was a

pictorialist who was known for his "camera portraits and camera sketches" taken in and around Victoria.[3] Pictorialists "sought to emulate traditional art media by using broad compositional design, suppression of detail, atmospheric effect, selective highlighting, and diffused or 'soft' focus to create photographs that could be judged as works of art."[4] Knight's work and pictorialism were to have a major effect on the development of Vanderpant's art, opening his

eyes ... to a beauty, different to all he had known at home [in Holland], but with a vast appeal of its own.
Immediately, he began to express through his camera the emotions produced in him by Canada in all its moods and seasons.[5]

For Vanderpant, pictorialism was the means to conveying the "feeling, character and atmosphere"[6] that set it apart from ordinary photography. While he moved away from it in his later work, and became more interested in modern abstraction, Vanderpant never completely rejected pictorialism, keeping "a foot in both camps."[7] Some of his early prints resembled Knight's mix of "Old World sentiment with soft-focus pictorial moodiness,"[8] but he was always concerned with forms and their interplay. His daughters recall that "Knight's compositions were more pastoral," whereas their father concentrated on the patterns and textures found in nature and his surroundings.

From the recollections of their children, it is clear that the two men enjoyed one another's sense of humour. According to Anna, they had "great fun." They would get together two or three times a year and share their latest work. Anna relates that when her father went to visit Knight, "he would take twenty to thirty prints; when Knight came to visit, he did the same. They delighted in each other's work." She also recalls that Vanderpant and Knight "could spend an hour or two without uttering words—just enjoying the beauty, the design, or the quality in one another's latest batch of prints."

According to Knight's stepdaughter, Lottie Kaiser, the two men

would have great discussions on how to take pictures, and they enjoyed going out to look at the countryside and to

search for pictures. Knighty's camera sketches were more English than John's: the scenes were similar to those found in parts of England and looked like landscapes painted by [the Romantic landscape painter, Joseph Mallord William] Turner.

They also talked and played records until midnight. The music would keep me awake, but they had such a good time it was worth it. John's tastes in music were more modern than Knighty's.[9]

During their visits, the two families often went for long drives. Anna remembers her father and Knight "stopping every few minutes to take a picture." Sunday drives were a regular outing for Vanderpant's family, and his daughters recall that he "loved to be behind the wheel of a car." Alone or with friends, the family motored in their vintage Ford to places in the Vancouver area and also to Blaine, Bellingham, and Lake Whatcom in Washington State. When something caught his eye, Vanderpant stopped to capture the image with his camera. One foray had surprising results and provided his daughters with a humorous vignette:

We were travelling in Surrey [a large suburb of Vancouver which was then mostly farmland] and Father stopped the car and jumped out, camera in hand. He wanted to get to a fenced field in order to take a photograph. What appeared to be a solid plank over a ditch overgrown with reeds and tall grass was really a rotten board which gave way under Father's weight. He fell "kerplunk" up to his waist in water! Instinctively, he raised the camera above his head, but he was soaked! At first, we all screeched with fright. Then, we just howled! Poor Father. He had to drive home in his underwear and a touring blanket, and every so often we all broke out giggling.

Unfortunately, most of Knight's private papers have been lost and there is only one letter from him in Vanderpant's papers.[10] That piece of correspondence gives important insights into the warmth of their friendship, their shared concerns with photographic techniques and copyright protection of their work, and their struggles to be recognized as artists and to have their prints

accepted in various photographic salons. Participation in the salons was costly and time-consuming because the prints had to be specially prepared and shipped, and most salons were in the United States and Europe. The process became even more disconcerting if prints were not accepted or, as was often the case, they were not returned promptly.

The letter also highlights the importance of the principles of Christian Science to their lives and work; that they shared the idea that the artist has a spiritual role, is evident.

My dear Van,
Would that I could disserve [sic] your sincere friendship. ...
Your last letter certainly opens up quite a new thought with regard to selfishness. I had not seen it in this light & appreciate your disclosing the thought; it shows us how very alert we must be to discern the subtle whiles [sic] of error & rely wholly upon divine Mind for guidance. I often think as to business, what are [we] striving for most? dollars & material success, or spiritual understanding? but we have the only solution in Jesus' own words "seek ye *just* the kingdom" & in this I have proved the truth of it in my earlier days of science [Christian Science] but somehow it seems to be more difficult now. [B]ut it cannot change the fixed principle of spiritual law any more than evasion of study can change the principle of Mathematics, so that we must just put on the whole armour & get into the fight with error & destroy it.
So glad to know of your further success with prints at Portsmouth & Southampton. My prints which I sent to the Salon were *not* accepted & [I] have not yet even had them back. I feel that there must be something wrong with my work. Have not yet received any notification from Montreal. I do hope that I get something hung, also at Buffalo where I sent six prints.
I have a very nice folio of Veltex prints[11] which I hoped to show you when I come over but Mrs. Knight has taken them with her to see if she can make connections with any art stores down south; have not been doing much lately but resurrected a negative from last August trip which is quite nice. Yes I would like nothing better than for us to get away

quietly for a few days & a pictorial hunt … would do us both good, we must talk it over when I come. …

Curiously, I have been working on making enlarged negatives from my sketches the past few weeks … & I think that it is a right move to endeavour to commercialize our work as it is in accordance with principle that our gift blesses as many as possible. I'd like very much to talk this over with you & compare notes & see if we cannot organize a system. Have enclosed two or three forms for American copyright, also the "dope" on it; much the same as our own. Three copies of each. I usually make small contact prints from the original negatives & mount 8 on a card & make a copy negative 10 x 8 of it. I then make three prints of it so you can [make] 8 studies for the cost of one! Quite a saving in cost but quite a big job when you are all behind with your negatives as I am, but we can select a few at a time & get to business. …

It occurs [to me] that I have got quite a lot to look forward to when I see you next; bye-the-bye have you thought of the possibilities large negatives will give us for gum prints?

Hoping that Mrs. Van. & the children are well & happy & hope to see them soon. …

Warmest regards to you all.

I am sincerely

H.U. Knight

Have you heard Victor records 6459.60.61.62.63? They are beautiful![12]

Inspired by Knight, Vanderpant began to observe his surroundings more closely and started recording images of his locale. He came to believe that "if you want to do pictorial work, you must observe. … Pictorialism looks … for beauty in very simple spots and in very simple motives."[13] His concern with simplicity most likely stemmed from a variety of sources. From his Dutch heritage Vanderpant had learned the proverb, "The earmark of what is true is simplicity." He interpreted this to mean "that all of life, its purpose, its expression, must be simple and through simplicity understandable." This notion may also have been influenced by artist friends such as Knight, who main-

Figure 14. *"Trespassers" 1926.*

tained that a photographer should "keep the equipment simple," and F.H. Varley, who believed that "the simpler work is, the richer it becomes."[14] Simplicity became a significant element of Vanderpant's compositions, connecting him to artists such as Amédée Ozenfant, who believed that "there can be no intensity without simplification," and Walt Whitman, who wrote that "the art of art, the glory of expression … is simplicity."[15]

The landscapes, still lifes, and other studies Vanderpant submitted to photographic salons won recognition almost immediately for two primary qualities: the subject matter, which concentrated on everyday life and commonplace subjects, and his unique way of strengthening the composition through what he called "the play of light and shadow." Vanderpant likened photography to interpretive dancing:

If we … look for the real thing, for the real dancing which is based on the higher quality of intelligence, we get a personal interpretation of the music like [Isadora] Duncan and those dancers who give interpretation of the classical music.[16]

In the years to come Vanderpant would find his "personal interpretation" in close-up images, which resulted in more

abstract views. The subjects of his prints, his stress on the relationships of forms and their removal from their normal terms of reference, and the spiritual inspirations in his work were part of "the new language of modernism."[17]

In New Westminster, Vanderpant became acquainted with another photographer, Johan Helders. A restaurateur, Helders was also "Canada's outstanding amateur pictorialist during the late twenties and early thirties."[18] Unfortunately, fewer than 40 of Helders's prints have survived.[19] From those prints, reproductions in journals, and Helders's writings, his link to Vanderpant is unquestionable. As Helders publicly acknowledged, "Under his [Vanderpant's] influence and friendship my work has certainly improved very much."[20]

Helders moved to Vancouver in 1924, met Vanderpant that year at a local photographers' meeting, and immediately began to participate in the New Westminster Salon of Pictorial Photography which ran from 1920 to 1929. The two men and their families quickly became close, and they socialized regularly. As they did with the Knights, the Vanderpants would often go for recreational drives with the Helders. On these outings, or specific photographic excursions, Vanderpant and Helders found subjects in the nearby waterfront, the surrounding farmlands,

Figure 15. *"The Burning Stable" 1925, Johan Helders; original 24 x 32.2 cm;* SPECIAL COLLECTIONS, VANCOUVER PUBLIC LIBRARY, 54763.

Figure 16. *"In the Blaze of Summer" 1925, John Vanderpant.*

and Mount Baker in Washington. They would often shoot the same object, presumably to compare the outcomes. Some of their prints are almost identical: Helders's 1925 print, "The Burning Stable," and Vanderpant's 1925 print, "In the Blaze of Summer" are two such examples.

Helders's methods and materials were also similar to Vanderpant's. Helders stated that, like Vanderpant, he used a bromide printing process and Kodak paper, P.M.C. No.8, for most studies. He also indicated that, like Vanderpant, he used an anistagmatic lens and enjoyed "a pleasantly diffused image."[21]

Helders's philosophy was also akin to Vanderpant's; his writing on the subject echoes Vanderpant's thoughts. Helders wrote:

> Subject matter has little or nothing to do with art. It is the essence that counts—the reflection of the artist's soul. There can be more art in the "shooting" of a dust-pail than in the setting of a sun. It all depends on what the man himself makes of it.[22]

Vanderpant wrote:

> Does subject matter, matter? Is light less glorious when it goldens ashcans than when it dips in fading red the rising

mountain range? … Both are messages of life's essential consciousness. That only counts. … [and is conveyed] in the accomplished translations of … mental vision by camera and lens.

Vanderpant and Helders were to live near each other for only two years. In 1926, financial difficulties forced Helders to sell his business, the Blue Bird Inn on Granville Street. He left Vancouver to take a job as maître d'hôtel at the Chateau Laurier in Ottawa and did not live in Vancouver again until 1939, the year that Vanderpant died.

According to Helders's son, John, "The big difference between John Vanderpant and Johan Helders is that Father never considered trying to become a professional photographer, and he didn't take many portraits."[23] The other difference between the two is that, unlike Vanderpant's, Helders's later work was not successful. He began "using a sharper focus and concentrating on detail, but his later efforts fell short of his earlier work."[24] The work of these two men, one a professional and one an amateur, is now a significant part of Canada's photographic history.

Although separated by thousands of miles, Vanderpant and Helders continued to give one another support and encouragement. According to Anna, Helders would often send negatives to Vanderpant, who, in turn, would critique their compositions. When the painter F.H. Varley moved from Vancouver to Ottawa in 1936, Vanderpant seems to have suggested that Varley could also assist Helders artistically. After their first meeting, Varley wrote that he thought he would see much of Helders and "I think too I can help him quite a lot in his compositions. He welcomes constructive criticism."[25]

In the late 1930s Helders found that his energy was not what it had been, and his photographic work began to decline. In a 1936 letter he complained, "In the realm of photography I haven[']t done a thing. I am usually so tired at night that I have no ambition."[26] A 1937 trip to Vancouver, and a visit with Vanderpant, revitalized Helders. He wrote: "Am … gratefull [sic] to you for renewing my interest in photography. Have about 30 prints and I think about one dozen of them are salon prints. … Yes John your company has done me a lot of good, in every way. Thanks old man."[27]

The Helders/Vanderpant correspondence illustrates that there were problems other than finances facing Canadian photographers during the Depression. Helders's 1936 letter indicates that the many miles that separated the country's prominent camera workers prevented communication on a regular and meaningful basis. Isolation from one another also encouraged minor rivalries and jealousies. When one of Canada's leading amateurs, Bruce Metcalfe, resigned his position as writer on Canadian photography for the British journal *Photograms of the Year*, he turned the position over to an energetic Ottawa amateur—C.M. Johnston. When Helders inquired why Vanderpant had not been selected, Metcalfe "claimed they thought you [Vanderpant] were too far out west and not informed enough." Helders thought the comment "too absurd" and concluded angrily that "if the West (according to Metcalfe) does not know what is going on in the East, then what about the East knowing about the West."[28] Problems of distance and east/west factionalism have long been an aspect of Canadian history and "the embryonic photographic community suffered from the typically Canadian problem of poor communication in a large and sparsely populated country."[29]

In the 1920s and '30s the main way for the prints of Canadians to be recognized in their own country, and internationally, was through the salon circuit. In Canada, however, camera clubs were "evanescent organizations,"[30] and the country did not have a national photographic journal until the late 1960s. (Indeed, the National Gallery of Canada did not begin collecting photographs until 1967.) Nor did the country's photographers produce work that conveyed a national identity.

Canadians wishing to keep abreast of contemporary issues and technological advances had to read foreign publications. In 1925 Vanderpant subscribed to "three American, two English, two Dutch, one German, and two French magazines." He considered them "a very great stimulant." He also belonged to numerous photographic associations and believed that such participation kept him "in touch with the progress of photography."[31]

Over the years, the proliferation of salons caused Vanderpant and others, including the American photographer Edward Weston, to question the quality of the prints being accepted. Weston wrote Vanderpant: "I am not interested in 'salons'. … I

saw the recent show in L.A. [Los Angeles]. With few exceptions the prints were pretty awful,—and about the worst ones were the judges' own!"[32]

As early as 1926, Vanderpant was concerned that salons were becoming the victims of "interfering interests." He believed that many photographers were submitting prints which would "meet with the approval and taste of the jury." On the other hand, he felt that the juries often accepted work which did "not measure up to reasonable standards." Vanderpant suggested that a circuit system would encourage smaller, more critically selected exhibitions. He also maintained that the salon should be an educational body, providing critical evaluations for those prints which were not hung. Finally, nine years in advance of its establishment in Canada, Vanderpant suggested the idea of national salons in which submissions "could be judged by the best and most fearless in the land."[33]

From 1919 to 1930, Canada had only three international salons and all were connected to agricultural and industrial fairs: Toronto's became an international salon in 1919; the Ottawa International Photographic Salon existed from the early 1920s to 1928;[34] and Vanderpant's New Westminster Salon of Pictorial Photography became an international salon in 1923 and continued until 1929. His had the added distinction of being the only international salon in western Canada in the 1920s. From 1934 to 1940 the National Gallery of Canada organized the Canadian International Salon of Photographic Art. In 1935 Vanderpant was one of the "fearless" judges, along with Bruce Metcalfe of Toronto, and Frank R. Fraprie of Boston. Vanderpant was never asked to judge the salon again, and there are indications that his tastes were considered to be too modern. While C.M. Johnston (the 1935 Salon Committee Chairman) believed that there had been "a very fair selection,"[35] Fraprie did not. An editor with the American Photographic Publishing Company, Fraprie complained that "the other two judges were strongly against the type of pictures which are accepted by other salons and reproduced by the photographic press."[36] Vanderpant, on the other hand, felt that the exhibition was "a rather conservative showing. The leading modernists are hard to get."[37] Perhaps more "fearless" judging would, over time, have attracted the world's most gifted photographers. As it was, the salon was mainly a showcase for amateurs.

Vanderpant participated in the Canadian Salon until 1938. His prints were included in those honoured by being reproduced in the Salon's catalogues: in 1934, "Concrete Power"; in 1935, "Floral Rhythm"; in 1936, "Spirit and Matter" along with a portrait of Vanderpant taken by Helders; in 1937, "Urge"; and in 1938 "Variations on a Theme" (similar to "Peacock Pride," Plate 29).

Vanderpant began receiving recognition for his work as early as the mid-1920s through his participation in salons and in individual exhibitions. In 1925 he held a solo exhibition at the first Hotel Vancouver. A review pointed out the great interest shown in Vanderpant's works:

> At the Vanderpant exhibition in suite 231 at the Hotel Vancouver there must be a feeling almost of envy on the part of visiting artists who employ pencil and brush, for ... Mr. Vanderpant takes the sun into partnership and paints with a camera. In considering these pictures, which are open to public observation without charge, one feels that the good old word, "chiaroscuro," which was so fashionable in writing about paintings a century ago, might again be brought into vogue. That word was made up from the Italian "chiaro," light, and "obscuro," dark. It meant the distribution of the lighter and darker shades in a painting or engraving, and it is this quality that is chiefly observable in the works now on view. There is, of course, selection of subject. Without an ability to do this, these pictures could never have been produced.
>
> But what must strike all visitors is that they show us that there is beauty in many things and places that we frequently pass by without noticing that there is any beauty [in] them at all.[38]

One of Vanderpant's most widely known prints during the 1920s was "The First Day of Spring," (also known as "That First Day of Spring"). While people are not often found in Vanderpant's extant photographs, they are in a number of his negatives. In "The First Day of Spring" the human subjects are "separate ... yet inextricable"[39] in their enjoyment of the sun's warmth; time and place unite them, and the viewer, in the enjoyment of human sensations. The curving path is a reminder

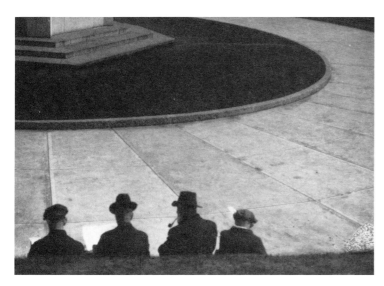

Figure 17. *"The First Day of Spring"* CIRCA 1925; *a modern image reproduced from Vanderpant's lantern slide;* NATIONAL ARCHIVES OF CANADA PA 175740.

of passing time, changing seasons, and the cyclical basis of the natural world. Yet, time has focussed on four individuals and has made them icons of the human condition. A monument in the background, though severely cropped, highlights the contrast between images made by humans and images of humans.

In July 1925, Vanderpant had a one-person show at the Royal Photographic Society, London. The prints then went on exhibition to other parts of Europe. One French reviewer was struck by "the perfect play of light" in the print "Symphony of the Sun," and in the portrait "A Son of the East."[40] A review for *The Photographic Journal* stated that Vanderpant's prints "showed a consummate technique …, great versatility, and an individual outlook upon Nature controlled by artistic feeling."[41]

In an interview, Vanderpant stated that the comments of a reviewer (who along with the journal was not named) caused him to reassess his work, marking a crucial point in his development. The reviewer stated that Vanderpant's photography lacked a Canadian character

and was undoubtedly influenced by the artist's early surroundings. Very carefully, Mr. Vanderpant examined the truth of this, and, in so doing, woke to the knowledge that

Canada as a country, has a beauty and character which may not be confounded with that of any other country.

Then followed a realization of the strength of the country, of the men and women who had made it, of the colossal work that must still be done to develop it for the vast body of people who will later enjoy it, and this sense of power and virility has crept into Mr. Vanderpant's work.[42]

In the mid-1920s, Vanderpant started to photograph the objects that were to become a major part of his *oeuvre*: grain elevators on the Vancouver harbour. His studies of these structures taken from 1926 to 1934 are among "Vanderpant's most successful images."[43] His equipment, outside the studio, was an ordinary roll film camera: a 6 1/2 x 9 cm. Ansco with an f/63 anistagmatic lens. Vanderpant often said, "It is the photographer and not the camera that makes the picture."[44]

From the time that he began exhibiting, Vanderpant won recognition in various international competitions. For example, at the Royal Photographic Society's exhibition in London in 1922, his was the sole Canadian work that was hung. Over the years, he was to win so many awards he could weigh his medals "by the pound … [and] paper a wall with his certificates."[45] In 1924 his print, "Window's Pattern" (Figure 18), was purchased

Figure 18. *"Window's Pattern"* CIRCA 1923; VANCOUVER ART GALLERY, 90.68.2.

by the San Francisco Art Museum as part of its collection of pictorial photographs. Beginning in 1923, Vanderpant's work was reproduced in photographic journals worldwide. Moreover, many European and American newspapers published reviews and commentaries on his work; in 1927 *American Photography* ran an eight-page article on Vanderpant as part of "A Series on the World's Greatest Photographers."[46] As articles in the local paper pointed out, Vanderpant was bringing New Westminster "worldwide publicity," and his "views of British Columbia scenery ... proved valuable advertising mediums for the province."[47] In 1924 two of his prints, "Curvature" (a study of a swan) and "A Son of the Earth" were accepted for the Royal Photographic Society's exhibition in London. As only 110 prints from around the world were hung, this recognition of his work was impressive. In 1926, Vanderpant was made a Fellow of the Royal Photographic Society of Great Britain, which in his day was deemed to be "the highest honour for photography that can be secured."[48]

Vanderpant was also doing his best to raise the general appreciation of photography and the arts. He began lecturing to local, national, and international groups, and over the years gave illustrated talks to such diverse audiences as art groups, business groups, photographic clubs and associations, university groups, the Girl Guides, and the Y.W.C.A. In the summer of 1924 he went on a three-week trip to Chicago and Milwaukee where he spoke to 1500 delegates of the Photographers' Association of America on "Studio Ethics" and "Pictorial Photography." During this trip he had "several flattering and tempting business offers but turned them all down in favour of New Westminster."[49] Moreover, in Milwaukee he was pleased to discover that instead of a showing of six of his prints, 36 had been chosen for exhibition. Vanderpant was also working to promote the work of other Canadian photographers: he took a number of prints by fellow Canadians, including those of Johan Helders and Harold Mortimer-Lamb, to the Milwaukee convention.

Vanderpant was on the executive of the Vancouver-New Westminster Photographers' Association; in 1922 he was the vice-president of the Photographers' Association of the Pacific Northwest; from 1922 to 1923 he held the position of vice-chairman of the art committee of the Royal Agricultural and Industrial Society in New Westminster, and from 1924 to 1928 he was its chairman;[50] in 1924, he joined the British Columbia Art League, a group whose mandate was to establish an art school and art gallery in the city of Vancouver. He was to publicize and champion Canadian photography and Canadian art and artists until his death.

One of the ways he first encouraged an appreciation of photography was through the Fine Arts Gallery of British Columbia's Annual Provincial Exhibition. Held in New Westminster under the auspices of the Royal Agricultural and Industrial Society, the exhibition came to be the largest agricultural fair west of Toronto until a fire in 1929 destroyed its buildings. From that time on, Vancouver hosted the Provincial Exhibitions.

Like other Canadian agricultural fairs, New Westminster's was a combination of local boosterism, agricultural and industrial displays, and entertainment. The exhibition received much media coverage, and attracted large crowds during its week of events. (More than 37,000 attended in 1929.) Although the exhibition was considered to be the province's best, the fine arts section had long been neglected; prior to the war it had for "years ... languished and deteriorated into an annex to the display of women's work."[51] Vanderpant played an important role in helping to revitalize the fine arts display. Through the art committee, he encouraged showing the work of B.C. artists, work from other parts of Canada including canvases from the new and controversial Group of Seven, and photographs from local and international photographers. By 1923 the arts section had grown to such an extent that two rooms were added to accommodate the entries.

In 1919 the photographic display was made up largely from commercial exhibitors. Vanderpant encouraged both professionals and amateurs to participate, and in 1920 he inaugurated the New Westminster Photographic Salon; within three years it was an international salon. By the mid-1920s Vanderpant was receiving and judging as many as 1400 prints, submitted from photographers in 23 countries. The exhibition's photographic section became one of the most interesting and popular facets of the fine arts displays. Fair-goers viewed examples of portraiture, landscapes, and still lifes, advances in techniques, and examples

of various arts movements in work from local, national, and international photographers. One critic noted that "Idealism, realism, cubism, and futurism are here with motifs which a layman can understand."[52] Some sections were competitive and some were loan displays. Like the other media displayed in the Fine Arts Gallery, many of the photographs were for sale. Vanderpant organized the photographic exhibition, and he often judged the competitive sections; for those reasons, his prints were not usually eligible for prizes. However, many were available for purchase, and their beauty and quality were regularly mentioned in the local papers.

In 1921, the Fine Arts Gallery of the New Westminster Provincial Exhibition displayed 400 works of art. Canvases by the Group of Seven were included in the 25 works provided by the National Gallery. The B.C. public had not yet come to terms with paintings by the Group. Vanderpant and a few other patrons of the arts in Vancouver, such as Harold Mortimer-Lamb (a pictorial photographer and arts enthusiast), would defend the Group's modernism to British Columbians; the general populace

Figure 19. *Interior view of the Fine Arts building, New Westminster Provincial Exhibition, 1921. Frederick Varley's painting, "John," is visible on the right side of the gallery; works by the Group of Seven are hanging on the back wall. The bouquets of flowers, always found in Vanderpant's studios and displays, were probably his suggestion.*

would, however, be slow in accepting this "new school." As a reporter for *The British Columbian* noted, while commenting on the work by the Group of Seven on display at the exhibition,

> Several fine examples ... were favorably commented on by few; the public taste requires to be cultivated. It is a bit of a wrench to enjoy these all at once. But [paintings such as Frederick] Varley's "John"... grow on one and at a proper distance, with the good light they enjoy, their beauties unfold to any but the casual observer.[53]

Vanderpant was an ardent supporter and defender of the "modern" approach of the Group of Seven, advocating their work in lectures and in print. As a member of the art committee, he welcomed showings of their work. From 1919 to 1929, the National Gallery loaned work to the Provincial Exhibition and work by the Group was always included; every year, their work met with criticism and controversy. Comments such as, "Ah, somebody's spilled little Willie's paint box," or, "It looks like a bucket of earwig bait with too much Paris green," were not uncommon.[54] For those who could appreciate the canvases, the exhibitions were marvellous displays of now-famous paintings. For example, the 1922 exhibition displayed 16 paintings by the Group of Seven which were loaned by the National Gallery.[55]

In the 1920s Vanderpant began writing articles and lecturing, and did so until his death. In his writings and talks he was either defending modern art, and artists such as the Group of Seven, or arguing for photography to be accorded its place in the realm of art. Vanderpant held mystical, artistic, and nationalist tenets similar to those of the Group of Seven.[56] These, and a close friendship with one of the Group's members, Frederick Varley, made him especially interested in their work. In a 1933 lecture, Vanderpant stated that he thought paintings by the Group of Seven were inspired by their intuitive desire "to express living, moody rhythms, movement in spaces, [and] the inevitable relationship between these forms."[57] His own inspiration was derived from a similar desire to express "the consciousness of life ... in aesthetic form, pattern, rhythm, and relationship."

Vanderpant championed the Group in local newspapers and in 1928 called it a "yearly privilege to draw the pen" on their behalf.[58]

In 1927 he wrote that it was "a glorious duty" to defend the Group against an "unjustified condemnation" and suggested that

one must realize that the aim of the School of Seven is not representation, but interpretation. ...

The men of the School of Seven ... felt that the immensity of Canada could not be truly painted with a European brush, ... so they ... went for the soul of the land in the ruggedness of form, the rhythm of line and color, by simplicity and directness of stroke and elimination— detracting detail, using freedom to emphasize either in form or color, what was personally most striking to interpret. ...

May many visit the ... gallery, grateful for the opportunity given to see and study a collection containing several interesting works. That many may go open-minded, in fairness to the artists, honestly trying to discover what Canada, pictorially, has to say. When Europe has recognized this Canadian movement, can the West afford to stay indifferent or insincere?[59]

Vanderpant could not be "indifferent" to new expressive movements. Over the years his work became more modern, and he continually encouraged the acceptance of new movements in all the arts. In a 1937 lecture to faculty and students at the University of Alberta, entitled "Art and Photography," Vanderpant said that

art ... is the result of deep feeling and striving on the part of the artist, to transmit a message of the expression of consciousness of life. ... We must arise ... to the concept of art as relation of parts. ... This concept of art applies not only to art in painting, but ... all the other branches of the fine arts. Thus with a camera one is just as well enabled to create objects of beauty; the beauty lying not in the objects depicted themselves, but in the individual's understanding of the subject. Thus art is the consciousness of life expressed in a static form of relationship.[60]

Vanderpant's "consciousness" was to lead him to explore many new avenues. In 1926 he entered into a partnership with Harold Mortimer-Lamb, and the Vanderpant Galleries was opened at 1216 Robson Street, Vancouver. Vanderpant's photographic work and his input into the local art scene intensified.

NEW DIRECTIONS

THE VANDERPANT GALLERIES opened with an exhibition that ran from 15 to 20 March 1926. The exhibition included a collection of oil paintings, water colours, pastels and etchings. The opportunity to view original works of art from 17th-century Japanese artists to those of Canadians like A.Y. Jackson, and Europeans such as Whistler, Corot, Millet, and Legros was rare in a city that did not yet have a civic art gallery. Also included was a collection of photographs by Harold Mortimer-Lamb and Vanderpant.[1]

Mortimer-Lamb was a wealthy mining engineer, art critic and patron, writer and editor, and amateur photographer. Like Knight he was a pioneer in Canadian pictorial photography, and he has been described as one of the "earliest and most effective champions of the pictorial concept" in this country.[2] The Canadian painter Jack Shadbolt has defined Mortimer-Lamb's portraits as "superbly sensitive and his figure and landscape themes the essence of poetry."[3] Mortimer-Lamb wrote numerous critical articles on photography in Canada, he was one of the first to defend the Group of Seven, and he is credited with calling the attention of the National Gallery to the paintings of Emily Carr.[4]

When Vanderpant and Mortimer-Lamb met is not known, but they may have become acquainted through Mortimer-Lamb's participation in the New Westminster Salon of Pictorial Photography.[5] The two must have felt an immediate kinship: both were talented photographers and arts advocates. Mortimer-Lamb's "idealist values in which art was the custodian of truth [and] beauty," and his desire "to encourage and perpetuate this concept,"[6] were shared by Vanderpant.

Vanderpant's daughters recall that "someone" suggested that Vanderpant should move his business to the larger city of Vancouver. In all likelihood that "someone" was Mortimer-Lamb. The two formed a partnership with the intention of operating a photography studio, an antique shop, and an art gallery. In a letter of 28 January 1926, Mortimer-Lamb wrote to the Canadian painter and member of the Group of Seven, Arthur Lismer, that he did not

anticipate that the art sales will support a business. Personally I do not expect to make any money out of it, but it will give me a new interest, & perhaps I may have an opportunity to do some useful work in the interests of art here.[7]

The venture was promising because of the men's shared expertise and the fact that the Galleries offered an important venue for art in a city in which exhibitions were limited. Moreover, Mortimer-Lamb was an influential individual in Vancouver's small but growing art circle. His contacts would certainly have attracted a clientele, as would Vanderpant's reputation for portraiture; Vanderpant's local popularity was more than likely the reason for naming the Galleries after him.

Mortimer-Lamb owned the building and agreed to rent the premises "to the firm for a period of 3 years, with an optional 3 years, at a rental of eighty-one dollars per annum!" He was to equip the photographic gallery and in return he was to "have first claim on rentals due and interest at 7% on money so invested, out of the income of the firm." He was to be reimbursed "for moneys so expended as soon as profits permit." Vanderpant was to provide whatever equipment he could and, like Mortimer-Lamb, he was to be reimbursed as soon as profits permitted. Moreover, Vanderpant was to "have second claim on a salary of $200. per month out of the income of the firm." After deducting the expenses as listed

above, they agreed to divide "the balance of the net profits" on a 50-50 basis.[8]

The enthusiasm with which the two took up their new enterprise is reflected in Mortimer-Lamb's letter of 8 March 1926 to Lismer. He wrote that

> as both Vanderpant and I do work different from the ordinary commercial kind, there may be a good opening for us. At present however, I only look on the venture as an opportunity to add a new interest to my life, rather than as a source of profit, & shall be content if Vanderpant can earn the salary that it is proposed the business shall pay him before there is any division of profits. The "stock" comprises my little collection of pictures, ... but ... I hope to be in a position to acquire Canadian work & be of some practical service to the "Group" out here. Until we are in a position to buy outright, do you think it would be possible to arrange that we be sent a few canvases by yourself, Jackson, MacDonald, and perhaps Gagnon & Robinson on consignment?[9]

In light of the continuing critical response by British Columbians to modernist paintings, Mortimer-Lamb probably made few sales of such work. Business was slow and he found the financial burden increasingly difficult. He very likely sold some antiques, and he and Vanderpant must have had some work in their advertised specialties of "Photographic Portraiture and Pictorial Photography of Homes and Gardens."[10] Instead of recouping his initial investment, however, Mortimer-Lamb lost money with every passing month. He tried to be optimistic, but three months after the opening of the Galleries he wrote Lismer that the business

> has proved so far a "frost." I hoped that it would at least make enough to pay the overhead, but instead of that it has become a heavy monthly charge—sufficiently so to cause me a great deal of worry. Nevertheless, I shall have to manage somehow to carry the thing on until the end of the year in anticipation of the Xmas business being profitable enough to recoup my losses.[11]

In July he complained to Lismer,

> So far my venture has proven financially disconcerting, as in four months I have dropped over a thousand dollars. But if I can hold I am satisfied the thing will go, & so I shall stay with it for a year anyway. Meanwhile we have stirred up lots of interest and are doing useful missionary work.[12]

In addition to the financial difficulties, Mortimer-Lamb and Vanderpant began having artistic disagreements. Anna remembers that her father maintained his New Westminster studio until 1927, with the help of a "capable assistant."[13] He commuted to Vancouver "two or three days a week," but became increasingly frustrated as Mortimer-Lamb began to insist on doing all the camera work, leaving Vanderpant to do all the developing and printing. By March 1927 the partnership had ended.

In keeping with the partnership agreement Vanderpant opted to take over the business and the building's lease. He also purchased the furnishings; a Sheraton chair and desk, a Chippendale table and chairs, a Victorian table and chair, a Georgian bookcase, and a Chinese cabinet and screen were among the articles. He could not pay for the furnishings immediately so the accounts, with interest charges, were settled slowly. The antiques that were not used for the studio were sold, and that aspect of the business ended. Over the years Vanderpant continued to exhibit and to sell works of art on consignment. Many years passed before he could reimburse Mortimer-Lamb for the money he had invested. Their "Agreement of Partnership" gave Vanderpant the option to purchase the building, but he was not able to do so in his lifetime. (Anna bought the building in 1941 but sold it in 1946.)[14]

Unfortunately, Vanderpant's friendship with Mortimer-Lamb ended when the partnership did. A letter of 4 May 1929 from Mortimer-Lamb that began "Dear Mr. Vanderpant" shows just how much the relationship had cooled, and the two were never to mend the rift. They treated one another with the courtesy of gentlemen and, according to Anna, were "friendly but not friends" after the partnership ended. In its small way, the schism between Vanderpant and Mortimer-Lamb was a forerunner of a

deeper schism that was to divide members of the local art community into differing factions in 1933.

Vanderpant and Mortimer-Lamb were catalysts in the cultural development of Vancouver for years.[15] One can only speculate on what might have happened if their partnership had remained intact. It is obvious that Vanderpant's relationship with Mortimer-Lamb was the beginning of a new direction: Vanderpant's gallery became a focal point in the city's cultural activities, and he was soon in the forefront of new ideas and art activities in the city. Like the famous American photographer Alfred Stieglitz, Vanderpant recognized and promoted the interrelationships of the arts; and like Stieglitz's famous Little Galleries at 291 Fifth Avenue in New York City, the Vanderpant Galleries, on a smaller and more

Figure 20. *The Vanderpant Galleries exhibit at the Vancouver Exhibition (n.d.). After the closure of the New Westminster Exhibition in 1929, Vanderpant regularly participated in the Fine Arts section of Vancouver's Exhibition.*

parochial scale, made innovative trends in photography, painting, and music available to the community.

For many years Vanderpant was involved with the British Columbia Art League. On 18 December 1920, a group of 12 arts enthusiasts formed a society whose declared aim was to found an art school and civic art gallery. They also wanted to promote art exhibitions, to bring about improvements in the city's architecture and landscaping, and to encourage the arts in every possible way. By 1 October 1925, this enterprising group had met one of its main objectives, the establishment of the Vancouver School of Decorative and Applied Arts. Eleven years would elapse before the members finally met their objective of establishing an art gallery.

Vanderpant's involvement with the B.C. Art League appears to have started in 1924 and lasted until the final meeting in 1931. The League's records indicate that he was an active and valuable member. In 1924 he was elected to the League's Gallery Committee: its purpose was to oversee the selection of works for exhibitions at the League's temporary gallery, and to select works which would form part of the gallery's permanent collection. In 1924 he gave the first of many lectures to the League's monthly meetings, speaking on "Pictorial Photography." Numerous executive meetings were held at the Vanderpant Galleries, as well as a few general meetings. Lectures given to the League's membership were sometimes hosted by the Vanderpant Galleries, and all the lectures for 1927 were held there. In a 1926 publicity campaign, Vanderpant was one of four members asked to select paintings from the gallery's permanent collection for reproduction in the local newspapers. In his capacity as an executive officer he worked to promote the art of B.C.'s citizens: for example, in 1926 his proposal that the League "assist B.C. artists to send pictures to the Royal Canadian Academy" was endorsed;[16] and in 1926 he organized a "pictorial photography Exhibition" for the gallery. According to the League's 1930 Annual Report, in May of that year Vanderpant was responsible for a "new departure" for the gallery when he "arranged an All Canadian exhibition of Pictorial Photography."[17] Vanderpant encouraged and supported both the exhibition and sales of art in the League's gallery. In an executive meeting of 12 February 1926,

It was moved by Mr. [Charles] Marega, seconded by Mr. Vanderpant "that we endeavour to have monthly exhibitions in the Gallery of Paintings, Sculpture & Applied Arts from Canada & elsewhere, which would serve as a stimulus to art, and especially benefit students at the Art School & the public generally"[18]

In 1931 the efforts of the members of the B.C.A.L. were rewarded when, through the financial assistance of Mr. Henry Stone, the Vancouver Art Gallery was founded. Vanderpant was a charter member, and he must have found it gratifying when the gallery he had worked so hard to bring into being hosted exhibitions of his work in 1932 and 1937. He must have found it equally gratifying when he was asked to give lectures at the gallery.

Helping others to understand the meaning of artistic expression "in relation to life" was, for Vanderpant, "as great a need as any in the educational field." In 1934 he told Eric Brown, "To that understanding my entire life has been given."[19] Both openly and behind the scenes, he influenced the direction of art in the city. While the walls of his studio were always covered with photographic prints (his own work and that of other photographers), and canvases by painters such as Frederick Varley and J.W.G. Macdonald, Vanderpant also hosted a number of significant exhibitions.

In 1927, under the auspices of the B.C. Pictorialists, of which he was president, Vanderpant's gallery mounted Vancouver's first International Master Salon of Pictorial Photography. The exhibition must have been especially exciting to the city's growing number of amateur photographers who were given the opportunity to view 140 prints from Austria, Belgium, England, Germany, Holland, Italy, Spain, and the U.S.A.[20]

In 1931 the Vanderpant Galleries hosted two significant and stimulating exhibitions. The first was in April. It was a showcase of work by B.C.'s most promising artists: Emily Carr, J.W.G. Macdonald, M.S. Maynard, Charles H. Scott, Frederick Varley and W.P. Weston; and that of three "students"—Fred Amess, Irene Hoffar and Vera Weatherbie. According to the *Vancouver Daily Province*, "one of the defi[n]ite objects of having the exhibition ... was to give the purchasing committee ... [of the new

Civic Art Gallery] an opportunity of viewing the type of work that British Columbia artists produce."[21] This was important because most of Vancouver's population was of British origin. Arts in the city tended to be influenced by "the more conservative aspects of British art" which had "dominate[d] the fine arts in Vancouver" from the city's inception.[22] Vanderpant was obviously concerned that the purchasing committee wanted to collect only the work of traditional British and central Canadian landscape artists while overlooking the paintings being produced locally, and the exhibition at the Vanderpant Galleries was a means of drawing attention to B.C.'s foremost modern painters. Vanderpant went a step further and sought to enlist the influence of the National Gallery. On 13 April 1931 he wrote Eric Brown, that

Vancouver is very pleased with the success of the local work at Ottawa and Mr. Stone going east on a buying trip. The thought came to me to hold an exhibition of the so-called modern local movement in the galleries. First of all I wanted to impress upon Mr. Stone the fact that not all the paintings to be bought ought to come from fields afar, and secondly I felt that after the recent publicity it was the right time to do so. It is quite an interesting collection and hanging in a way or rather in a surrounding as it has never been shown in this city before. There is a good response and the papers are taking notice so I feel quite happy about it. If the opportunity arises I hope you will impress upon Mr. Stone's mind the fact that some of the Western work should be in the local gallery. Please use your good influence if you feel so inclined. I think Mr. Stone would be quite ready to accept a hint from you and you will realize that it may be necessary to apply some pressure from the proper source. I have done all I could and I trust you will support my good intentions.[23]

Vanderpant's comment regarding "recent publicity" was a reference to the January 1931 Annual Exhibition of Canadian Art held by the National Gallery of Canada. Ever since its first annual exhibition in 1926, artists, art societies, and art critics in B.C. had criticized the National Gallery for not fairly repre-

senting the work of the province's artists. No B.C. artists were included in the first exhibition; in 1927 only two were represented—Charles H. Scott and Frederick Varley; and in 1929 only Nan Cheney and Varley.[24] In 1930, 17 paintings from Vancouver were sent to the National Gallery, but the British Columbia Society of Fine Arts complained that it was time to "obtain fair and considerate treatment for the artists of British Columbia by giving them a proper proportionate representation at Canadian Art Exhibitions at Ottawa."[25] The National Gallery appointed a B.C. jury to select work for the January 1931 exhibition and the province was to be given "proper" representation. Ironically, when Vancouver finally had a chance to obtain a permanent collection that could be showcased in the city's gallery, the purchasing committee had to be persuaded to consider the work of significant local painters. Even more ironic, the Vancouver Art Gallery's records indicate that it did not acquire a modern canvas by a local painter until 1934 when Irene Hoffar Reid's "Margaret" was donated by Mortimer-Lamb. In 1937 the gallery grudgingly bought Emily Carr's, "Totem Poles — Kitseukla." One financial backer described the canvas as "dreadful."[26] In 1938 the gallery purchased two paintings: Jock Macdonald's "Indian Burial, Nootka" and Emily Carr's "Logger's Culls." That such paintings were seldom acquired was noted by Garnett Sedgewick, a professor of English at the University of British Columbia, who lamented that "so much debris from nineteenth century England had washed up on" the gallery's walls.[27] That description seems to have been apt, for many of the early acquisitions are no longer part of the gallery's collection.

Vanderpant's second 1931 exhibition, held in September, brought the photography of two now-eminent Americans to Vancouver—Imogen Cunningham and Edward Weston. As far as can be determined, this exhibition was the first Canadian showing for Cunningham and the second for Weston.[28] (The Vancouver Art Gallery exhibited 60 of Weston's prints eight years later, in October 1939.)

Organizing and hanging such exhibitions was arduous work. Vanderpant ran his portrait studio by day, so all the work related to an exhibition had to be done in his spare time. Working with and coordinating other artists was no small feat, especially in the days when one had to rely almost entirely on the mail or the telegraph systems. Initially, Vanderpant seems to have planned a spring exhibition, but Weston and Cunningham were unable to participate until September. As it was, they agreed to forward him prints, in spite of their own busy schedules and commitments, because both admired Vanderpant's work. On 7 May 1931 Cunningham wrote:

> I assure you I would not, for any other worker in the northwest, take the trouble to put together a group of prints. The few things which I have seen of yours and that only in reproduction have said so much to me, that if you want my things, any amount of work would not be too much.[29]

Weston held similar sentiments and remarked that Vanderpant's work had "imagination, and form,—vitality."[30]

For Vancouver, the 1931 exhibition was a stimulating example of the new "straight" or "pure" photography. Proponents of this style rejected any form of manipulation in the photographic process, such as enlarging or cropping, so that the resulting prints were exact or pure images as previsualized by the photographer. In her review of the exhibition, columnist Reta W. Myers wrote:

> Has the heart of an onion any interest for you, or the leaf of a cabbage recommend itself as a delicate design for an artistic composition?
>
> Probably not, for unfortunately we are not all gifted with the imagination that finds in the most common things beauty of form and design. But Imogen Cunningham, ... and Edward Weston ... are two photographic artists who can make the most ordinary subjects interesting. ...
>
> This exhibition, acclaimed by photographers as one of the best in America, expresses almost entirely the art of pure photography. No tricks of the camera are relied on to lend glamor to the work, only the pure form of the subject, plus imagination of the artists in arrangement and placing of lights and shadows, is drawn on for results. It is photography at its most modern point, where the absence of detail emphasizes the mood of the picture.

... Vancouver is particularly lucky to have obtained this exhibition of work. Included in the exhibition are a few of Mr. Vanderpant's own studies, which merit considerable attention.[31]

Unfortunately, the records on which prints were hung are incomplete, but the Vanderpant Galleries must have presented Vancouver with quite a sampling of contemporary photography. Cunningham sent 47 prints, the majority of which were plant studies. Weston sent approximately "fifty" prints.[32] He described his work as "comparatively recent,—the last three years"; and he included "a few older prints, the earliest from my 'industrial period,' 1922." Weston, who was noted for his nude studies of women, did not send any to Vancouver because he "feared postal regulations. Uncle Sam is prudish. I don't know B.C., but I guess the same!"[33]

Weston guessed correctly. As it was, dealing with customs and postal regulations turned out to be a complicated, time-consuming, and frustrating task. When mailing his prints, Weston "had to go through a lot of red tape, swear before a notary, [and] sign papers." He had wanted to have the prints returned "by the first week in October" so he could send them to an exhibition in San Francisco.[34] On 25 October he wrote Vanderpant that he had just received the prints that day, "after endless waiting & red-tape, from Customs. ... In all the years I've shipped to foreign countries, I've *never before* had this trouble and expense."[35]

Vanderpant's correspondence suggests that the three had fleetingly entertained thoughts of a joint American exhibition, referred to by Cunningham as a show by the "three westerners."[36] This display of west coast photography never came to fruition. The difficulties of sending prints through customs were probably the main reason that Vanderpant did not again exhibit the work of his American counterparts. One also has to wonder if such an exhibition was worthwhile financially: conservative tastes and the onslaught of the Depression probably meant that Vancouver sales were few. There also seems to have been little communication between Cunningham, Weston and Vanderpant after the 1931 exhibition, and he was never to meet these two photographers with whom his work was closely aligned.

Artistically, there were many similarities between Vanderpant and his American neighbours. The three were professional portrait artists, and earned their livings from that work. Only a few years apart in age, they were all influenced by the Photo-Secession, a New York-based group formed by Alfred Stieglitz in 1902, whose purpose was to have the medium of photography accepted as an art form. To do so, its members used diffused lenses in order to produce romantic, painterly images. In their early works Vanderpant, Weston, and Cunningham attempted to "remove the subject from the ordinary workaday world and carry it to a high, unearthly plane."[37] Vanderpant's "Builders" (Figure 30) exemplifies that ideal.

By the 1920s (and in some cases as early as 1915) a number of leading American photographers were moving toward less romanticized, more sharply defined images. This "straight" or unstylized work coincided with the desire, in the main the result of World War I, to portray a more realistic view of the world. Definitions of beauty were changing and photographers like Charles Sheeler, Paul Strand, and Edward Steichen were focussing their cameras on ordinary objects such as industrial structures, the sides of barns, picket fences, and natural objects like rocks. These "objective" studies were often taken close up and from various angles so as to produce intense and exact images.

In 1930 Weston, Cunningham, and five other California photographers formed what came to be known as the f/64 Group. This informal group was "dedicated to the honest, sharply defined image," and they felt that the lens opening, f/64, provided "the ultimate in resolution and depth of field."[38]

Vanderpant also moved away from the impressionistic and soft-focus canon of pictorialism, and he supported the precepts of a pure or straight photographic process:

The lens drawing must have all the characteristics of lenswork and not be by process manipulation transferred into prints which do not in the first place reflect photography but texture resemblance of paintings, drawings, etchings, etc. ... More than ever I am convinced that back to purity, to photography for photography's sake employed by a mind rich in artistic vision—either creative or selective—is the only way out of the rut of sentimentality and process faking.[39]

However, he never fully embraced the aesthetic of the f/64 Group.

In looking for what Cunningham described as "the subtleties of life ... which need delicate interpretation,"[40] she, Vanderpant, and Weston focussed their cameras on commonplace objects. Plants and vegetables became subjects of intense interest. In 1931, Weston and Vanderpant both participated in a California salon and Weston commented: "Strange coincidence, we both showed red cabbages,—halved: but mine was cut the other way."[41] All three were finding inspiration in the abstraction inherent in natural forms. Weston found that such exploration led, as he points out in the discussion of a pepper, to "an intensification of its own important form and texture." Weston wanted to *know* things as they are, their very essence, so that what I record is ... a *revelation*."[42] Vanderpant held a similar view. He believed that "Beauty is a deep quality of essences" and that in capturing those essences on film he would "echo the absolute."

In Vanderpant's published and unpublished views on photography, and in Weston's published thoughts on the subject, one finds that many of their objectives were similar. Weston sought to capture "a living, quivering picture,"; he wanted to record the "quintessence and interdependence of all life."[43] Vanderpant sought "a living print,"[44] a "vibrating ideal or vision"; he wanted his work to be a reflection of the "continual unity of all life."

As Vanderpant moved away from the pictorial aesthetic, his images did take on a greater clarity, especially after 1932. According to Charles C. Hill, a curator at the National Gallery of Canada, Vanderpant never achieved "that sharp immediacy of the work of Imogen [Cunningham] and Weston. The viewer is perhaps more conscious of the exterior vision and less of the inner energy of the photographic subject."[45] Yet Vanderpant's prints do have the "vitality" that Weston recognized; and like the work of Cunningham and Weston, his images do carry the viewer beyond the physical forms of his subjects. Through the use of light to model, contrast, and symbolize, Vanderpant achieved a unique and often spiritually motivated energy in his compositions.

Unlike the advocates of straight photography, Vanderpant was not always averse to enlarging, dodging (a technique for lighting an area of a print), cropping, or retouching an image. He believed in artistic freedom and diversity: that "genius may be styled after" someone or something, but an artist "rightly ... cannot belong to any school or style ... he himself is uncontaminated in his expressive relationship to purpose." Although he manipulated the prints less in his later work, he believed that in order to attain "aesthetic values ... often part of the subject, correctly composed, would make a better picture than the whole."[46] A comparison of two images reproduced from his nitrate negatives, with the finished prints, illustrates his point. In both, cropping and enlarging have changed the images from mundane studies to works of distinction. In Figure 21, the subject is an endive. By bringing the subject closer, and removing the endive from its normal frame of reference, Vanderpant has stressed the visual cadence in its form (Figure 21a). The endive is vivified by its rhythmic motion, its "urge" to expression; in turn, the viewer is "urged" to respond. Figure 22 is a prosaic study of a bok choy. In Figure 22a the image's immediacy intensifies the vegetable's structure and texture while drawing the viewer to its core, its physical and symbolic essence. The subtle lighting and deep, soft shadows are also more dramatic close up and heighten the potency of the composition, imparting a sense of the profound to what would otherwise be commonplace.

Vanderpant's use of toned matte papers and the bromide process gave him "all the qualities of contrast and texture wanted; it expresses completely my concept and emotion at the time of the exposure."[47] He held that

a print is not made artistic by process printing, but by the Mind. ... The fact that a bromide print may be made speedily does not exclude the fact *that the mind* making the print may have had as much cultural training as the slow printmaker had. ... Technique is the craft through which art, ... emotions ... form relationship and balancing light, can be expressed.

While his prints do not radiate with what Charles C. Hill described as the "inner energy" of Weston's subjects, Vanderpant's images do convey a dramatic energy. In many cases, cropping and enlarging enhanced their vibrancy. His preferred printing size was

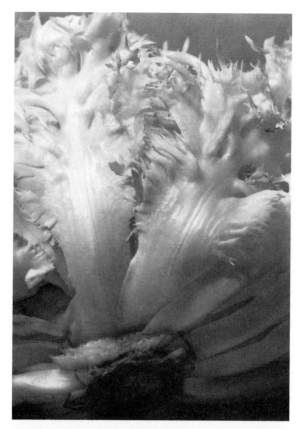

Figure 21. *"Urge" before cropping and enlarging (n.d.). A modern image reproduced from Vanderpant's negative;* NATIONAL ARCHIVES OF CANADA PA 175769.

approximately 35 x 27 cm., but he printed in a variety of sizes and two of his largest prints are "Peacock Pride," 45.8 x 35.5 cm., and "Angles in Black and White," 45.9 x 35.2 cm.

Through the use of unique perspectives that were achieved by "light playing over form and texture … playing with values of relationship," Vanderpant often obtained subtle, sensual, and visual tempos which are at once delicate and powerful. He stressed that a print should "not so much be looked at, but looked *through*, in order to gradually discover the meaning of aesthetically conceived form, inspired by the maker's emotional response to his mental contact with the essence of life." For Vanderpant, photography was "dealing with … ideas in light."

One of his finest examples of an idea in light is found in the print "Concrete" (Plate 42). The image, a close-up of a concrete

grain silo, conveys the strength of the structure which is also a monument to human engineering. Yet this formidable structure, like the humans who designed it, is vulnerable. The evidence is the crumbling base. This opposing sense of power and fragility is heightened by the textural qualities of the print: the image could represent the ravages of old age; permanence versus impermanence; technology versus humanity; or, simply, the characteristics of cement.

Light is significant to the image. A shaft is projected arrow-like on the elevator; it directs one's vision to the weakening base and then upward to a second, brighter light that moves upward and out of the photograph. The ascendancy of light is a common feature in Vanderpant's images and symbolizes the light of a "higher" or "divine" spirituality. The upward/downward movement and the spiritual implications are emphasized by the darkened window. The viewer cannot see what lies behind the

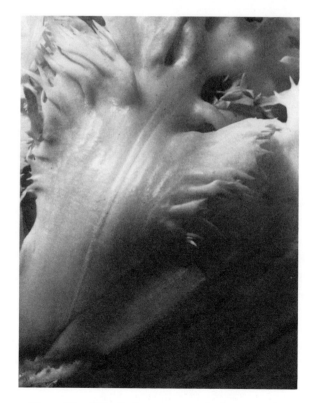

Figure 21a. *"Urge" after cropping and enlarging (n.d.).*

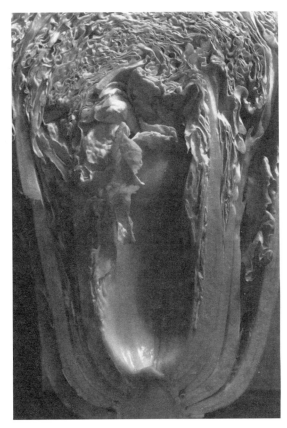

Figure 22. *"Untitled" (bok choy), before cropping and enlarging (n.d.). A modern image reproduced from Vanderpant's negative;* NATIONAL ARCHIVES OF CANADA PA 175770.

shaded opening, but the darkened interior presents a foreboding contrast to the uplifting flow of the shaft of light.

The title "Concrete" can be interpreted as a simple description of the structure; it can be an ironic comment on the supposed permanence of the material; or it may, like the light illuminating the structure, suggest the "concrete" or everlasting light of God. In the subject, lighting, and titling of one image, Vanderpant has successfully communicated many "ideas."

In "Summer Riches" (Plate 31) Vanderpant again uses light as a vital element. The brilliant sunlight, representing the riches of summer, contrasts directly with the derelict condition of a wooden house. Weathered, aging, and impoverished, the house is adorned only by tattered curtains. One spot of light, perhaps

symbolizing fortune beyond the material world, illuminates the handrail at the entranceway, bestowing a new wealth or emotional vitality on the structure. The light can be viewed as emphasizing the upward lines of the handrails and house planks, or as suggesting a movement away from the structure. In either case, it represents the treasure of life-giving sunlight; it gives the print vitality through its emphasis. On another level, the light can be construed as representing the grace of God, or the spiritual idea that a richer world awaits. The impact of the "ideas" in this print are as powerful and moving as those of "Concrete." The two images are visually, emotionally, and intellectually intriguing; both invite the viewer to contemplate their "dramatic simplicity," and their "ideas" are open to interpretation.

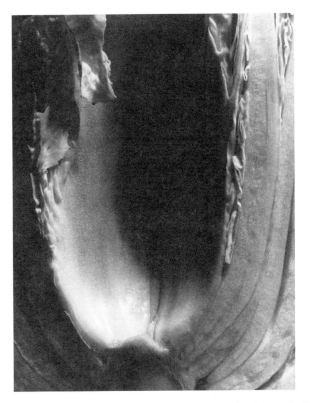

Figure 22a. *"Untitled" (bok choy), after cropping and enlarging (n.d.).*

CHAPTER FIVE

VIBRATING CONTACTS

Figure 23. *"Untitled" (drainpipes) (n.d.).*

WHEN WORKING OUTDOORS Vanderpant rose early in order to make use of the morning light; in his Vancouver studio he used large, moveable electric lights which could be wheeled about so as to control the illumination of his patrons and still-life subjects. Whether it was natural or artificial, Vanderpant considered light to be "symbolic of [the] mental light of [the] balance of understanding." He felt that the true artist is in touch with the "mental realms where to the spiritually minded ideas are blooming like flowers in a seasonless garden."[1]

In his work, forms were important "only in relationship to one another and their ability in different degrees to reflect light." In one untitled print (Figure 23) the forms are not only insignificant in themselves, they are barely recognizable as cement drainpipes. What is stressed is the reflection of light. Although irregular, the light's movement is continuous, suggesting an energy that is infinite: a cosmic or divine force.

For Vanderpant, who wrote "I live the silence and the penetration of silences," illumination, both literal and spiritual, was paramount. The print "Into Silences" (Plate 58), is also more a study of light than of structures. Framed by black and gray shadowed forms that angle upward, the focal point of the composition is an arrow-like shaft of intense white. This triangular form, which is "associated with the universal triune

godhead,"[2] points up and out of the composition, suggesting a dimension beyond that of the darkened and humanly constructed forms. "Into Silences" has a subdued, reverential quality; the image and the title imply the silence of meditation, the passing from one dimension to another.

Vanderpant believed that the artist "gives materially composed forms" to spiritual ideas "making them thereby understandable."[3] He wanted his "ideas" to extend and alter the viewers' perceptions; to suggest possibilities that lie beyond the literal visual spectrum; to portray qualities "hidden to those looking at surfaces." In "Cylinders" (Plate 57), the texture of cement in a grain elevator is altered through the reflection of light. The resulting image resembles a row of shimmering glass "cylinders." The textural change is significant, for Vanderpant is literally and symbolically implying that interpretations of the universe extend beyond external realities.

Other than the teaching of Christian Science, the inspirations of what Vanderpant described as his "mental vision" can only be surmised. His library is no longer intact and his daughters do not recall what he read. While he did not often cite books or authors, his lectures and manuscripts indicate that he was attuned to a variety of spiritual philosophies.[4]

Like his passion for photography, music, and art, writing was an intrinsic part of Vanderpant's life. His daughters recall that he was forever jotting down a poem or a thought. When the family went for their weekly drive, it was not uncommon for his wife and daughters to go for a stroll while Vanderpant settled on a patch of grass and lost himself to introspection and writing. Though his verse is not sophisticated, many of Vanderpant's poems indicate a playfulness, experimentation with form, and the integration of divergent elements.[5] As with his prints, Vanderpant's poetry often incorporates differing styles. Attracted to modern verse, he experimented with capitalization, punctuation, spelling, and format; however, his imagery and themes reflect sometimes the Romantic Movement, sometimes the Symbolist Movement.

Vanderpant was an active member of the Vancouver Poetry Society. The first president and one of the founders, Ernest Fewster, was a theosophist. He and the six other original members believed that "art … must necessarily be the symbol of a spiritual experience."[6] Vanderpant surely shared that belief and most of his lyrics reflect his metaphysical interests. He also supported the objective of the society, which was the "promotion of a wider reading of poetry and the encouragement of beginners."[7] The records show that the society was a lively group in the 1920s and '30s. The meetings were well attended and many now-noted academics and writers gave talks or read from their work: from 1936 to 1938, Dorothy Livesay gave a number of readings and lectures to the gathering; Bliss Carman held the position of honorary president until his death in 1929; and U.B.C. professors A.F.B. Clark, Ira Dilworth, and G.G. Sedgewick were frequent lecturers. Not all the society's activities were formal, however. In June of every year the society celebrated with a gala, and in 1936 the society held a special soirée for Charles G.D. Roberts and members of the Canadian Authors' Association.

The Vanderpant Galleries was often used as a meeting place for the Vancouver Poetry Society. All the general meetings and those of the executive were held there during the 1931-'32 season, and throughout the 1930s, the year-end galas were hosted by the Vanderpant Galleries. In 1935 approximately "seventy-five members and their friends attended."[8] The society's records, and Vanderpant's notebooks, indicate that the galas were festive occasions in which members joked, read poetry, and held panel discussions. During the 1937 gala a panel discussed the question, "Is the traditional form of poetry adequate to express Canadian contemporary life?" Vanderpant was one of the members taking the position that it was; Duncan MacNair (Dorothy Livesay's husband) was one of those supporting the position that it was not. The secretary's minutes state that "the question was discussed in a lively and often amusing manner."[9] Vanderpant said that in supporting such a statement he felt like "a lawyer—pleading against one's own convictions." He went on to say that in creative expression it does not matter whether the form is traditional or not; what matters is for the poet to approach a "Canadian Scene as a beautiful expression of universal life." He stressed that a poem was successful if "within the form is the vibrating contact with life's essence: idea—the consciousness thereof and its expression."[10]

Vanderpant's busy work day, the time he devoted to his family, and his involvement with arts-related activities, did not leave many hours for writing. When he was not attending an arts function or meeting, he would usually read the paper after dinner, spend a few hours with his wife and daughters, and then stay up late listening to music, reading, or expressing his ideas in written form. Although he found his chosen field rewarding, he obviously also tired from the tedium and "duty" of running a commercial portrait studio. His verses indicate the fulfillment that Vanderpant felt while composing, or meeting his "singing self." This treasured activity, a stimulus to his creative spirit, is best exemplified in the following poem which, like most of his verse, was untitled.

> Somehow I knew that I would write tonight
> like one will know how in a gardenpatch
> seeded and then dipped in the splashing sun
> the flowers rush to fold their colours open!
>
> For all day long I did suppress desire
> to throw the tools and meet my singing self
> upon the lawn, where sun designs the shadows
> and red of roses breaks the laurelhedges.

But I kept firm, facing a fierce temptation
with knowledge of what life calls duty,
until the night entered day's golden portals
and called me guest in its immensity...

I think a thought and thousand sounding echoes
intensify the joy of understanding darkness.

In the poem, freedom versus confinement is the main theme, and Vanderpant used a number of opposing images to highlight that motif. While folding is usually a means to enclose or envelop, Vanderpant used the word to convey the opposite—a means to "open"; the writer's restricting "duty" is directly contrasted with his "fierce temptation" and the sense of release when freed from obligation; the red of the roses is contrasted with the green of the laurels, and the flowers manage to burst through the barrier of the hedge; the light of the sun brings about the contrasting darkness of shadows. Day and night are also used as opposing images: "all day long" the writer had to suffer his confinement until released to the "understanding darkness" of evening. Only in the darkness, which usually represents obscurity, can the poet's thoughts find their "sounding echoes"—the rhythms which are pertinent to poetry, music, and the reverberations of thought.

The use of conflicting arrangements was significant to Vanderpant. He enjoyed its effect in music and employed the technique in his verse and photographic works. He stated that "Counterpoint ... is merely another name for note—so counterpoint—counternote, meaning note against balancing note, leads at the same time up to form relationship."[11] Undoubtedly, he would have agreed with Lawren Harris's statement that "all creative activity in the arts is an interplay of opposites. It is the union of these in a work of art that gives it vitality and meanings."[12]

Vanderpant described poetry as "the reflection of unfolding reality," and as "the stringing of words on a thread of rhythm ... [and] like beads [on a necklace] ... the beauty is ... in the relationship of their shapes and shades." He sought to convey the same "beauty" in his prints. Like the canvases and poems of both Bertram Brooker and Lawren Harris, two of Canada's pioneers in abstract painting, Vanderpant's verses and photographs reflect a belief in cosmic unity.[13] Vanderpant's poetry was not as successful as his photography, but it is interesting in that the written images offer insights that reflect on his character and his aesthetic. He experimented with modern forms, and just as many of his prints were imbued with mystical and romanticized ideals, so are most of his verses.

Dynamic opposites were vital to Vanderpant's photography. He wrote that "no matter how dark a print ... may appear—that is the negative side as in all things—but it [darkness] is always used to place emphasis on light—on light playing its glow over visual forms." While a number of his prints could be used as examples, "The Fence Casts a Shadow" (Plate 14), is one of his subtlest renderings of the beauty of the differentiation of light and shadow. The muted gray shadows of a fence projected on an uneven surface of snow create an exquisite, undulating and abstract rhythm of geometric patterns and textures. The image, as simple in its inception as it is complex in its design, is potent in its understated vibrancy.

In "Coated Candy" (Figure 24) an abstract pattern is again achieved, but in this print the contrasts are more obvious. The deep blacks obliterate any background detail, thereby removing

Figure 24. *"Coated Candy"* (n.d.).

the context of the image so that the pervasive feature is a geometric design. The title further removes the image from its context and conveys a sense of whimsy. (One can only speculate on how amused Vanderpant was with his visual pun on "Allsorts" candy.) Whether such compositions were inspired by the theosophical belief that "the essence of nature was manifested as a rhythmic geometric force"[14] is not known but, in these and other compositions, Vanderpant successfully conveys intriguing rhythmic and geometric images.

The arts scene in Vancouver began to change in 1926. That auspicious year heralded not only the opening of the Vanderpant Galleries, but also the arrival at the Vancouver School of Decorative and Applied Arts of two of Canada's now most noted painters. Frederick Varley was hired to head the drawing and painting department; J.W.G.(Jock) Macdonald was employed to head the design department and to teach commercial advertising. They became friends with Vanderpant and over the next ten years all three were to have a profound effect upon the city's art students, the cultural activities of Vancouver, and each other.

An anecdote from Vito Cianci, who was an art student from 1925 to 1929, illustrates the conservative attitudes of Vancouver at that time.

Fred Amess, [who later became the principal of the Vancouver School of Art] once took a big canvas home to stretch on a frame. [The next day] while riding the streetcar to the art school, he had to sit with the painting in front of his knees. From the reactions of the other passengers he knew something was wrong, and finally realized that his canvas had part of a nude painting on it. Everyone was looking at it uncomfortably. To appease them, Fred turned the canvas around. There was also a nude on the other side. The passengers were so disturbed that Fred finally got off the streetcar. He went to a nearby store, bought some brown paper, and covered the canvas so that he could continue his ride to the art school.[15]

Vanderpant, Varley, and Macdonald all wanted the students to discover new ideas and art experiences. Varley, in particular, had an electrifying effect on the students. According to Cianci, "the art school was dull until Fred Varley arrived ... and shook it up." One of the ways he did this was to introduce the students to drawing and painting nude models. Irene Hoffar was a student from 1925 to 1929 and, according to her,

in the 1920s and '30s Vancouver was a small, new city that was growing rapidly. In the years that I was an art student, and before the Vancouver Art Gallery opened [in 1931], there were exhibitions beyond British Columbia, but we were isolated. There were art galleries in Eastern Canada where national and international works of art could be seen, but we couldn't do that here. We would also hear of exhibitions that were being held down the West Coast. Seattle was more advanced than Vancouver in terms of the arts. As art students we were interested in each other's work, and in small, local exhibitions that were taking place in the city: it was all we had.

It was so exciting when Varley came. ... There was more stimulation, and we heard of and learned more about the outside painting world. The year before his arrival we were being taught in an academic way. Mr. Scott [the principal and a painting instructor] was very kind, and if you really got to know him he had a great sense of humour. He was, however, usually very formal and distant. He didn't communicate in the same way as Varley did—with warmth and enthusiasm.

Varley came with his enthusiasm, his associations with artists in Eastern Canada, the Group of Seven, his way of painting, and his life style. We thought, "This is the way a real artist should be." Everything at the school seemed to change then. ... The whole atmosphere was charged. Varley was a stimulating influence in making us see other things, and in other ways, and it was tremendously exhilarating.[16]

Varley's charisma was matched by his intense interest in painting and mystic inspirations. Like Vanderpant, he was "a glutton for all kinds of literature relating to art."[17] Both were intrigued with philosophical ideas and all the forms in which those ideas were communicated. From their correspondence and writings, and the recollections of others, it is obvious that

they were kindred souls. Whether it was in painting, photography, theatre, dance, or music, the two were concerned with what Varley termed the "vitals," and what Vanderpant described as "the true substance of lasting self-expression."[18] Vito Cianci was present during a number of their philosophical discussions and recalls that while Varley

had contact with theosophy through Lawren Harris.[19] ... Vanderpant was the key figure [in terms of encouraging ideas on spirituality]. ... He was a few jumps ahead of the others. Vanderpant believed in establishing a harmonious relationship with the universe, with the Great Spirit. Vanderpant was, and Varley was also, a great believer in the arts and bringing us as close to what is the ultimate aim of a good life, and that is a harmonious life: good design, good pattern, true harmony in everything we do.

The way in which their interactions and shared interests inspired each other was related by Varley in a 1928 article. Dwelling on the question of whether the artist can reach "the universal centre," he found the answer at the Vanderpant Galleries. There he "heard the conflict of question and answer in the Symphony of Caesar Franck, which theme Beethoven also used in his last composition and when trying to express in words the fullness of its meaning to him [Vanderpant], exclaimed, '[Is] ... it music? Music it is!' Moving form, majestically conceived."[20] Both men were invigorated by the desire to create their own "majestically conceived" work. Their fervour fueled their imaginations and generated an exciting atmosphere for the arts in Vancouver.

Vanderpant and Varley shared an earnest interest in the education of the city's art students, both wishing to expand the students' experiences and to challenge their perceptions. Varley even hoped to "develop a B.C. Group."[21] Vito Cianci remembered that besides sharing ideas on the spiritual quality of art, the two men "introduced the art students, in a casual way to the oneness of all the arts." Vanderpant began doing this in 1928 when he first invited students to special evenings at his studio. There they listened to selections from his vast collection of recorded music, which included modern and avant-garde compositions.

For the next eight years, Vancouver's intellectual and artistic communities were drawn to Vanderpant's musical evenings.[22] His "music room," which could accommodate over 100, was usually filled. Vanderpant's "evenings" were significant because, until 1930 when the Vancouver Symphony began a regular schedule, orchestral concerts in the city were infrequent. Moreover, the musical tastes of Vancouverites paralleled their conservative artistic tastes. John Becker has pointed out that the "most memorable aspect" of a concert given by Ravel "was the mass exodus of the audience during the first couple of pieces."[23]

Students from the V.S.D.A.A. and the B.C. College of Arts were regularly invited to the Galleries for an evening of music. Students from the University of British Columbia were also invited, but on different evenings of different months. Two or three times a year each group would settle on chairs or cushions and listen to Vanderpant's records. The room was comfortable, with Oriental rugs, candlelight, vases of flowers, and a fire crackling in the hearth. From Vanderpant's Columbia gramophone, and the innovative dual-speaker system he had devised, the

Figure 25. *Interior view of the Vanderpant Galleries* CIRCA *1928. The back room was used for taking patrons' portraits, for musicales, and for any gatherings hosted by Vanderpant.*

music of the "old masters" would surge through the room.[24] The compositions of the more modern composers, such as Paganini, Stravinsky, and Ravel, were not readily accessible in Vancouver. Vanderpant imported these records from Europe and the United States, and they were listened to with excitement. During the interval those in attendance could sit in absorbed silence or take part in discussions on music, art, and mysticism.

Margaret Williams, who was a student at the V.S.D.A.A. and later taught at the B.C. College of Arts, recalled that going to the Vanderpants' "was so wonderful because he introduced us to all sorts of things that were modern then [and] that we didn't know about ... and [he] contributed very much to our education and pleasure."[25] Ada Currie, another student at the V.S.D.A.A., and an enthusiastic participant at "The Vanderpant Musicales," described the setting and ambience of the soirees:

Save for the tapers on the mantelpiece and the ever-changing flames in the fireplace, sending out their understanding light—all was in velvety darkness. There we were—lounging—sitting— ... waiting expectantly. Then it began—that wonderful inspiring music, pouring like the happy morning song of a bird from the very heart of the machine. Enraptured, we listened to number upon number of the very finest of musical compositions. ... The old masters of music were listened to with keen appreciation and a good deal of awe—the same reaction as to a fine painting, a piece of sculpture, or a magnificent old-world building. Perhaps different thoughts possessed us when our more modern music, by Ravel and Stravinski, was played. Its newer harmony, its impressionism, was keenly realized and enjoyed in contrast to the mathematical precision—the building up of certain movements, the more guarded expression—of the older compositions. In like contrast we have in the painting world the works of the old masters, and the newer art and impressionism of the modern artists. ...

It is the first time that our school has been asked to join hands, as it were, with her sister art in this manner.[26]

The musicales had a memorable effect on Vito Cianci and Irene Hoffar. According to Cianci,

Vanderpant started his regular musical evenings and I'll never forget the first one. I was 19 and green as grass. ... All I knew about music was the grand opera, church music, and popular sheet music. I had never heard of Beethoven or Bach. You can imagine what a shock it was to come into contact with [classical music] for the first time.

Vanderpant had one of the first ... of the new electronic record players, a Columbia; and we'd been used to the crank and wind up phonograph, the Victrola. All of a sudden there was a new and marvellous sound coming out of his machine; ... it just staggered me. I thought, "This isn't music!" I even remember which selection it was: Bach's "Toccata and Fugue in D Minor." It sounded just like a jumble of noise to me, but I eventually got on to it.

[The Vanderpant Galleries] had a big studio. There was a grand piano in one corner with a candelabra on it. Dim lights always—candelabras lit on the piano and we [the students] sat around on cushions on the floor ... just soaking up the music. If there was something really new that none of us had heard before or knew about, John would explain briefly at the beginning, just enough to introduce us to what was coming, no extended analysis of any kind, and then away we'd go. He was just happy to expose us to this good music. We were delighted. ... Afterwards we'd have hot chocolate and biscuits, or coffee and biscuits, or something like that; sometimes, a little conversation.

For Irene Hoffar,

going to the Vanderpant musicales was a wonderful experience. ... I remember the feeling of music pouring over me. In particular, I recall hearing a very modern composition. It was more strident and unharmonious than Stravinsky or Debussy. The music was very different and it made a great impression on me. It was like seeing an abstract painting for the first time.

My uncle, who was living with us, played Beethoven and Bach and all the well-known composers on his gramophone. When I went to Vanderpant's and heard contemporary twelve-tone music, I was shocked and amazed. I think that was Vanderpant's aim: to expose us to new "ways."

Now and then Vanderpant and/or Varley would discuss the music. I remember that after [the piece I found so startling], Varley asked us, "Now what did you think about the music? How did you feel?"

I was very shy but I managed to say, "It went right over my head!" But that piece did reach me.

Ivan Denton, a reporter for a small Vancouver paper, attended one of the musicales in 1933. Five years after it began, the event was obviously still a moving one. Fascinated with the visual setting as much as with the music, he wrote that he

came rather late on a dismal, rainy night. Mr. Vanderpant's musical evenings begin at the unfashionable hour of 8 o'clock. How shall I describe the room?—it was dim, spacious—great bulks of shadow were balanced by lighted spaces. [L]ike a canvas perfectly composed—no one part of the composition of that picture could have been taken away without marring the completeness of its sombre beauty. Many people, sitting in the shadow, made up part of the picture. . . .

The room was filled with the sound of a great symphony. . . . I am trying to think how I would describe this music—it was like moving masses of color—chords as vibrant as the crash of a waterfall—melodies as delicate and elfin as the pipes of Pan. I likened the music also to the shadows and lighted spaces of the room—or the thunderous rhythm of old Latin verses quoted by a master steeped in classic lore.

Outside, in the murk and the wet, the great world-wide depression prowled like a lean old wolf. . . . I saw the hands of a girl near me—shapely hands they were—sometimes relaxed and sometimes tense—I saw the diminutive spheres of her amber earrings swing to and fro, catch the candlelight and shatter it into a thousand splinters of yellow radiance.

For quite apart from the music at Mr. Vanderpant's old house on Robson Street, there is both time and inclination to delight in such jocund beauty as a swaying earring in the light of a candle.[27]

Vanderpant had a genuine liking for young people and was generous to the city's art students in another way. He and his wife held a number of dances for the students, and Anna recalls that her parents did so "in the European way. This was to host their young guests, rather than joining in." Instead of dancing themselves, the Vanderpants mingled with the party-goers and looked after the music. In 1929, the Vanderpants had a year-end dance for the students of the V.S.D.A.A., and in 1930, after the first graduation exercises, they held "an informal dance . . . to which the staff, all students and their partners were invited, [and the dance] brought to a close an auspicious occasion."[28] According to Cianci,

Vanderpant liked having us around. He said so many times, as did Mrs. Vanderpant. We were always made to feel very welcome. . . .

One evening [at a dance at the Vanderpants'] Sybil Hill [a classmate who became Cianci's first wife] and I, . . . were standing beside Vanderpant watching the dancers and listening to the music. He looked at us and said quietly (he had a quiet speaking voice), "If you young people were smart, you'd go home now."

I looked at him and said, "Why? We're having fun!"

He said, "That's just it. This is the peak of the evening. You should go home. Leave at the peak of the adventure. Don't wait until it starts going downhill. . . .

True to his belief that the artist is an instrument whose purpose is to illuminate, and through his passion for innovative music, Vanderpant tried to present Vancouver with other challenging musical experiences. In 1936 he spent approximately three months working for radio station CKFC. Every Wednesday afternoon, from 4:00 to 4:30, he hosted a show that "feature[d] the recorded music of modern composers seldom or never heard in British Columbia."[29] He was aware of the initial effect his selections would have and tried to prepare the listeners for contemporary pieces by composers such as Roy Harris, Constant Lambert, Francis Poulenc, and Sergei Prokofiev. His delight in unconventional compositions is reflected in a poem that was inspired by the music of Roy Harris: "Agitation of violins... / Hell to tradition, / they squeal...." Realizing that such music would be jarring to many in the audience, he advised

people "to listen rather than to hear. ... Only in active listening rather than in passive hearing lies the progress of musical appreciation." When introducing "Symphony 1933" by Roy Harris and the Boston Evening American Band, Vanderpant warned that the music might sound "strange and weird," but that it was better to be "disturbed at first than by immediately agreeing with certain melodic ... developments ... [and that] listening with irritation is far more enriching than 'hearing'." In another broadcast in which he played Constant Lambert's "Rio Grande" he cautioned that the

> music of today will at times sound strange to some of you and will require real listening and patience, but let us not forget it is the musical reaction to today's experiences and as such worth listening to.[30]

The programs were sponsored by the Vanderpant Galleries, and Vanderpant asked that listeners phone or write either the station or the Galleries with their comments. He stated that if the program was "supported with expressed approval the opportunity to hear contemporary music MAY be extended."[31] Whether listeners responded negatively or, perhaps, not at all, is not known. In all likelihood, Vanderpant's selections were as startling to the radio audience and, perhaps, the station's management, as they had been to the art students. Apparently, Vancouverites did not like "irritation," for the program was cancelled.

Vanderpant also seems to have worked behind the scenes to encourage the presentation of modern musical compositions. In 1934 the Hart House String Quartet gave two concerts in Vancouver. Peter Varley, son of the painter Frederick Varley, recalls:

> The first concert kept to safe ground. The second, however, was to cause "R.J.," the critic to write: "True, some of the listeners did find much food for thought, but the majority must have wondered at times what it was all about." ...
> The program consisted of two works: Respighi's "Doric Quartet" and Ernest Bloch's "Quartet in B Minor." It is likely that John Vanderpant had a hand in selecting the program.[32]

Another of Vanderpant's initiatives appears to have led indirectly to the establishment of Malkin Bowl in Stanley Park. In the summer Vanderpant walked through the park to reach the cricket matches (he enjoyed spectator sports such as cricket and soccer) and on these walks he noticed an area that he thought would be ideal for outdoor symphony concerts. He believed that such concerts would be enjoyed by enthusiasts and, at the same time, would familiarize others with classical music. According to Anna, her father also felt that outdoor summer concerts "would help increase attendance at the winter symphony concerts." (In 1988, the Vancouver Symphony Orchestra again began presenting outdoor summer concerts.) Anna recalls that her father thought

> the perfect spot for the concerts was a gently sloping grass area [south of the dining facility known as the Pavilion] in Stanley Park ... Father invited [the conductor of the Vancouver Symphony Orchestra, Mr. Allard] de Ridder to view the area ... [and he] was most enthused. The Symphony Society was approached and agreed to the concept. My father met with Mr. Willie Dalton, a prominent businessman who, in turn, involved ... Mr. Malkin.

In 1934 William Harold Malkin, a wealthy businessman who was an active participant in Vancouver's cultural affairs, donated a shell-style bandstand to the Parks Board as a memorial to his late wife, Marion. It replaced an earlier structure (erected in 1911) on which the Vancouver City Band had "played only martial or religious music."[33] Anna remembers that "Symphony in the Park ... was always well-attended ... [and] during the Great Depression, people had free food for the soul and spirit, via beautiful music, as my father had hoped." Today, Malkin Bowl is used to stage Theatre Under the Stars: outdoor theatrical productions during the summer months.

Vanderpant also figured prominently in other cultural endeavours in Vancouver. According to Mrs. Vanderpant, her husband was one of the founding members of the city's Arts and Letters Club.[34] The purpose of the club was to further the members' appreciation of the fine arts. The meetings were informal and records were never kept, but a number of former members, and

their children, recall that during the 1930s the meetings were held once a month at the Vanderpant Galleries. There, the members would listen to guest speakers, selections from Vanderpant's recordings or piano recitals, and a variety of arts-related topics were discussed. John C. Lort, son of the Vancouver architect Ross Lort who was also an active member of the Vancouver Little Theatre, remembers attending the get-togethers in 1929-'30 when he was 15 years old. Mr. Lort's recollections, those of his younger brother, Tony Lort, and Frank Taylor who attended many of the evenings, indicate that most of the individuals who attended the meetings were leaders in the city's artistic community.

According to John C. Lort:

I think ... that my father spoke to the group. At that time he was ... lecturing to schools, church groups, and others on stage design and scenery and [he] had a portable stage complete with numerous scene changes and lighting with which he demonstrated his talks. The only meeting of the Arts and Letters Society of which I have definite memories was ... [one] at which various members put up examples of their work for auction. Miss Reynolds [a local playwright] offered the original script of one of her plays, and F.H. Varley offered to paint a portrait but insisted that the bid must be at least $300.00. Being in the Depression period no one could afford this. ...

As I remember, every meeting began with the playing of one or more records from the Vanderpant collection. Gramophone records were about the only way in which one could hear classical or serious music at that time in Vancouver. Radio for most was still crystal sets with limited range. [The] Vanderpant Galleries was possibly the first place in which the members of the Society heard [Gershwin's] "Rhapsody in Blue," [Prokofiev's] "Love of three oranges," and other contemporary works.[35]

Tony Lort sometimes "tagged along" with his parents to the cultural evenings. He recalls that Vanderpant always played

some marvellous new record by Stravinsky or Schonberg and everybody would sit around and look serious. ...

Vanderpant presided over the Arts and Letters meetings. ... He was a very courtly person, but he had a sense of humour. He was a merry looking person with twinkly eyes and a pleasant smile.[36]

Frank Taylor was a regular member of the Arts and Letters Club. He remembers that the meetings were held every month in the winter:

Vancouver was a really small community and the Arts and Letters Club was a small organization. I don't suppose there were more than 25 or 30 people in it. The purpose was just to have artists talk to us. One or two of the Group of Seven came. [I think] Varley lectured, and [A.Y.] Jackson when he was in Vancouver. We'd have anybody who seemed to be of interest. Dr. A.F.B. Clark of the University of B.C. spoke several times on music. ... And another man who was there often was Ross Lort. ... I remember that one time some of us put on a play—a lot of fun.[37]

Exhilaration, inspiration, and education were vital to Vanderpant's personality and to his view of the arts. He believed that "the artless community is more intensely poverty stricken, than is the one penniless," and enrichment of the community was obviously a major motivation in his life. To that end he undertook to present, and received recognition for, a number of exhibitions, publications, and lectures.

In 1929 Vanderpant went on a five-week tour of central Canada, and had two solo exhibitions: one at the Royal York Hotel in Toronto, and one at the Chateau Laurier in Ottawa. A glowing letter from Frederick Varley, in which he described Vanderpant as "a rare artist ... [and] the one being [in the] west with true art apprecia-tion, abounding vitality & ambition," introduced Vanderpant to H.O. McCurry, the Assistant Director of the National Gallery.[38] Vanderpant also became acquainted with the members of the Group of Seven, photographed four of them at the Arts & Letters Club in Toronto, and made preliminary arrangements for an exhibition of 30 or 40 paintings by the Group to be exhibited at his gallery.[39]

In Toronto Vanderpant also met the painter and writer, Bertram Brooker. As a result, Brooker published Vanderpant's

print, "Elevator Pattern," in the 1928/1929 issue of the *Yearbook of the Arts in Canada*; in 1936 Brooker published Vanderpant's "Expression in Form" and Karsh's "Grey Owl" as two of the year's finer examples of photographic art. Although the two did not correspond regularly, a 1936 letter from Brooker illustrates their spiritual kinship and Vanderpant's abilities as a lecturer:

> I cannot recall ever being quite so moved by a lecture as I was by yours. ... Even after the opportunity I had on that evening you spent at my house several years ago to get an idea of you, I nevertheless was astonished at the emotional impact of your words and your personality on the lecture platform.[40]

Nineteen twenty-nine was a momentous year, and one of "experimentation and great creativity for Vanderpant. He explored new avenues, new approaches to photography."[41] This is exemplified in his abstracted view of stacked restaurant chairs, "The Morning After" (Figure 26). In August 1929, *Saturday Night* (at the time one of Canada's leading national magazines) ran the first of two illustrated articles on Vanderpant. Titled "Unique Photographs by J. Vanderpant F.R.P.S." the article

Figure 27. *"Untitled" (Union Station I) 1930;* Vancouver Art Gallery, 90.68.30.

Figure 26. *"The Morning After" 1929;* Vancouver Art Gallery, 90.68.22.

included six Vanderpant prints: "The First Day of Spring," "Colonnades of Commerce," "The Morning After," "Trespassers," and portraits of the Canadian poet, Bliss Carman, and the Indian poet, Rabindranath Tagore.

The next year was also exhilarating: Vanderpant undertook a six-week commission for the Canadian Pacific Railway. Wanting an artist who could capture "the spirit and progress of the railroad" to mark its 1931 jubilee, a company official telegraphed Vanderpant, "You were chosen because you ... have imagination and can get much out of little."[42] Travelling from Vancouver to Quebec, Vanderpant took approximately a thousand photographs. Unfortunately, due to a lack of funding during the Depression, those images are not identified as Vanderpant's in the C.P.R.'s archives.

Many exist as negatives in the National Archives and, as Charles C. Hill has noted, "show little stylistic development" from his earlier work.[43] Vanderpant's developing and cropping techniques may have resulted in more intriguing work, but only the identification of the prints (if that is possible) will allow a thorough assessment.

In 1932 the Vancouver Art Gallery held an exhibition of Vanderpant's work. A local review stated that

> The common, everyday things of life have been touched with unusual beauty. ...
> Mr. Vanderpant has caught bits of Vancouver street scenes, laborers at work, glimpses of elevators, of ocean liners, of buildings ... wrapping paper, ... deserted banquet tables, ... smoke funnels of ships. ...
> He has caught the raindrops as they lay on the petals of flowers, and has captured the majestic beauty of distant mountain peaks.[44]

The exhilarating effect of the exhibition remained vivid for Vito Cianci:

> I was vaguely interested in photography ... and all [the art students] went to it [Vanderpant's exhibition]. I can still remember the shock I felt when I first saw the work. I thought, "My God, if this is what the camera can do, this is for me!" It just reached out and punched me! It was just so exciting! It was more than a thrill. It was a complete revelation! My eyes, all of a sudden, opened up to what the world was like out there and [to the fact that] I could catch it with a camera. I never was a good painter, but [I knew then that] the camera was for me.
> One [of the photographs on display] was a study of men's stiff shirt collars. The title was "Cactus Collaratus." And another one was of some chinaware platters and in the middle was an egg cup with a snowdrop. It was called "Spring on a Platter." And [there were also] greatly enlarged close-ups of the "Honesty" plant [also known as the Lunaria or Money Plant]. One was called, "Honestly, Honesty." I remember all of them. He used those [the "Honesty" prints] on his Christmas cards [one year].[45]

Figure 28. *"Honestly, Honesty"—a Christmas card sent to H.U. Knight and family (1937);* COURTESY OF L. KAISER.

Vanderpant put us on his mailing list for Christmas, so I had three or four of his cards. At that point my own photography had come along very rapidly. When I got married I built a house and I built a dark room; I got a good camera and got down to some really serious work. Then one day I made a print of a dogwood and I said, ... "This print is as good as anything Vanderpant has done. I'm going to send it to him as a Christmas card." So I made a 5 x 7 print and mounted it and ... sent it off to him. About two weeks later I was downtown ... and in front of the E.A. Morris Cigar Store I met Mrs. Vanderpant. We stopped and talked. She said, "We both want to thank you very much for the lovely Christmas card. ... John has put a matte on it and it's hanging in the studio." Vanderpant didn't have to directly critique my work: hanging my print was my critique. I'll never forget the thrill!

In May 1934 the Seattle Art Museum held a solo exhibition of Vanderpant's prints, and he had the distinction of being the first Vancouver artist to have work exhibited in the new building. Larry Cross, an art critic for *The Seattle Times* wrote that "though

less widely known than Edward Weston ... Vanderpant's prints definitely place him next to Weston in importance if not excelling him as an exponent of photography as a creative medium." He also wrote that

Vanderpant ... wants to see and know the texture of things. He feels the necessity of structural strength, knows the value of pattern and massing. It is these things that he achieves. ...

Vanderpant ... is interested in reality and truthfulness, using his camera for the fine discrimination, a knowledge of form and pattern that is as rare as it is beautiful."[46]

Vanderpant found lecturing to local, national, and American audiences a gratifying experience. Those lectures clearly discuss the inspirations and ideals that shaped his aesthetic and his championing of modern art. In 1930, for example, Vanderpant gave a talk to the Vancouver Poetry Society entitled, "Concerning Matters Artistic." He told the group that

in science, in literature, and in architecture, ... momentous changes have taken place in which new standards have been raised and many old traditions set aside. It would be strange ... if art alone should remain unchanged. Yet, modern painting has been subjected to much greater adverse criticism than any other of the fine arts. A study of the work of modern artists reveals the fact that there has been a revolt against mere representation. Art ... should not be a photograph of nature, but an impression. ... The appeal of modern art at its best is to the aesthetic sense.[47]

On 5 March 1932, Vanderpant again addressed the society with a paper entitled "Meditation." His discussion of architecture (in which he noted that Vancouver's "lacked originality"), painting, modern poetry, and education focussed on "progress" in these fields. His knowledge of avant-garde trends was indicated in his discourse on "Electric music with colour combinations." Vanderpant viewed such innovations as the route of progress and concluded by stating that the "abstract quality of today becomes substance of the future."[48]

In 1934 he lectured on "Art in General; Canadian Art in Particular," to an audience at the Vancouver Art Gallery, a lecture he had also given to the Poetry Society on 28 October 1933. At that time, he showed reproductions of works by Canadian painters "dating as far back as 1840 ... and contrasted [them] with modern reproductions."[49] This lecture reflects Vanderpant's artistic vision and the spiritual influences on that vision. In attempting to define art, Vanderpant suggested that because it is always changing, a lasting and satisfactory definition is not possible. He went on to say that

all definitions put together would still fall short of the living emotion for which art stands. ... But it IS possible, even easy, to enter into the essence of art. ... The vital characteristic of art is the creative factor, the ability of the active artistic mind to convey to you and me the observations, emotions, reactions, reasoning of one's arranging, selecting mind. ... Technique and execution are consequences; the *creative* element is the all-important essence.

... In art forms against form ... in itself is not sufficient to create living emotion, only when one admits that the form in itself reflects certain qualities, vibrates some power from within ... lies the secret of expressive or creative desire. Art in this logic would become the manifestation of the artist's consciousness of life—his joys of living—his gratitude in being alive—the awakening of his oneness with creation as manifested in related forms and moods around him.

... The spiritual value, the value between forms, the value of spaces and magnitudes [are] of greater consequence than the actual forms. ...

... art is in the emotion which carries forms into harmonious balances; in play of rhythm and purpose.

In March 1934 Vanderpant lectured to the Vancouver Camera Club, of which he was an Honorary Member, on "pictorialism and composition." According to an article in *The Vancouver Sun*, Vanderpant

stressed particularly a proper use of light and shade in revealing the art and beauty behind a camera study, no

matter what the subject might be. [He emphasized that] "too little attention is generally paid to aesthetic values in photography …" illustrating his point by suggestions of different treatments for prints submitted for criticism.[50]

Vanderpant's busiest and most exciting lecture year was 1935. He started the year with a lecture entitled "Lyrics and Epics in Photography" given to Art Club at the University of B.C.[51] In the autumn of 1935 the National Gallery of Canada sponsored a cross-country lecture tour in which he spoke on "Adventures in Pictorial Photography." He lectured in Winnipeg, Kingston, Toronto, Ottawa, and Montreal; on his return to Vancouver he also spoke there. Vanderpant

based his address on three points, namely, a definition of art, a discussion of the question whether photography is art, and finally, what approach to make in photographic studies. …
… By an ingenious method of suggestion rather than statement Mr. Vanderpant finally showed that art was the relation between beauty and the beholder moulded by intellect into coherent form.
A series of photographic studies left no doubt in the minds of the audience that photography could not only be an art, but that Mr. Vanderpant was a superb exponent of his form of art. Almost half the pictures shown were "shots" of a grain elevator, which opened to the eye a vast field of hitherto unknown beauty, form and contrast. …
A reading of poetry and remarks on the subject of art expression of Mr. Vanderpant's own composition completed a delightful lecture.[52]

That year Vanderpant also acted as judge for the Second Canadian International Salon of Pictorial Photography, held under the auspices of the National Gallery. In his lectures, he praised the National Gallery for being "the first state institute to thus recognize the artistic value of photography and to make a representative exhibit available to the public at large."[53]
Speaking to the Montreal Art Association, "in an address bristling with aphorisms and illustrated by a series of excellent slides," Vanderpant stressed

the necessity for keeping the mentality as well as the lenses clean, for building up a rich mental reserve. … He pleaded for modesty and the observation of little things, for love and sincerity.
The examples on the screen began with reproductions of a Van Gogh painting and of works by Emily Carr and F.H. Varley and moved on to Mr. Vanderpant's photographs. … If one were sometimes reminded of Georgia O'Keefe, it was … that the photographs … had such purity and dignity of formal design. It is evident that when photography ceases trying to look like Corot, it not only begins to realize its own strength but it shows itself to be in the true spirit of modern art.[54]

On this trip Vanderpant also managed a quick visit to New York City. There he spoke to the Association of Pictorial Photographers of America. He enjoyed a concert by the New York Philharmonic Symphony at Carnegie Hall, attended Colonel W. De Basil's Ballet Russe de Monte Carlo, wrote a series of personal impressions titled "Meditations While in New York," and photographed a number of city scenes and structures. Although many of those studies "lack the power of synthesis" seen in his more successful prints,[55] a number of his New York prints deserve attention. One, "Spirit and Matter" (Plate 43), is a powerful example of his combined technical abilities and personal vision. The subtly toned print is filled with the stark and monotonous repetition of the towering exterior of a skyscraper. Its counterpoint, a small church spire, ironically and profoundly comments on the material versus the spiritual in one of the world's largest commercial centres.
Another, "Shadows Over New York" (Figure 29), is a compelling fusion of light and dark tones, patterns, and textures. The towering city structures convey a repetitive banality when dwarfed by distance and perspective. Seen from a bird's-eye (or God's-eye) view, it is the effect of nature in the contrast of light and shadow, as compared to the mundane efforts of humanity, which gives the image its dynamism. It is interesting to note that both of these studies were made into lantern slides. Vanderpant must have felt that they exemplified his attempts to portray "a deeper vision of reality."

Figure 29. *"Shadows Over New York" 1935. A modern image reproduced from Vanderpant's lantern slide;* NATIONAL ARCHIVES OF CANADA PA 175739.

... He is a man for whom the simplicities of life mean a great deal. ...

... He wants you and me and his neighbor to feel the same exhilaration that he does from the common prosaic beautiful things of life.[59]

Through his photographs, musical evenings, exhibitions, lectures, and arts-related pursuits, Vanderpant was successful in sharing new perspectives in the fine arts.

On his way back to Vancouver Vanderpant stopped at Port Arthur and Fort William (now Thunder Bay), a major grain port in Ontario. There he spoke to the Kiwanis Club on "The Architectural Importance of Grain Elevators in Canada," and suggested "that the railway and tourist officials should make it a point to advertise ... [the terminus] from an architectural standpoint."[56] He said that the grain elevators there were "often regarded as big prosaic and unlovely monuments of commercialism"; but to Vanderpant they were "examples of some of the world's finest art. He regarded them as symbols of confidence, strength, and stability."[57] To stress his point, Vanderpant showed a number of his grain elevator studies.

The lecture tour gave Vanderpant and his work much media attention. Besides the notices and reviews in the local newspapers, *Saturday Night* again noted Vanderpant's contributions to Canadian culture in an article "People Who Do Things."[58] Upon his return to Vancouver the *Province* newspaper ran a major article entitled "Cabbages and Cameras." According to the reporter, Norman Hacking, Vanderpant

captures the basic essentials with his camera, and by this means you and I are also able to share in his inner emotions.

CHAPTER SIX

LIGHTING THE "UNMAPPED WAYS"

T HE YEARS 1926 TO 1936 were invigorating. Vanderpant's work from that period shows that he experimented with a variety of styles, and highlights his knowledge of contemporary trends in art and photography. The slides that Vanderpant used to accompany his lectures indicate a broad interest in modern arts movements. A scholarly analysis of the ways in which these movements inspired his work may be one of the future areas of study on Vanderpant's *oeuvre*.

Clarence White, Alvin Langdon Coburn, and Edward Steichen are three photographers whom Vanderpant noted as being of particular importance to his development.[1] All three were members of the Photo-Secession, the movement dedicated to furthering the acceptance of photography as a fine art. This was a goal that Vanderpant shared, and he did much to promote photography on the west coast and the rest of Canada. During Vanderpant's years there, Vancouver became an international photographic centre; and as early as 1927 he was urging the National Gallery to undertake "a permanent collection of pictorial studies."[2]

Like Vanderpant, his American peers were noted for their portraiture, and the early work of all three reflects a soft-focus, pictorial style. Vanderpant shared White's interest in rhythmic compositions and the work of both is characterized by subtle lighting effects, especially that of early-morning sunlight. Like Coburn, Vanderpant could portray mood in evocative, soft-focus images; both photographed romanticized studies of labourers and industrial subjects. In 1913 Coburn shot his famous study of paths in a New York park, titled "The Octopus." It was taken from a bird's-eye view, and this new camera angle became the vogue with many photographers—Vanderpant included. Finally, Coburn and Vanderpant believed that "all effects, even transient natural ones, evoked a spiritual meaning as well as producing a decorative or formal pattern."[3]

Vanderpant's career parallelled Steichen's. As portrait photographers, both had the ability to communicate ideas in visual terms. Each attempted to convey powerful emotional images; both moved from pictorialism to the straight approach; and both came to use nature's forms as the basis for artistic design.

While Vanderpant was stimulated by the work of other artists and by modern movements, the vitality of his work was the

Figure 30. *"Builders" 1930.*

result of his personal vision and the ways in which he attempted to reflect "the soul of his day." He never interpreted the "soul" of the 1920s and '30s from the perspective of social realism: he held that spirituality was the only means of correcting the world's problems, including the sufferings of the Depression. To that end he maintained that he could help bring about change by capturing images of spiritual reality. This was in keeping with the Christian Science belief that "metaphysics contains the spiritual dynamics to transform human society."[4] Drawing from his mystical beliefs, his appreciation of the rugged grandeur of the Canadian landscape, and the technological and artistic developments of the first part of the 20th century, Vanderpant evolved a unique style.

In writings by and about Vanderpant, two important motives for his work are evident: the urge to contribute to Canadian art, and the desire to portray the cosmic energy that he believed united all things. Those stimulants directed him to an exploration of simple, "joyous," "dramatic," and harmonic forms.

Canada "opened" Vanderpant's eyes and he

> became attuned to his new surroundings, which offered new beauties to his vision and stimulated his genius to interpret and record them. He saw Canada as one who adored it, and he had the advantage of observing it in long perspective. For the peculiarities of Canada and Canadian life, which might appear ordinary to a native born and bred, to him were patent, and so appealed forcefully. Hence the virility, power and simplicity of his work.[5]

Not all reviewers of his work concurred. In June 1928 a British critic, F.C. Tilney, published an article in *The Photographic Journal* that chastised Vanderpant for having "forcible effects, angular compositions, patterns of strong contrast, lines of unmitigated straightness," in his "very dark" prints that had been exhibited at the galleries of the Royal Photographic Society in April.[6] In July, three members of the Royal Photographic Society also reviewed Vanderpant's exhibition. They described his prints as conveying "an extreme gloom." One stated that Vanderpant's prints "would interest one for ten seconds, but after that the interest would not be maintained." Another stated

that "some of the pictures were ugly and absolutely repellent."[7]

In a rebuttal, Vanderpant justified his work by saying that there had been a change in his work since his 1925 exhibition. That change had come about as a result of a criticism that the work "reflected so little of the Canadian spirit." He went on to say that he had

> learned to see the impossibility of conveying the spirit of Canada ... by employing methods of petty representation. ...
> Canada is not beautiful in detail, but by the immensities of its proportions, the tragic unfoldment of its forms and contrasts. ...
> This rudeness, this immensity and tragic unfoldment one tries to express in extreme simplicity of composition, form strength, obvious contrast in light and shade. One is not looking for gloom, but rather dramatic strength, ... for the forms, contrasts, proportions and designs, which belong to Canada and to no other country.
> It does not do, for instance, to hide telephone poles because they are considered ugly—they are ugly—but they are also part and parcel of this country and one therefore rather builds them into the composition, turning ugliness into beauty of strength.[8]

Vanderpant's concerns about Canadian art were similar to those of the Group of Seven. In describing their "vision" of "Art in Canada," the Group stated "that the greatness of a country depends upon three things: 'its Words, its Deeds and its Art'." Like Vanderpant, the Group's members believed that the artist had "a special unifying role ... [because] more than anyone else artists or creative people ... clearly see spiritual reality."[9] Vanderpant believed that

> the true artist should be the humblest man on this planet. Like the scientist who realises he knows very little, he is to my mind, no more than the channel, the interpreter, between the beauty which is, and the masses who want to understand it. Artistic ability, to me, is a great privilege, which carries with it the duty to use it to the best advantage for the benefit, not of oneself, but of mankind.

This is his creed and he lives it. Every spare moment is taken up with this urge to express a national beauty, and all his simple pleasures are so arranged that he himself may be in tune with Nature and so a fit medium through which she may be expressed.[10]

While Vanderpant did photograph a number of mountain scenes, some of which are reminiscent of paintings by the Group of Seven (e.g., "In the Wake of the Forest Fire," Figure 31), mountains were not to become part of his iconography. Unlike the Group's members, he was not interested in hiking or camping: any views of mountains in his work were taken on accessible summits such as Grouse Mountain in Vancouver. Vanderpant's symbol of Canada's "dramatic strength" was his views of Vancouver's grain terminals.

Vanderpant was not the first to note the importance of those edifices. In 1923 the French architect, Le Corbusier, wrote that the North American grain elevators were significant architectural structures. Vanderpant's treatment of them supported this idea, but in a distinctive way. For him they were also "essential" symbols of Canada's agrarian heritage. Vanderpant described

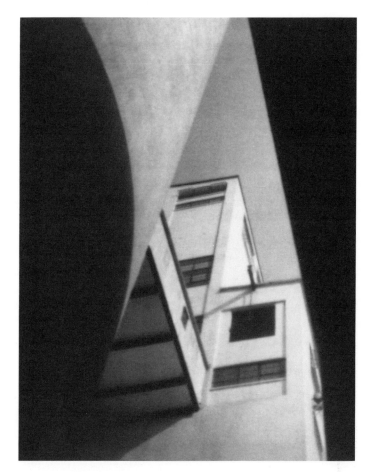

Figure 32. *"Elevator Pattern" 1929;* VANCOUVER ART GALLERY, 90.68.20.

"Elevator Pattern" (Figure 32) as a pattern of triangles "based on an essential structure of today, selected from essential things and thereby to my mind tied up with the heart of humanity which ... must be the underlying foundation of all art."[11]

Vanderpant photographed other subjects, but his interest in the dramatic and symbolic qualities of grain elevators lasted for many years. For him, they contained "the hidden flavor of lasting value" which was the "result of human or natural activity, and out of this human struggle selected to reflect in pattern or rhythmic play of form relationship, the sentiment of that struggle."[12] Titles such as "Temples by the Seashore," and "Colonnades of Commerce" reflect a glorified view of the

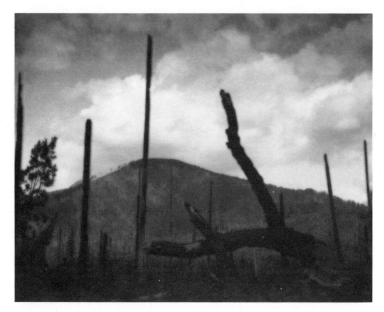

Figure 31. *"In the Wake of the Forest Fire" 1926;* VANCOUVER ART GALLERY, 90.68.12.

towering structures. In prints like "The Watchman" (Plate 35), the elevators loom powerfully, dwarfing humankind; like the Egyptian pyramids, they are symbols of human progress and achievement. Vanderpant wrote that the elevators

> rise on lakeshore and terminal throughout the land and in their rigid strength and sublime simplicity are the unpretentious temples of trade and a trade more vital through [the] distributing and storing of ... essential grain, than any other. ... They ... [are] usefulness personified ... [and] through simplicity, through repetition of the cylinder form, pure architectural monuments of modern life.[13]

For over 60 years Vanderpant's studies of grain elevators have been recognized as unique depictions of Canadian industry. In 1929 Bertram Brooker stated that Vanderpant's print, "Elevator Pattern," possessed "the qualities of a fine abstract painting," and illustrated "the thesis ... that grain elevators offer ... the only distinctively Canadian contribution to architectural design."[14] In 1987-88 the Art Gallery of Hamilton sponsored an exhibition entitled *Industrial Images*: in the exhibition catalogue, Rosemary Donegan stated that Vanderpant's elevator prints "have become symbolic images of Canadian industrial architecture."[15]

Vanderpant believed that photography was ideal for conveying a new vision of beauty as embodied in the cement silos. He considered "Towers of Today" (Plate 21) an example

> of a simple pattern, modern in concept, striking in contrast yet based on a reality of human industrial endeavor and achievement. It gives part of whole leaving, to an extent, light and masses to the imagination. ... The black blower gives the feeling of a tremendous bell against the whiteness of concrete structure and so in a simple, strong, modern pattern, a hidden hint of romance of human heroism in industry. ... Just this basic touch ... gives the vibrating emotion to this print ... [and] a secondary satisfaction in texture rendering.[16]

By 1929, Vanderpant's studies of the elevators were becoming more abstract. Through close-up views, he sought to portray the "strength of form and cement—the tenderness ... of texture—

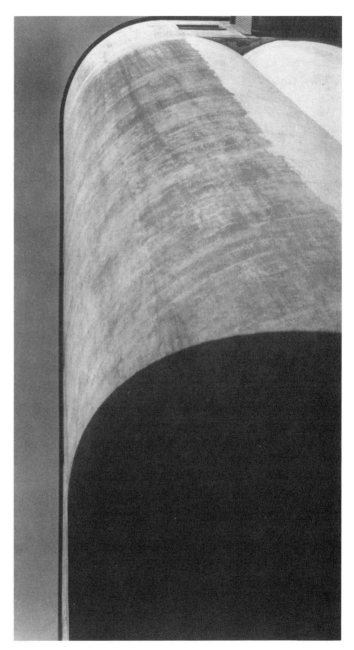

Figure 33. *"The Cylinder" 1934;* Vancouver Art Gallery, 90.68.44.

[and] the design possibility in form and shadow relationship."[17] In "The Window" (Figure 34), the dynamism of the structure is accentuated through the use of light and shadows to delineate powerful geometric forms. In this print Vanderpant seems to have shared Varley's exhilaration over Plato's "astounding words, … 'God geometrises'!" Like Varley, Vanderpant wanted to "get nearer to the universal centre,"[18] and many of his photographs reflect Le Corbusier's pronouncement that

cubes, cones, spheres, cylinders or pyramids are the great primary forms which light reveals to advantage; … [and] provoke in us … emotions and thus make the work of man ring in unison with the universal order.[19]

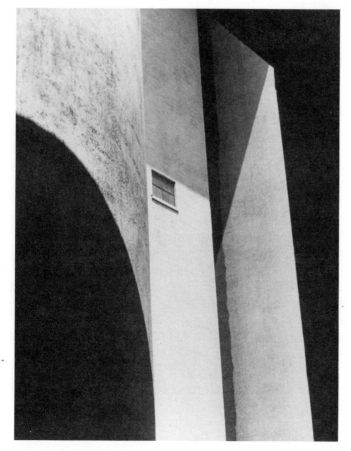

Figure 34. *"The Window" 1934;* VANCOUVER ART GALLERY, 90.68.51.

With their emphasis on the relationship of forms, Vanderpant's elevator prints, like most of his work, communicate what he referred to as an "underlying vibration": that is, multiple levels of emotion and meaning.

Vanderpant was a visionary who, like his painter friends, "used mystical form rather than aesthetically invented or initiated form"[20] in his work. He wrote that

reality in relation to art and life … is the moment of contact of one's own mind with that of the universe— another mind—or the humanly observable observation of expressions in apparent form thereof. This just means that reality is not in material appearances as such, but in the contact, the conflict … the harmonious balance of activities … of the mind. …

Mental contact with essences, not appearances, sees clearly the only actual reality, the only purpose that counts.

Linked to Vanderpant's definition of reality was his definition of art. He said, "Art is the consciousness of life expressed in aesthetic form, pattern, rhythm, and color relationship … aesthetically [it is] the expression of the consciousness of all inclusiveness, for art is the echo of the absolute."

Wishing to "echo" the divine, Vanderpant turned to the natural world. Like Ralph Waldo Emerson, he believed that "the invariable mark of wisdom is to see the miraculous in the common";[21] like William Blake, he looked "To see a World in a Grain of Sand / And a Heaven in a Wild Flower."[22] Whether he was photographing a vegetable, a grain elevator, a flower, or starched linen shirt collars, Vanderpant sought to challenge perceptions of reality through his dramatic representation of commonplace objects. He stated that

it is the simplicity of form in the grandeur of mountains which makes them grand ever. Detail … simply disappears in their massed greatness of interrelated forms. They pronounce in silence the significance of simplicity. …

Treating small objects artistically a similar simplicity must be created. By elimination of detail and selecting what are elementary forms … or subjects without apparent beauty a

similar result is obtained. The elementary parts [are] amplified—distracting ornamentation subdued or rejected, and essentially the same emotional response will be created as is by the observing of a mountain landscape. ...

This principle of simplification ... is what makes a print of a cabbage, part [of a] flower, a snowy patch, a kitchen still life, of equal aesthetic value as the print of the mountains or an ocean.

Vanderpant repeatedly stressed that the subject of art did not matter; rather, it was the response to or interpretation of the subject that counted. He stated that the technical aspects of photography had to be mastered so that they could be used "almost unconsciously," enabling the photographer to concentrate on "self-expression [which] should be the only conscious activity in the production of one's work."[23] However, just as the choice of colours is intrinsic to the process of communication in paint, papers and developers are intrinsic to photography. Vanderpant's choices enhanced the tonal qualities and textures which were vital to his desire to convey "inner values"[24] and

Figure 35. *"Kitchen Symphony" CIRCA 1935;* JOHN VANDERPANT COLLECTION, FILE II PANT 193-12, PRENTENKABINET, LEIDEN UNIVERSITY, HOLLAND.

"aesthetic truth." He also believed that by "playing with forms, tones, [and] gradations," the "inherent qualities" of photography could be "so exquisitely rendered." Through such work, he hoped that photography would be accorded its place "as a medium of self-expression."

The print "Heart of a Cabbage" (Plate 5) was, for Vanderpant, representative of his work. Taken around 1929-30, it conveys the complex beauty of a halved cabbage. The pattern, a convoluted circling movement, rigorously draws the viewer to the heart of the vegetable and the "heart" of the image, linking and balancing the composition. The core represents the visual and philosophic element of unification: the drawing together of divergent units to form a harmonic entity. Like much of Vanderpant's work, this print is a simple image that is striking for its composition, its tonal qualities, and its "underlying vibration."

Vanderpant was particularly intrigued by the rhythms and designs in fruits and vegetables. His daughters remember that when Mrs. Vanderpant was preparing a meal, a halved grapefruit, an endive, or some other fruit or vegetable might catch their father's eye. The food would be whisked away and placed before his studio camera, where the intricate patterns of the subject would be captured in subtly toned prints. The natural juices of each subject glisten and sparkle, adding new textures and highlights to the sweeping, curling, radiating, and thrusting lines. Titles such as "Agitation," "Intimate Design," "Birth" and "Mystery Stage" reinforce the dramatic, poetic, and mystical aspects of these plants.

Vanderpant believed that beauty was everywhere and, no matter what the artistic endeavour, the artist was responding "to beauty already expressed [but] individually discovered." He used the print "An Expression in Lettuce" (Plate 54) as an example and stated:

Though the halved head of lettuce was used as a means—it was never the intent to photograph mere matter—but to emphasize the rhythm and beauty of design in ... nature's architecture. It is well to remember that living beauty is never a thing, but a quality or qualities expressed in balanced relationships. ... The observer ... responds to his joy in nature and uses its forms to express that joy. ...

The lettuce print may seem to represent an old, bleached-oak door panel; it may mean a pattern in rhythmic action; or it may mean just ordinary lettuce—whatever one's reaction, next time you cut your lettuce for a juicy supper, observe and contemplate.

Vanderpant believed that any object could be emotive, and he found inspiration in a variety of commonplace subjects. By photographing materials such as wrapping paper, light bulbs, blocks of wood, and stacks of dishes from different perspectives, he made familiar objects into abstract visions.

In "Cactus Collaratus" (Plate 28), starched linen shirt collars convey a plant-like impression. The intense backlighting gives the forms translucence while creating a silhouette. The light and the shadow meld together so that both a positive and negative image (connected but separate, the same but different) is created. The opposing light and dark spaces surrounding the forms further accentuate and balance the contrasting qualities of the image.

In "Expression in Form" (Plate 27) the detailed, intimate view alters the forms from a recognizable entity to an unusual one. The vigour of the curling, surging forms suggests an internal energy or proliferation; the close focus and the lighting stress the collars' delicate, paper-like qualities while the rich shadows suggest the structure of a succulent; the overall effect synthesizes the familiar and the exotic, the animate and the inanimate.

Vanderpant surrounded himself with individuals who shared his concepts of beauty and spirituality. In the Vancouver arts community, he, Varley, and Macdonald became the advocates of spiritually inspired art. Their "belief that art was the highest expression of society, synonymous with religion, gave ... [them] a feeling of power in a social milieu that didn't necessarily support their activity."[25]

Vanderpant and Varley became particularly close. Vito Cianci recalled that the two "had a lot of ideas in common ... especially when it came to ... the spiritual quality of art." Art, music, and religious philosophies were subjects of unending interest and motivation, and the men frequently spent time together discussing such topics. According to Vanderpant's daughters, their father was

a night person. By 10:30 Mother would be goodnighting us. After she retired, Father would invite himself over to Varley's (who was also a night person) for a chat; or he would bring Varley over for a chat by our fireplace. They would talk late into the night.

These conversations took place while Varley was living with his family at Jericho Beach, between 1926 and 1932.
Anna remembers that

imaginative expression in artistic works was often a topic of thoughtful discussion.

Fred was intrigued with Buddhism and its application to life. Through his interest in Eastern philosophies our families had thoughtful, sincere discussions about the faiths of India, China, and Japan. All were explored; all had merit; although, no one in our family fully comprehended the deeper aspects since none of us were dedicated students of those teachings. As a family, we tried to appreciate and learn. Over the years there was a growing awareness of spirituality among people who visited [us].

His talks with Varley, and his interest in religious philosophies led Vanderpant to ponder whether or not

there can be a great Western creative epoch without the adaptation of the influence of the Eastern ideal; without an intense spiritual revival of consciousness, or the coming to light of a mass ideal in economic reconstruction based on a concept of spiritual brotherhood.

Vito Cianci spent some time in the company of the two men and recalled that they held similar ideas on the interrelatedness of

the arts. ... Their ideas ... [were] completely strange to me. ... I always thought that music is music, and painting is painting, and sculpture is sculpture, and they were all entirely separate activities. But through Vanderpant and Varley, we got the notion that it was all one. ...

In Kipling's *Kim*, the lama speaks of reaching out and trying to reach or touch the Great Spirit, the Great Soul. Well, this is what Vanderpant, Varley, and Macdonald all worked towards, all were working up to consciously. It was apparent from their work. They didn't speak of it in a formal, arranged kind of a way. It would arise naturally out of conversation. Being so green and unused to that sort of thing at that time, most of it was over my head. I felt, "This is not my field." I listened and I occasionally asked a question, but not that often.

Vanderpant and Varley both had passionate natures that were reflected in their art and in their appreciation of music. Whenever possible, Varley had a piano in his home; and "he would often play Bach ... until early morning."[26] Vanderpant was equally enthusiastic. Anna remembers that her father listened to music "from morning until night. Carina and I went to sleep to, and awoke to, symphonic recordings. Sometimes, Father played the same record over and over again. I can remember waking and thinking, 'Is he *still* listening to that?'"

In spite of their similarities, Vanderpant and Varley had differing temperaments and habits: for example, Vanderpant was a teetotaller, while Varley enjoyed alcohol; Varley was a rugged outdoorsman who liked hiking and camping, while Vanderpant's recreations included activities such as bowling, horseshoes, and sojourns in his car; Varley was bohemian, while Vanderpant was pragmatic. Vito Cianci recollected that their differences did not interfere with their camaraderie:

They were good friends. I recall the time Varley was in St. Paul's Hospital [in 1934]. He'd had a mastoid operation. Once in a while I would go to see him, after school or on the weekend, and he always went through the same routine. As soon as I came in, he'd reach into his pocket and haul out a $2.00 bill and I'd go down to the local liquor store and get a bottle of red wine and bring it back to the hospital. And we'd drink the wine and play chess.

I remember two occasions when Vanderpant came in while we were drinking and playing chess. Vanderpant was a good chess player and he'd watch and make all sorts of

biting comments on the way I was playing because I was hopeless, no good at all. He was teasing, but with a perfectly straight face. Vanderpant had a sense of fun. And I can still see Varley sitting up in the chair, his ear all bandaged. He looked like a self-portrait of Van Gogh with his ear cut off. Vanderpant was a teetotaller, but he didn't judge us whatsoever. That's the way we were, and that's the way Vanderpant was, and that was it. We accepted each other.

The Varley and Vanderpant families spent much time together. Anna remembers Varley being "gentle and sweet." According to her, Vanderpant

didn't allow alcohol in the house. We knew that Varley drank, and sometimes smelled it on his breath, but we never saw him drunk. He was always a gentleman. During our family visits, Varley would informally show his work. What I liked about Varley, and Macdonald, was that to them art was a means to convey their love of life and their gratitude to nature and God for what we have.

Varley's youngest son, Peter, recounts that

Specific nights were reserved for visiting each others' homes. ... As we had no car, ... [Vanderpant] would come to the house in his "Moon," a name which always added a flavour of pleasant excitement to the evening journey, gather us all into its gently upholstered interior, then off to Robson Street.[27]

The Vanderpant Galleries had a roofed gate at the sidewalk edge under which a display case showed the passing people the most recent portrait that pleased John's own aesthetic feeling. The memory of my own shy face in that special box still lingers strongly. ...

The welcome was always warm, and my young soul felt it magical to enter the candle-lit sitting room, with a quiet fire in the small grate. Here for a time there would be comfortable talk and laughter, until John started sharpening his thorn needles and set some shining new recording onto the turn-table of his magnificent Columbia gramophone. ...

In those early days recorded music was a rarity in Vancouver homes, and I'm fairly certain he had gathered one of the finest collections in the city— certainly the most catholic—including the Lener Quartet readings of Beethoven, Stravinsky, Richard Strauss, avant-garde German *Gebrauchmusik*, the 13th Sound Ensemble of Havana, Satie, and to lighten the evening, the comedy of "The Two Black Crows," "Cohen and Kelly" and other monologue readings including Jean Cocteau's telephone piece. After music, pastries and coffee in delicate china with those delightful silver spoons, with tiny windmills at the handle end the Dutch are so fond of, to gently stir the sugar cubes.

Sometimes we would gather in the large room behind, which was his studio-gallery, for a showing of glass slides of his recent photographs, sensitively made images that always astonished with their simplicity and fresh vision. …

… His eyes cleaned, refined, simplified all that caught his imagination, always searching for the essential, simple statement of his love for the inner growth of character, whether animate or not. His humor was always gentle, capricious. He took great delight in puzzling friends with images, grandly composed, completely abstract, of something he had seen in a new way. …

When business was slack, or on weekends, he used a … folding pocket camera wherever his wanderings took him— the grain waterfront, along the Fraser Delta, up in burnt-timber country—searching for the same simplicity that dominated his studio work. His humour surfaced in this too; a lovely backlit photograph of casks grouped lying on their sides became "The Barrels of Marpole St."…

When photography became my interest later in my teen years, it was a secret joy to visit his studio, find him and his daughters busy in the mounting room at the front, negatives in print frames on the window-sill being proofed on the old, gold chloride paper then used, fresh prints all about, portraits finely mounted and signed by John. He took me to his darkroom at the end of the front hall, and in its exciting dimness with the sharp smell of hypo, I watched him work, with rolled shirt sleeves and an occasional glow from his cigar, fastidiously and with precision exposing paper, then taking it from tray to tray set in the long sink. …

Figure 36. *"Barrelaria"* CIRCA *1931.*

He asked me to bring some of my negatives, and out of a fair assortment, surprised me by choosing a simple silhouette of the top part of a young cedar. Later he gave me a mounted print cropped to simplify again—a lovely dancing form— and had titled it "The Velvet Dress." It was a good lesson.

The other side we younger ones knew of John was from the family visits to our home, where in wild, perspiring agility he regularly beat my father at table tennis, played on a large round table we had at the time, delighting in a dribble shot just over the net at the table edge. Games of all kinds— cards, bagatelle, word games, limericks, memory rounds, balloon bashes, his cigar exploding one—all in a fine spirit of fun. On whim, he thought nothing of driving the young ones in the "Moon" to fetch good ice-cream from the other side of town, or having a high-spirited ride on New Year's Eve to Chinatown. He loved films—Laurel and Hardy, Marlene Dietrich, Greta Garbo [and Charlie Chaplin].

John was warm, jovial, thoughtful—a tender, perceptive man.[28]

Vanderpant's interactions with Varley occurred during a period of experimentation and intense motivation for both men. In their work, they were attempting to convey mystical perceptions.

Occult writings and related theories of creativity were popular with many Vancouver artists, especially the works of Annie Besant, H.P. Blavatsky, Jay Hambidge, Wassily Kandinsky, Charles W. Leadbeater, Amédée Ozenfant, P.D. Ouspensky, and Rudolf Steiner. Kandinsky believed that human emotions are comprised of spiritual vibrations and that those vibrations are set in motion by nature. Vanderpant held similar sentiments: he believed that the photographer should interpret "a vibrating idea or vision" and that the artist's role is to "Awaken Aesthetic Emotion in the Conscience of the Onlooker."[29]

Motivated by spiritual philosophies, Vanderpant produced some of the best work of his career in the years 1929 to 1939. His prints explore visual surfaces so that the viewer is engaged by their physical characteristics and textures. Removed from their contexts through close-ups, dramatic lighting, and the elimination of background, the sensual beauty of each subject is emphasized; at the same time the lack of context often creates an enigmatical image that is imbued with transcendental qualities. In this way Vanderpant transformed celery into a magical entity in "Mystery Stage" (Plate 6). The shadowy forest of stalks conveys a sense of secret spaces while the mysterious, lush textures and the shimmering highlights emphasize the sense of otherworldliness.

Another striking perspective is conveyed in a 1934 photograph of grain elevators (Figure 37). In the untitled print, Vanderpant's perspective and the lighting he chose give the cylindrical columns a bark-like texture which makes them resemble a stand of towering trees. Vanderpant wrote: "As one can love the grove of virgin cedars for their silent enormity, so one can … [the] rising cones … [for their] shadow plays … and … their fearful silence."[30] To stress the towering perspective, Vanderpant eliminated the tops and bottoms of the forms; the relation of the image to its surroundings is thereby also removed. The surfaces of the forms are not as normally perceived, implying that in a search for spiritual truths we must transcend superficiality: like the soaring objects in the print we must look to divine or elevated realms.

In two views of grain elevators, "Broken Lines" (Plate 56) and "Liquid Rhythm" (Plate 55), Vanderpant used the reflecting qualities of water to enhance and alter his compositions. Again,

Figure 37. *"Untitled (Verticals)" 1934;* VANCOUVER ART GALLERY, 90.68.41.

the images are devoid of contextual relations, especially as they appear upside down and distorted by the movement of the water. Like "Elevator Pattern," both prints resemble abstract paintings. In "Broken Lines" the elevator's appearance is "broken" from its normal frame of reference into an undulating and unfamiliar form. The fluctuations of the watery mirror in "Liquid Rhythm" reflect an image that is paradoxically accurate but metamorphosed: the "underlying vibration" is as much a physical reality as it is a perceptual one.

While he was in Vancouver, Varley began experimenting with colour and "like the Buddhists, Theosophists, and others interested in esoteric colour theory, Varley categorized the psychological value of colours. … By the … 1930s he …

perceived colour vibrations or auras around objects."[31] His expression of spiritual values resulted in a number of intriguing canvases, including his 1930 masterpiece "Vera." A student at the V.S.D.A.A., Vera Weatherbie was a talented painter and a striking woman. According to Harry Adaskin, hers was

a very spiritual beauty. ... Vera, who was involved in mystical speculation, taught Varley about auras: vibrations which surround all people revealing the true state of their emotions and spirit. These vibrations were depicted as colour by those spiritually ready to receive them. Varley, who did his best work when deeply moved by the subject, painted his Vera in green as a symbol of both the sensuality and the spiritual significance of her character.[32]

Weatherbie was also a talented painter and Varley referred to her as "one of the biggest events in Canadian painting."[33] Yet, she seems to have sold few of her canvases, and a lack of recognition appears to have disheartened her. In 1937 Varley counselled her, "*YOU ARE AN ARTIST*. Keep on & work. It is a crime, Vera, to have a gift such as yours & forsake it."[34] In 1941 Varley told her that he was

tongue-tied ... about the news you gave me—but please realize this state of no desire to paint again cannot last. ... I always speak of you as one of the *real* artists in Canada—so you are and you'll get active again when the right time comes.[35]

Although Weatherbie exhibited in the Annual Exhibition of B.C. Artists in 1944, and at the Vancouver Art Gallery in 1945 and 1949, her painting seems to have drawn little attention; she gave up painting as a career.[36]

Weatherbie had a romantic liaison with Varley who was not only her senior by many years but her instructor at the V.S.D.A.A. from 1926 to 1929; he was also a married man with a family, and many in the community were scandalized. Their relationship also caused some strains in Varley's friendship with Vanderpant. In a 1931 letter, Varley "told Vanderpant the other night to go to hell. [H]e was a b— moralist. He'll be back again & forgive me. I suppose."[37] Vanderpant may have been

expressing his concern over the hardships Varley's wife and children were enduring. The Vanderpants tried to help the Varleys with emotional and financial support.[38]

At the same time, Vanderpant was aware of Weatherbie's painting ability. In January of that year he wrote the Director of the National Gallery to say,

Don't you think that Varley's portrait by Vera Weatherbie is one of the best things the West has produced yet? It is so original in content, striking and strong and of splendid art and colour. If you agree with me and like it would not you use your influence to have the gallery buy it? It would [be] such an encouragement for the girl who to my mind deserves recognition.[39]

Brown responded that the gallery's acquisitions were handled by a committee. The canvas was not purchased, but Vanderpant continued to advocate her work. In April 1931, he included Weatherbie in his exhibition of B.C. painters. A review in the *Vancouver Daily Province* stated that

the most gripping painting of the show is the portrait of F. Horsmann [sic] Varley by Vera Weatherbie. ... This is the canvas which caused so much comment at the Ottawa show, invoking critics to ask whether the young pupil had painted Varley or Varley's soul.[40]

Vanderpant offered her other encouragement. According to Anna, Weatherbie was unemployed in the spring of 1933, so Vanderpant hired her to give oil-painting lessons to his wife and daughters. Once a week the three worked at their easels, painting still lifes. The lessons lasted until the fall of that year when Weatherbie took a position as Varley's assistant at the B.C. College of Arts. Vanderpant also used a portrait of Weatherbie on an advertising brochure. Like Varley, he knew that she was a captivating model.[41]

Weatherbie's painting and the ways in which she "encouraged and perhaps even guided"[42] Varley's development are yet to be fully explored. Irene Hoffar Reid feels that Weatherbie "taught art ideas and techniques to both Lamb and Varley." Reid also

believes that the dramatic change in Varley's colour palette was due to Weatherbie's influence.[43] Varley acknowledged her inspiration. He told her that they "used to work well together. You did me a world of good—and you had the guts to scrape my canvas of Dhârâna down."[44] He also told her that he "missed very much not talking to you about paintings as they were developing. I got into the way of your mind and mine criticizing & suggesting until the canvas belonged to both of us. ... We have done splendid work together."[45] Weatherbie's romance with Varley has been given more attention than her role in the history of Canadian art. As has been noted, the "current research which only places her in a secondary position with male artists must be revised."[46] Only then will it be known if Vanderpant's early appraisal of Weatherbie's work was accurate.

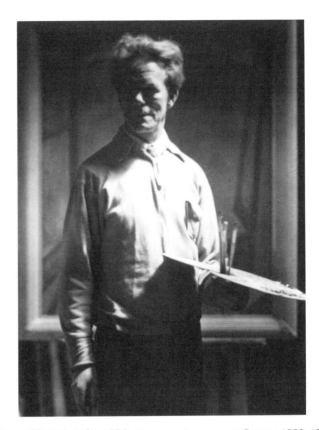

Figure 39. *F.H. Varley 1932;* NATIONAL ARCHIVES OF CANADA 1992-453.

Like Varley, Vanderpant sought to capture the essence of Weatherbie's character (Plate 17). Both men chose to portray her dressed as the Virgin Mary (her role in the 1928 V.S.D.A.A. Christmas pageant): Varley in "Head of a Girl" (*circa* 1929), and Vanderpant in "Vera" (1930). While both portraits convey a sense of introspection, Vanderpant's also imparts a feeling of mystery and sensuality; Varley's study "demonstrates the contrast between the evanescent quality of the [Vanderpant's] photograph and the plasticity of paint."[47]

Vanderpant also took a number of portraits of Varley, including Figures 38 and 39. Both stress the artistic and mystical aspects of his personality. In Figure 38, Varley is posed in front of what appears to be a painting which contains a band of light that seems to emanate from both sides of his head: the aura-like band and his reflective demeanour suggest a potency beyond that

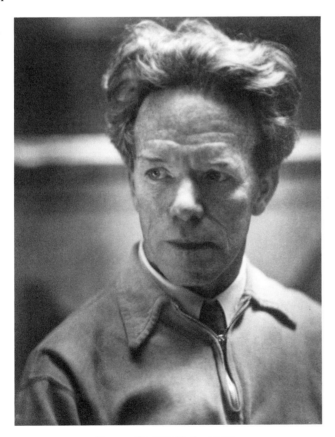

Figure 38. *F.H. Varley 1932.*

of his physical presence. Vanderpant's regard for Varley's abilities is indicated in the portraits and in a recollection of Carina's. She recalls that once, while Varley was visiting the studio, "He was drawing as he and Father were talking. When leaving, Fred tossed the sketch in the waste basket. After he was gone Father took the paper, smoothed the wrinkles, and kept the drawing."

In Figure 39, Vanderpant placed Varley in front of his painting "The Open Window." The lighting illumined only half of Varley's face, suggesting a mind/body duality. Varley's palette and brushes, the instruments of his intellectual, artistic, and spiritual communication, are highlighted. His posture is formal and rigid, stressing the confines of his physical being as compared to the beckoning freedom symbolized by the painting: the artist and his spiritual presence are stressed rather than the mere man. Vanderpant also added an interesting dimension to the photograph: Varley's canvas encases a window, and Vanderpant's print encloses both, conveying a frame within a frame within a frame. In Vanderpant's portrait, and Varley's painting, the artist is symbolically depicting portals of insight.

Jock Macdonald was another artist with whom Vanderpant shared an interest in "the creation of an art symbolic of Canada's unique national identity,"[48] and in the development of a new artistic vision based on spiritual precepts. Like Vanderpant, Macdonald believed that the artist had a prophetic role. He stated that

the creative artist's duty is to convey new reflections about life which the masses have not yet become aware of and it should be understood that the conscious level of the creative artist is above the conscious level of the masses.[49]

Inspired by the scenery of B.C. and by Varley, Macdonald began painting landscapes; his work evolved into increasingly mystically inspired abstraction. By 1937 Macdonald was experimenting with a new non-representational form which he termed "Modalities." He was apprehensive as to how the work would be received, but decided to show the canvases to Vanderpant. Describing the visit in a letter he wrote:

About ten days ago I enjoyed an evening with Vanderpant, saw all his new photographs and tried him out on my new painting experiments. We had as full an evening together as we ever had and I believe we found that our thoughts ran along very similar lines in relation to expressive impulses. His most recent works are amazingly spiritual—even though the material of the subject matters runs though chard, celery, melons, cauliflower, etc.—and somehow his technique is so superb that he can lose almost completely any indications of the selected subjects. ... I honestly don't think he has a master of photography to surpass on the surface of the globe as his work is so removed from any photographic "study" stuff. I just wonder how far he can still actually go. I thought before that he had practically reached the depths of possibilities in his medium but I was quite wrong.

About my new efforts I think I can quite honestly say he was sincerely surprised, if not truly amazed. He appeared to enjoy himself over them for about two hours. The one you saw he thought "simply delightfully beautiful" and without any remarks from me he named it "The Song of the Sea."... I came away with the happy thought that I had found another being who felt what I had tried to express.[50]

Both Vanderpant's and Macdonald's work at this time may have been influenced by *Thought-Forms*, a theosophical text by Annie Besant and C.W. Leadbeater. Vanderpant called his vegetable studies "thought expressions in nature";[51] and Macdonald referred to his work as "thought-expressions," "Expressions of *thought* in relation to nature," and "thought-idioms of nature."[52] Like Vanderpant, Macdonald was using natural phenomena to communicate his belief that "the only reality is the spiritual."[53]

Another B.C. artist who was concerned with expressing "the divine in all" was Emily Carr. She believed that the "test" of a painting was "the existence of the thing *spiritually*."[54] How or when she and Vanderpant met is not known, but Vanderpant did visit Carr on several occasions. Although she could be short-tempered, cantankerous, and contemptuous of others, Carr seems to have enjoyed her interactions with Vanderpant. All references to him in her journals and correspondence are pleasant. In a 1933 journal entry Carr wrote that, "Vanderpant & Knight two artist photogra-

phers came to the studio today[.] They were very enthusiastic over my work, said it was individual & I was getting someth[in]g."[55] This was probably the visit in which Knight took 18 photographs of Vanderpant with Carr in her studio.[56] In all of the views Vanderpant and Carr are studying or discussing various paintings. In a 1935 letter to her friend, Nan Cheney, Carr wrote, "Bless old Vanderpant! He is a nice person isn't he? He comes to see me occasionally when he is in Victoria." She made a similar reference to Vanderpant in a 1938 letter to Cheney, when she again described Vanderpant as "a nice man."[57]

In part, their friendship was based upon a shared sense of humour. Vanderpant's daughters recall that Carr visited the Galleries a few times and that during her visits "there was lots of

Figure 40. *This photograph of Emily Carr in her Victoria studio with Vanderpant was taken by H.U. Knight.* Victoria City Archives, H.U. Knight Collection, Emily Carr Series 4257-(1). *On the back, Vanderpant's copy is inscribed " 'Off the Record' Love to all, Knighty."*

laughing." Isolated on Vancouver Island, Carr often felt that her work was not recognized; therefore, she must have valued Vanderpant's appreciation of her painting. Although the records are not complete, Carr exhibited, and possibly sold, some canvases through Vanderpant's 1931 exhibition of B.C. artists.[58] He also had reproductions of "The Raven" (1928 or 1929), "Shore and Forest" (Cordova Bay, 1931), and "A Young Tree" (1931) in his lantern slide collection and often used the images to accompany his lectures.

The two also shared artistic aims and ideals: like Vanderpant, Carr wanted to convey "the inner essence" of her subjects, and to show "a portrayal of relationships."[59] Both loved nature and struggled to be receptive channels for its beauty. Carr wrote: "The woods are brim full of thoughts. ... Trick is to adjust one's ear trumpet."[60] Vanderpant expressed a similar sentiment in a poem:

> The woods are alive with sensitive aerials
>
> .
>
> I heed mind's aerial and try to catch
> what is beyond the prison of my senses.
> For if my eyes will elevate
> this day into its beauty known,
> how much higher is the secret purpose
> to which the woods are holding silver aerials?

Another acquaintance of Vanderpant's was Philip Surrey, an emerging young artist during the 1930s. Surrey studied life drawing with Varley and through him was introduced to Vanderpant; the three often spent time together. Surrey also attended many of the musical evenings in Vanderpant's "big new house w[ith the] huge high living room & big picture windows. Other times at his studio."[61]

Vanderpant's daughters remember that Surrey "was a quiet guy. He would often come around with the Varleys." At other times the young man visited with his mother, who was living with him, and who liked to spend time with Mrs. Vanderpant. Young and single, Surrey was frustrated with the ways in which his mother impinged on his time, creativity, and privacy. To others, however, she was "the sweetest, cutest little old lady," and the Vanderpants appear to have been charmed by her. They also

might have been aware that Surrey was struggling to support, financially and emotionally, a mother with whom he was "in a continual state of irritation."[62] A family photograph shows Vanderpant working on a canvas while Surrey paints in the background. At the time, the Vanderpants were holidaying at a rented summer cabin in North Vancouver, and Surrey and his mother were visiting for the day.

The young artist attended lectures on mysticism (probably those given by the Viennese artist Harry Täuber) and recalls that

in the twenties ... Fred [Varley], Lawren Harris and all his circle were steeped in mysticism. ...

In 1932, from the Library, I got Amédée Ozenfant's "Foundations of Modern Art," which so impressed me that I bought it. It was a very important book for me, opening a whole new world of ideas, since he points out that all lines, shapes, colours derive their effect from our experience of them in the real world.[63]

Surrey left Vancouver in 1936. He went first to New York where he was a member of the Art Students League and then settled in Montreal. Vanderpant's empathy for the plight of a fellow artist is evident in his relationship with Surrey. The young man was always welcome at the Vanderpants' and, although contending with a reduced income due to the Depression, Vanderpant managed to give Surrey financial and emotional backing. A letter from Surrey indicates that the two men also shared interests in literature. A reference is made to Canadian poet Dorothy Livesay, who was starting a chapter of the New Frontier Club in Vancouver (at least one of the Club's meetings was held at the Vanderpant Galleries).[64] On 23 April 1937, Surrey wrote to say

Ever so many thanks for your letter and for all you've done for us, storing and sending our things. Too bad you had to pay in advance. I'm terribly sorry I've kept you waiting so long for it. ... As I write ... am astounded to see that it's a whole month since you wrote. I hope I haven't inconvenienced you with my tardiness. I send cheque for $26.25. ...

Varley was down here for the Easter week-end. If you had been here too it would have been quite like old times! ...

As I write I am accompanied by the Fifth Symphony coming from Cincinatti [sic]. It is the Andante now. What a beautiful mood it has. Speaking of moods, I am sure you would enjoy Bob Ayre's "Mr. Sycamore" in the April issue of "Story."...

... I'm glad Dorothy Livesay is getting something going out there. I gave her a list of people to approach for her club. ...

Best regards to you and all the family.[65]

For Surrey, and others interested in the arts, Vancouver was an invigorating centre in the late 1920s and early '30s. Like Varley, Macdonald and Vanderpant had "unbounded enthusiasm."[66] They inspired and challenged Vancouver's art students and their fellow artists to discover new forms of expression. Irene Hoffar Reid was one of those influenced by the new perspectives. She recalled that

Vanderpant's photographs of grain elevators led other local artists to see grain elevators as beautiful objects. ... I tried to paint them. And after I saw Vanderpant's photograph of a sliced cabbage, I cut a cabbage and marvelled at its design.

Varley also appears to have been inspired by Vanderpant's images of grain elevators: in 1937 he sold a drawing of a grain elevator; in 1940 he wrote Vera Weatherbie that he hoped to spend the winter in B.C., and that while there he wished "to paint the grain elevators in the morning light."[67] A number of Canadian photographers were also stimulated by Vanderpant's images, including the noted Vancouver amateur James Crookall,[68] and Yousuf Karsh. In 1960, Karsh published his interpretation of the structures in a book of Canadian images. Photo-archivist Melissa K. Rombout states that Karsh's print, one of a series of 46 elevator studies,

taken at the lakehead (now Thunder Bay, Ontario) during one of Karsh's assignments to document Canada for *Maclean's Magazine* in the early 1950s revisits a subject which

was so well-identified with Vanderpant nearly two decades earlier in works such as *Temples by the Seashore*. ...

What is remarkable about Karsh's image is its close compositional correlation to Vanderpant's own studies, of which Karsh was undoubtedly aware, *and* its symbolic links to the industrial expansion and development of the 1920s and 1930s as depicted by the American Precisionist artists and ... by Vanderpant. ... Karsh emphasizes the monumental grandeur of the architectural forms; the scene is tightly cropped and devoid of human presence which elevates the focus on the physical structures as protagonists of the scene (it becomes essentially a "portrait"); finally, there is the presence of the undulating reflection on the water's surface, again an allusion to Vanderpant's own explorations.[69]

In a 1928 lecture, titled "Artery," Vanderpant told the students of the V.S.D.A.A. that they had to establish a "firm contact of one's individual mentality with the infinite laws of life," in order to create "the correct attitude essential to artistic self-expression in the material appearance of fine art." He stressed that they also had to develop the fortitude to endure financial hardship, criticism, and indifference. He stated that "the voice of art in the west, is the voice of one crying in the wilderness. Therefore those with strong voices: cry and cry and cry again."[70] Unfortunately, like Vera Weatherbie's, many of the voices faded; others, like Macdonald, Surrey, and Varley, found they could only be heard if they left B.C. Vanderpant never wavered as the "voice of art in the west."

"CRY AND CRY AND CRY AGAIN"

FTER TAKING OVER the Robson Street studio in 1927, Vanderpant moved his family to Vancouver where they rented a house on Trimble Street. His business quickly prospered and, in 1928, in the light of his continuing success, Vanderpant decided to have a house built at 1750 Drummond Drive; it was completed two years later. Anna remembers that the family "loved the house. It was our home, our taste, our dream: loving, warm, cozy, and elegant all at once." Vanderpant was so enthused about the new house that in December 1929, while it was still under construction, he decorated the beams with cedar boughs and drove the family over for a Christmas celebration in their home-to-be. Tragically, soon after the family moved into their new abode, the Depression began curtailing Vanderpant's clientele. He struggled to keep up his payments, but lost the house in 1934. The family then moved into the residence above the Galleries, which Carina describes as "small, but charming. Mother had a natural talent for artistic arrangement, and she used that talent to make the living quarters beautiful and homey."[1] Catharina was a loving and supportive wife but, according to her daughters, there was one endeavour of her husband's that Catharina did not condone. She was distressed when Vanderpant began photographing a nude female model, around 1927. As a result he made only a few nude studies.

Architecturally ahead of its time, the Drummond Drive home is still vivid in Anna's mind:

The house was built on a well-treed lot, mostly cedar and fir trees. It looked, somewhat, like a Swiss chalet. ...

The living room had a fireplace and a vaulted ceiling. The far end of the room had a very large window with a view of the North Arm [of Burrard Inlet] and the mountains. Opposite the fireplace were two double doors opening onto a patio. ...

The house was simple, but cozy and comfortably furnished: Oriental rugs in the hallways, in the living room, and in the dining area. The living room had a grand piano and a large chesterfield sofa and chairs, occasional antique chairs for decorative effect and, of course, the forever favourite brass candelabras glinting in the dimly lit room when we had musical evenings with friends. At the far end of the room, on one side of the picture window, was a large gramophone and a cabinet with a vast collection of classical recordings. The resonance and tone of the music was magnificent in acoustical values for which the room was built.

... We had a large Frederick Varley painting in the hallway. It was a magnificent painting of the Black Tusk [in Garibaldi Park], of which I was extremely fond. [Varley titled it "Mimulus, Mist and Snow."]

After 19 years of marriage, Mrs. Vanderpant had been thrilled to finally have her own home, and one that was unique for its day.[2] A happy woman, whom her daughters recall as "always singing, even when hanging out the laundry," Mrs. Vanderpant tended to her new abode with joy. Visitors were always welcome and the Vanderpants regularly entertained their artist friends and those from the Dutch community. Carina remembers that, while living on Drummond Drive, she was allowed to have "dancing parties" to which she invited her school friends. Her father would decorate the trees surrounding the verandah with lanterns, and her mother would provide refreshments.

The prospect of losing their beautiful house was difficult for the family, especially Mrs. Vanderpant. As they were coming to

terms with the situation, Anna became a go-between for her parents. She would listen to her father's explanation of their financial state, then go and talk to her mother who

> couldn't understand why we had to sell the house. She would ask, "But why?" I would go back to Father, who would again explain why to me, and then I would again explain why to Mother. Her distress and the worry were very difficult for Father. I would get up during the night to find him pacing the floor.

Anne le Nobel, whose family was close to the Vanderpants, believes that, in wanting to protect his wife and daughters from the reality of the situation, Vanderpant had not prepared them for the loss.[3] Perhaps he even deluded himself into believing that leading a good life could bring only rewards, not privations. Indeed, a letter threatening the cancellation of Vanderpant's life-insurance policy seems to have been ignored: the back of the letter was used to record Vanderpant's thoughts on new modes of expression.[4] In the end, he and the family came to terms with their loss. He told H.O. McCurry, the Assistant Director of the National Gallery,

> You will be sorry to hear that it seems as if we are going to lose our lovely home, a real home to us; the fact that hundreds are sharing the same misfortune is small compensation, and for one so willing to give and serve it seems a shame to have to give in to the universal belief of lack. However true home is in consciousness which we will try to keep in contact and good cheer.[5]

Like Vanderpant, other Vancouver-area artists had to endure hardships. In 1933 the Depression forced the Vancouver School Board to reduce the funding given to the V.S.D.A.A., causing an already tense situation to explode. In spite of the enthusiasm of the students and staff, there had always been problems at the school. Housed in cramped quarters above the Vancouver School Board offices, the space, materials, library, and funding had never been adequate. These problems were aggravated by an underlying discord between the reserved principal, Charles H.

Scott, and his two exuberant head instructors, Varley and Macdonald. There also appears to have been friction between the two and Grace Melvin, Scott's sister-in-law and an instructor at the school.[6]

Vito Cianci had a unique vantage point for viewing the school and its problems: he was a student and also worked as Scott's part-time secretary. From the beginning he was aware of the tensions that existed between Scott and the two teachers, particularly Varley. This dissension, compounded by financial cutbacks, led Varley and Macdonald to quit their positions in 1933. Cianci recalled:

> When the school broke up I thought that it was largely Scott's fault. He had two powerful personalities to deal with and he couldn't quite handle it. And ... his sister-in-law, Grace Melvin, was also on the teaching staff, and there was a certain amount of favouritism. ... I was put in an awkward spot once or twice because Varley would come and talk to me about his problems with Scott. He had to get it off his chest, and he thought I was a neutral soul ... [and] that I knew what was going on. He said, "Well, this isn't fair," etc. I really couldn't say anything about it. I just let him talk. ... And I used to get the same thing from Scott. Here was a twenty-year-old greenhorn right in the middle of all this! ...
> Scott was an old fashioned painter and teacher. He was a very bright guy ... but he just didn't fit into the same milieu as Varley and Macdonald. ...
> And Scott kept a certain reserve with the students; this was quite different from Varley and Macdonald's interactions with them. For example, Jock had an end of the year party for the students. We whooped it up [at his place] until 2:00 A.M. and then Varley said, "Let's go down to the beach." [At the time, Varley was living at Jericho Beach.] We went to Varley's and danced, and then we went swimming. At 7:00 Mrs. Varley had breakfast ready.

The strains that Varley and Macdonald had been feeling at the V.S.D.A.A. came to a head when, as a way to deal with the worsening financial position of the school, the instructors' salaries were drastically reduced: Varley's by 60%, Macdonald's

by 57%, Grace Melvin's by 58 $^2/3$%; and Scott's by 33 $^1/3$%.[7] The cuts left Varley and Macdonald with extremely low salaries, and they were insulted and angered that Scott's reduction was so little in comparison. When the school board would not revise the cuts, Varley and Macdonald resigned and, with the Viennese artist and anthroposophist, Harry Täuber, started their own school—the B.C. College of Arts. (The college opened on 11 September 1933 in a converted showroom and garage at 1233 - 39 West Georgia.)

Apparently hoping to make his way to Hollywood and work in the film industry, in 1931 Harry Täuber "had blown into town like a zephyr from the mysterious East. His presence was espoused by the potential occultists. He started a class ... in *constructivismus, kinetismus, vorticismus*, and ... [joked Jack Shadbolt] everything but the Isthmus of Panama."[8] Täuber's credentials were impressive, as was his knowledge of metaphysics and avant-garde art theories. Vanderpant, Varley, and Macdonald surely concurred with Täuber's statement that the artist was to be a "spiritual pioneer, helping to bring the dawning of the creative age to come."[9]

The Vancouver sculptor, Beatrice Lennie, stated that Täuber "had a terrific impact" on the arts community and "opened doors that wouldn't have been opened otherwise."[10] She was probably referring to his lectures on art and the philosophies of P.D. Ouspensky and Rudolf Steiner; she may also have been referring to his classes in eurythmics—the students wearing black silk, Täuber a blue jumpsuit.[11] In 1968, Lennie described Täuber as being "way ahead of his time because things are just coming about now that he predicted. ... I remember everybody thinking he was mad when he talked about round houses."[12] According to Gerald Hall Tyler (secretary of the B.C. Society of Fine Arts during the 1930s), Täuber's ideas were

25 or 30 years ahead of their time in Canada. ... Täuber came ... full of ... new ideas ... [on] the interrelationship of art and architecture, the wholeness of art, which was one of the main approaches of the Bauhaus. Anything from a chair to a telephone was a work of art if it was designed properly, and this was all quite new and revolutionary.[13]

A Vancouver artist, Margaret Williams, noted that Täuber's teaching methods were unusual for the day: "He would put on music and you would express it in a design. ... He would give us a subject, say monumentality, and you'd express that."[14]

From 1933 to '35, Täuber gave five free lectures under the auspices of the college. Jack Shadbolt attended one

on the origins of culture. Täuber was hypnotic. We, as audience, sat on floor cushions ... titillated by snake-charmer Oriental music and the spectacle of a giant cross, projected onto a wall, with light rays quivering behind it. Täuber magically appeared at the top of a nine-foot pulpit: shaven head, dark clipped beard and jet-black eyes (one was glass) accentuated by an up-light. ... It was exotic and mystery-inducing. ... Ouspensky and Madame Blavatsky were new names to discuss.

A wave of interest in the occult ... in the art world of Vancouver seems to have risen about then.[15]

The years 1933 to '35 were marked by creative experimentation and increasing enrollment at the new college. Vanderpant supported the vision of the college, which Varley and the other instructors believed would "give our students what is a rare thing today and that is 'A Belief in something,' a belief which goes deep into life and becomes more radiant with the fuller understanding of its laws."[16] They thought the way to achieve their ends was in "drawing together from the East & West powerful forces of the art world, welding them together on the B.C. Coast—fusing Occident with Orient into one vast activity." Unfortunately, this goal, which Varley described as "practical,"[17] never had a firm monetary basis. The college was started through the generosity of patrons but had to compete with the firmly established V.S.D.A.A. for funding at a time when such support was limited. In May 1935, in what appears to have been a desperate plea, Varley wrote the assistant director of the National Gallery that the college was almost clear of

debts, but only because the whole staff have been staunch to us, working for next to nothing & nothing at all this last month except for the stenographer & janitor. ...

Frankly, if we do not receive recognition from some quarter in the next few weeks, we shall be forced to relinquish our hold. ... I've sold everything in my home in order to continue and we are literally down to the last cent. That goes for the 3 of us as Directors [Macdonald, Täuber, and Varley]. Three wise fools or blithering idiots. I wonder![18]

In spite of the school's creative programs, government and institutional backing was never secured. The college, a wonderful innovation "on the edge of entirely new adventures," collapsed.[19]

From its beginning to its demise, the B.C. College of Arts divided members of the arts community. People were perceived as supporting one school or the other. Vanderpant's ties to the college's instructors, his attendance at college functions and his photographs of activities at the school,[20] and the fact that Anna was a part-time student in 1933-'34, caused him to be viewed as a traitor to Scott and the V.S.D.A.A. The taking of sides caused a "great rift"[21] which was to have repercussions on Vanderpant and the rest of the community. Gerald Hall Tyler recalls that when the college opened the members of the two factions were not speaking to one another. Being "on both sides of the fence" he "was a sort of go-between" for what he called the "Scott faculty" and the "Varley faculty." He would be asked questions such as, "Have you seen so and so lately? What's he doing?" According to Tyler, he organized a luncheon and invited members of the two groups, without stating that the other parties would be present, and persuaded Scott and Macdonald to shake hands.[22] There was, however, never a complete reconciliation. Although the closure of the college ended most of the animosity, for some the split was permanent.

Art students were placed in the difficult position of having to choose between the two schools. In a diary entry, Rowena Morell wrote:

An upsetting day. Mr. Varley and Mr. Macdonald are leaving the school and starting one of their own next term. ... Rather mean on poor Mr. Scott. I think he doesn't know yet. V[arley] and M[acdonald] ... are the best teachers we have. I don't know what I shall do.[23]

Bertram C. Binning, a graduate of the V.S.D.A.A., was also faced with a difficult decision. Scott offered Binning a teaching position, but Binning did not want to alienate his former instructors. According to a friend and fellow art student, Pindy Barford, "It was a real dilemma for him. We'd go for walks, and he'd say he didn't know what to do."[24] In the end, Binning took the job at the newly named Vancouver School of Art. Irene Hoffar was also hired, but found that her teaching position strained her friendship with Vera Weatherbie, who was working as Varley's assistant at the college. She recalled that

it was a confusing time for the students and the staff. ... Mr. Scott had organized the art school and to have it break up must have been hard on him. He was left without a teaching staff. I never heard him say anything about it though. The art community and students, however, were divided over which school to support. ... [One example of how the community took sides is that] Mortimer-Lamb was a friend and admirer of Varley's, but I think he felt that Varley had not been fair to Mr. Scott.

[In 1933] I had a studio on Granville Street near Dunsmuir. I had heard about the new B.C. College of Art from Vera [Weatherbie]. But I really hadn't taken in what was actually happening until Mr. Scott came to my studio and asked me if I'd teach [at the Vancouver School of Art]. I decided that I would. Vera was ... at the B.C. College of Art and that led to the feeling that she and I were in different camps.

The other school [the B.C. College of Arts] seemed to me to be more glamorous. Täuber was teaching there, and I would hear of many interesting things being done, and we [at the Vancouver School of Art] seemed to be behind the times. I went to see the college's production of "Volpone," which was marvellous, and went to the college several other times, but always felt guilty and that if Mr. Scott knew I was there he'd think I was not loyal. The situation was also very difficult because I didn't see Vera [who had been a friend since art school] very often. It was a trying time.

The collapse of the B.C. College of Arts healed some of the wounds incurred in 1933, but it opened others. According to

Gerald Hall Tyler, "Varley ... left Jock [Macdonald] holding the bag" for the college's debts; this broke the bond between the two and it was, apparently, never mended.[25] Both painters were destitute, and both left Vancouver. Macdonald and his family, Täuber and another young artist, Leslie Planta, moved to Nootka Sound, on Vancouver Island. Macdonald returned to Vancouver in 1936 and undertook a number of poorly paid and unsatisfying teaching positions.[26] In 1946 he moved to Calgary, and then from 1947 to his death he taught at the Ontario College of Art. In those years he became known as a master teacher. Täuber also left B.C., and was never heard from again.

Varley, the "revolutionary" who had "*laid the foundation stone of imaginative and creative painting in British Columbia,*"[27] now found life there impossible: his relationship with Vera Weatherbie, which had contributed to the breakdown of his marriage, was strained; he was unemployed and unable to sell paintings due to the poor economy, and his financial position became desperate. Varley turned to the National Gallery and on 23 February 1936 he wrote H.O. McCurry of his plight:

After 9 years trying to buoyantly float a worth while [*sic*] craft, I am stranded in the flats surrounded by indolent and sleepy natives who yawn at me with more or less disinterested curiosity.

I cannot get off here without a rope of some kind. In fact I cannot get away without a suit of clothes. This, my only suit is worse than threadbare and I would be put to the blush if I had to appear so naked in the open. I hate to tell anyone this but I am out of everything usually looked upon as necessities and my once lusty cries are all but drowned in the growling threats of creditors demanding their dues—I fear they want to devour me for I have nothing to give them. ... However, I'm calling out again in another direction.

I've lots of work to buy money with and once on my feet I can make good. What can I do in Ottawa? I can put on a show of drawings and sketches ... with a view to selling and getting, if possible, portrait commissions. ... Also, I can teach and lecture. ... The main thing is to pay my way in order to paint more. ...

Can it be possible for me to do this in Ottawa? If there is a ghost of a chance, please do your best swiftly. New surroundings and comradeship will give me renewed vitality.[28]

Vanderpant was distressed by Varley's situation. On 23 February 1936 Vanderpant wrote to Eric Brown to support Varley's request for assistance. He concluded the letter with a reference to divine guidance that was obviously meant to appeal to Brown's Christian Science beliefs:

Fred was here for supper last night. He has told me about his correspondence with you and Mr. McCurry.

Humanly speaking he seems at the end of the rope. He has to vacate his Lynn [Valley] Studio and where can he go? Even his clothes are turning him out.

... Have you ever considered engaging for the Gallery an educational instructor[,] one who gives arranged afternoon talks and who for certain hours daily leads visitors around to help aesthetic understanding? ...

One who has had such influence to the artistic good upon this community, seems to be deserving of support. He has mellowed much and is just a genuine human trying to do what he conceives as right.

He does not know that I am writing you and there is no need for an answer to me. I am just responding to an urge knowing the one source of all guidance will prevail in the solution of this individual problem.[29]

On 21 March 1936 Vanderpant wrote the following to McCurry:

Your lines of March 13th concerning Varley invite a reply. There certainly is support needed and to my mind not in the form of charity but in the opening of some definite opportunity in new fields in recognition of the great influence to the good Fred has had and is having in these parts.

Now his idea was to come to Ottawa, confident that in the field of politicians and statesmen some commissions could be had—if need be this combined with teaching. And

I feel he should do portraits—he did a fine thing of Mortimer-Lamb and possibly one of his finest of myself—this in return for assistance already given.[30] But even the activity with these portraits has made him a different man—with more courage again. ...

... I suggested [to Eric Brown] the possibility of creating at least a temporary job for him in Ottawa. ... It would keep Fred going for awhile and meantime he could try and establish contacts, possibly with the assistance of the Gallery. Or if you could find him one or two commissions—what is wrong with the Prime Minister?—he could then build up on that. I think that even temporarily a new environment is needed and supposing he did succeed in doing some fine things there—that again would shake up the sleepers in this community—even to the extent of having themselves painted because Mr. So and So and So and So had been done by him. ... The sale of some of his work now in Ottawa would enable him to make the trip.

From an official angle I feel that the Gallery is justified in supporting a proved man who is really despairing under the strain of lack—lack of moral support as well as financial ...

Figure 41. *Portrait of John Vanderpant* CIRCA *1930, by F.H. Varley, oil on panel;* PRIVATE COLLECTION; TRANSPARENCY COURTESY OF PETER VARLEY.

To me he is a lovely character, artist always, and he has forgotten the bad habit of manipulating other liquids than paints and terps.

I am urging you to do the best you can for him in the conditions and circumstances you have to consider. Not for the sake of person—but for the sake of art.[31]

Three days later McCurry telegraphed Vanderpant to say that if Varley would accept a "modest price" for his self-portrait, he could be sent enough money to get him to Ottawa. The next day (25 March) Vanderpant wrote McCurry:

We are all grateful ... I feel sure that this will mean a successful turning point in the career of a great painter. ...

Fred is going to bring as many sketches and drawings as possible—the sale of some of which should keep him going. ...

I am sending enclosed some glossy prints of Fred in case you feel it wise to give him advance publicity. This in view of possible commissions may be good. It may also be good to ask local papers to send a reporter upon his arrival. ...

To Mr. Helders I am writing as a friend to see if he can arrange the same reduced rate as they gave me—[at the Chateau Laurier] so that at the start he will have a good domicile.[32]

Varley left Vancouver with "a great send-off" from Vanderpant and his wife, and Phil Surrey and his mother.[33] Vanderpant also gave him a friendly contact in Johan Helders and a "heavy fur coat."[34] The two corresponded over the next two years, and from those letters it is clear that they remained close friends.

Upon his arrival in Ottawa Varley was commissioned to paint a portrait of H.S. Southam. McCurry wrote Vanderpant that Varley was "hard at work," and that he was "greatly impressed" with his work.[35] Although Varley was pining for the B.C. landscape that he so loved, his start in Ottawa boded well. He sold ten landscapes to Southam and began work on a huge painting titled "Liberation." Varley's financial and emotional difficulties, however, were far from over. From their letters it is clear that Vanderpant continued to assist Varley in a number of ways. First, he was a simple sounding board: a friend to whom Varley could

express his loneliness and concerns. Second, the two men had entered into a creative venture (probably Vanderpant's idea) that helped Varley through some lean times. While Varley was still in Vancouver, Vanderpant had photographed a number of his sketches. Varley sold the prints for five dollars apiece, or in sets. Varley wrote Phil Surrey that the prints were "*well mounted & quite liked. ... That explains how... son John and I have kept going. He sold about 40 of them ... [and] the National Gallery will have some.*"[36]

On 3 November 1937, Varley wrote Vanderpant to say that he only had "six prints" and "one complete set" left. He asked Vanderpant to send "a few complete sets" and said that he would do his "best at this end."[37] Payment for the work was not discussed and it seems likely that Vanderpant was happy simply to know that he was helping his friend. Varley often thumbprinted and then signed his work. The fact that some of the prints also carried Vanderpant's thumbprint and signature acknowledged his art and was probably a gesture of the mutual affection, respect, and humour the two shared.[38]

Vanderpant also helped Varley by keeping in touch with and helping his family, who were then living in Lynn Valley, North Vancouver. On one occasion, the Vanderpants checked on the family and, discovering that there was little food in the house, immediately bought some groceries.[39] A few months after his departure, Varley wrote: "I am awfully glad you keep in contact with Mrs. V[arley] and Peter."[40] A year and a half later Varley wrote: "I am confident I shall be able to look after Mrs. Varley as she deserves. ... I cannot express here my appreciation of your recognition of our problems and the lovely way you have helped us all."[41]

Vanderpant continued to be a sympathetic ear for Varley's frustrations, worries, and successes. He was also the recipient of a number of complaints and cautions about Varley. When Varley began thinking of a return to B.C., which he did briefly in 1937, Brown wrote Vanderpant: "I presume you have done your best to offset his return."[42] Helders originally welcomed Varley because, as he wrote to Vanderpant, "Your friends are my friends, John," and "nearly every Sunday he [Varley] ... goes fishing with us." By November 1936, however, Helders wrote that Varley was "sore" because Helders had refused to lend him

money.[43] Through it all, Vanderpant was there to soothe and lend support, in any way possible, to Varley, his family, and his contacts in Ottawa.

The two men corresponded until April 1938 and their letters convey a deep affection. In what was probably a response to a 1936 Christmas card from Vanderpant, the print titled "Honestly, Honesty," Varley wrote: "Honestly, honesty, honest John, Whew! you wonderful man to be the essences of all that."[44] Varley also tried to provide encouragement for Vanderpant who was feeling the financial pinch of the Depression and a growing sense of artistic isolation. Months earlier, he had written that he was "very sorry things are so dead in Vancouver. Write to me & tell me about yourself."[45]

Not all of what Vanderpant confided to his friend is known, as some letters have been lost; however, Vanderpant seems not to have revealed the severity of his hardships. In 1937, at the age of 53, his health was beginning to decline with the early stages of lung cancer. Over the next two years, he quit exhibiting his work and, finally, had to forego photography altogether. His participation in the arts community was reduced to giving lectures. He rarely had stimulating interactions with other artists after the close of the B.C. College of Arts, and in 1936 Jock Macdonald described Vancouver's artistic climate as being "as dead as an Egyptian mummy, as lifeless as a pickled herring, and ... [like] a stagnant cesspool."[46]

Trying to buoy Vanderpant's spirits Varley wrote: "You ... are living in the wonder-spot for work & progress. ... I hope you are getting a great thrill out of whatever work you are moved to do. Is it almost time to publish some of your verse?"[47] In November 1937, Varley wrote Phil Surrey that "Vanderpant is almost resigned to drab conditions which really is not like him."[48] Varley seems to have been unaware of Vanderpant's illness. His last letter to Vanderpant was an attempt to cheer his friend, but he did not know that Vanderpant was no longer able to do photographic work. Varley wrote:

Comment ca va—Do you wake up in the mornings full of song with lots of work to fill the day or weary you for rest at night? Or does the main song squander its notes in poetry and preparation of lectures?[49]

Vanderpant's reply was never completed, and it seems that the two did not correspond again. The unfinished letter indicates that, rather than dwelling on his problems, Vanderpant was still concerned with the plights of others and offering support. He had just written a letter of reference for Varley's son, John, and said he was

> sure if John gets that job ... it will be the most lovely solution for both of you. It will make a man of John—lack of self-support—without blame of course—is driving him into indifference, or rather in a state of unnatural and uninspiring neutrality which in the long run must be destructive. All concerned did what could be done—so the final result should not disappoint.[50]

Unlike Vanderpant's normally vivacious letters, this one has a somber tone. Like Carr, Varley, and Macdonald, Vanderpant was to suffer a physical breakdown that was, in part, attributable to the strains of the Depression. In 1937, "overworked and consistently having to make financial shortcuts," Carr had a heart attack from which she never fully recovered; "Varley had severe personal and financial difficulties," after the closure of the college; and overwork and undernourishment took its toll on Macdonald.[51] In 1937 Vanderpant attributed his cancer to a lack of "balance." In an untitled poem (dated only May 13 and found in a Venetian Parchment Vellum writing pad) he described himself as having "Not a penny to my credit / Not a dollar in the bank," and went on to say that under such circumstances "life is rough." In his unfinished 1938 letter to Varley, Vanderpant wrote:

> I have been roaming around this winter and ... seeming injustices in Europe... [and] the giving up of idealism to brute power have made me for a while very unhappy and of course this was reflected in poor physical conditions. I am getting out from under just by trying to rise above them and it is the only right way not only to correct self but also to help the state of thought generally! This probably is the reason why I did not write at all these months. I am ashamed the way I neglected Phil [Surrey], but I just could not come to set my pen going. He deserves better and

meeting him you may tell him that nothing of course has changed in the appreciation of his friendship and qualities.[52]

Vanderpant went on to say, "This seems a strange letter." Indeed it was: illness and financial hardship were taking their toll. His closest friends had moved away or were, like Macdonald, enduring difficult circumstances, and his relationships with many local artists had cooled due to his association with the "Varley faculty."[53] Charles Scott, in particular, appears to have remained resentful. Prior to the opening of the B.C. College of Arts, Scott had exhibited work at the Vanderpant Galleries and he and his wife had "often visited."[54] (It is interesting to note that, according to Anna, the Scotts were never invited to visit on the same occasions as the Varleys or the Macdonalds.) Anna remembers that her father and Scott "were friends until the college was formed."

In 1934 Vanderpant wrote the assistant director of the National Gallery that "contact with Scott I am sorry to say has not been reestablished yet—but it can only be a matter of time where good will on this side is so strong."[55] Vanderpant's optimism proved incorrect. Two years later he wrote the assistant director that a lecture he had given at the Vancouver Art Gallery had been "slightly slighted" by Scott.

> There was no reason for a special student entertainment at Mr. Scott's that same evening. He had also invited several Arts and Letters Club members who otherwise would have gone to the lecture. Mr. Scott is a member of the educational committee of the art gallery and also an executive member. The lecture was decided upon some 4 weeks before it took place. All one can say—it should either have been postponed or Mr. Scott should have chosen another evening for his entertainment. ... The old beliefs of the disadvantage of the local man, specially when he is guided to take a stand in certain so-called conflicts, has been well indulged in it is clear to me. We did our best and many phone requests for a repeat came in. It is under any conditions a privilege to serve in the cause of good and as such I look back upon this local experience—and not backward any longer for in the now is our progress. I know you will

see local conditions in the right light—otherwise I would not have mentioned this disappointing point.[56]

Further disappointments were to mark his final years. In 1937 Vanderpant complained that he had not heard from the National Gallery "for a year. Somehow unless the West jolly well shouts that it is there—it seems soon forgotten."[57] Remarks made to him a year earlier in a letter from H.O. McCurry were also a cause for dismay. McCurry wrote that "Canada is moving into a new era and fresh impulses are felt in the East a long time before they get across the mountains to you."[58] Vanderpant had been one of Canada's freshest "impulses" in the early 1930s. In 1931, Eric Brown had described him as "the most artistic photographer in this country ... [and] one of the foremost in the world."[59] In 1937 Jock Macdonald thought him "the only 'living' being" in Vancouver, a person who "radiates personality," and whose work "steadily increases in aesthetics."[60] Unfortunately, the end of the decade was to be frustrating and lonely for Vanderpant. Although his spirit was weakened, he endured and continued to "cry" out. As he wrote to McCurry:

I am kept busy with service clubs, high schools etc. and last night addressed—what a miserable word—the Arts and Letters Club. I make an occasional portrait, try to shake the chains that are holding me in such [a] limited field and I often remember the lovely experience of the lecture and judging trip east.[61]

Vanderpant hoped to tour the country again, lecturing under the auspices of the National Gallery. He also hoped to serve again as judge for the Canadian International Salon of Photographic Art. He was not asked to do either. Through his unending determination, he did organize a lecture tour of Alberta in 1937.[62]

Vanderpant also continued to take an active interest in his fellow artists. In 1936 he lamented that he had "failed to contact Emily [Carr]" while in Victoria.[63] In 1937 he wrote the National Gallery regarding one of Macdonald's paintings, "Indian Funeral" or "Pacific Commerce," both of which had been accepted for the Coronation Exhibition in England.[64] Vanderpant stated that

Macdonald ... did to my mind a splendid thing for the London selection. What striking composition;... grand is the mountain distance as a liberation of limited thought. It is ... splendidly painted and of fine color. I hope you will take a special look at it and when it returns from Europe hang it in the National Gallery. I hope you agree with its values.[65]

In the late 1930s, with the Depression severely affecting his business, Vanderpant had to devise creative ways to advertise. In an undated, rough draft of a letter to W.G. Murrin (president of the B.C. Electric Railway and second president of the Vancouver Art Gallery Association), he wrote: "Last season in winter setting I took a view of your home which I think would make an interesting Christmas card. I am sending you an enclosed sample and wonder if you would be interested in having some finished." In another draft, he wrote: "While passing your home last winter I photographed your two dogs through the gate. As this may make a Xmas card to your liking I am sending you a sample under separate cover & shall be glad to hear from you."

In a further effort to generate business, Vanderpant opened a "showroom" in the Georgia Hotel in November 1936. Anna and Carina were "looking after" the prints on exhibition, answering queries, and directing prospective clients to the Galleries. In March 1937, Vanderpant stated that the venture "may not be permanent," and it closed shortly thereafter.[66]

Vanderpant's most poignant remarks on his emotional and financial state survive in an undated fragment in a notebook. Whether it was a draft of a letter and, if so, for whom it was intended, or if it was ever sent is not known. It may have been merely an attempt to sort out his thoughts and feelings—a form of prayer intended to bring him guidance. He wrote:

Having a grave problem to face—which I don't seem to be able to solve. I take liberty to ask your opinion—suggestion—help in the following delirium.

Why is it that with a ... reputation I am unable to make in Vancouver a living?

Why is it—that one practising the golden rule—trying always to give good work—service— ... has to worry about tomorrow?

Why is it that Vancouver is indifferent to one who through exhibition and lecturing tries to keep the name of Vancouver intellectually before this continent?

Why is it that one who should experiment in color work—candid camera work, etc.—simply cannot do it because local financial support is insufficient?

These are a few of countless worries—which at times are a decided hardship to one's expressive progress. Must one leave … [a] province one loves for its beauty to find support elsewhere adequate to meet unselfish—and only right desires?

I shall be grateful with any suggestions you may care to make.

The answer to his invocation appeared in the prospect of photographing Lord Tweedsmuir, the Governor General of Canada from 1935 to 1940. Yousuf Karsh's successful portraits of the previous Governor General and his wife, Lord and Lady Bessborough, seem to have led Vanderpant to believe that a commission for Tweedsmuir and his wife would bring other prestigious Canadians to the Vanderpant Galleries. Prior to the Tweedsmuirs' 1936 visit to B.C., and in anticipation of photographing them Vanderpant "papered and painted" the entire studio at his own expense. His effort proved futile because "the Tweedsmuirs did not show up, partly my own mistake through not getting early enough in touch with their local aide. One pays a price for inexperience in official matters! It was quite a blow!"[67]

Vanderpant's plight and the hardships endured by artist friends such as Carr, Macdonald, and Varley likely prompted him to write the following sardonic lines:

The Poor Contemporary
A buoyant artist (one can hardly laugh or blame
him for his pride) called at the hall of fame
and knocked … no answer … knocked with care again …
then somewhere asked a voice: "Can you explain

why this abode should open to your glam'rous claim
and in its golden halls, your greatness entertain?"
"Well," spake the artist, "Did I paint and work in vain
there are a hundred noble works signed with my name!"

Then looked he wond'ring at the great blind walls, no door
or window opened to his ent'ring, so he knocked again:
"Would please for once the voice its silence now explain?"

And through the golden dome it did respond once more:
"My artist friend, you are not wholly bad, not that,
but too alive; to enter here you must be dead!"

His family and spiritual beliefs sustained Vanderpant in his final years. In 1936, on their 25th wedding anniversary, he presented Catharina with a bouquet of flowers and a special note in which he wrote that the flowers symbolized "the good and love you have given these many years." In what was obviously a reference to the loss of their Drummond Drive home, he lamented that he had not given her the

human happiness you should have had—still—I have intended to do my best and tried to support you in your effort to understand life aright.

We must not measure experience by hours and years if we will … support a happiness more sublime than the human hand of man can grasp.

I am grateful to you for all you did for the girls and me and … Love will unfold it to you and reward you with the full measure you so deserve.

In 1939, just prior to his death, he wrote Catharina another anniversary message "from the old sweetheart." He could only manage one line, a parting appreciation for her "patience and love and … 28 years of gallant support."[68]

At his wife's urging, Vanderpant made a few trips to a Christian Science healing centre in Victoria.[69] While he struggled to continue his commercial work in order to provide for the family, doing so became increasingly difficult. Anna recalls that he tired ever more easily: "Sometimes, when working on touch-ups, he would become too tired to continue. He would look away, and I would have to take over." Vanderpant eventually turned the business over to his daughters. He then spent his days writing prose and poetry and trying to remain sanguine. In turn, his wife "tried to be brave" and "prayed and prayed."[70]

In 1938 the Vancouver painter, Nan Cheney, noted that "Mr. Vanderpant looks very ill—he is very thin & a grey yellow colour. ... [H]e does not seem at all worried."[71] The source of his fortitude is best described in one of his poems:

> I know,
> Eternity is the curving line,
> Where no beginning was
> Nor end will be;
> Without repeat of action
> Or retrace,
> And all I have to do
> Is keep in curving with the line
> Or readjust my being
> When fallen out of line.

In his final days, Vanderpant's faith helped him to accept his fate calmly. One morning as Anna straightened her father's bed, in a voice as frail as his wasted body, he tearfully whispered that he did not want to die. Anna recalls that

> there was no time to think about what to say. I wanted to soothe him and the words just came. I asked, "Do you remember being born?"
> He replied, "No."
> I said, "Well, as it was when you were born, so it will be when you die." I could see him thinking it over—the wheels turning. A few days later, [24 July 1939] he died peacefully.

Anna's response was a reflection of the religious principles by which she had been raised. Vanderpant was consoled by the belief that he was moving to a new level of consciousness—something he had sought to attain in his life and his work. In January 1940 the Vanderpant family sent out their Christmas and New Year's greetings. The image on the cards was Vanderpant's "Spring on a Platter" (Figure 42). The choice of that print had personal significance for the family, and the image is representative of the ways in which Vanderpant's religious beliefs inspired his work. The circular pattern of the forms, their

Figure 42. *"Spring on a Platter"* (n.d.).

ascension to a life-sustaining and chalice-shaped vessel, and the symbol of spring and rebirth, represented by the flowers, adds a new dimension to an otherwise ordinary stack of dishes.

For 20 years, 1919 to 1939, Vanderpant was at the centre of a whirlwind of innovation on Canada's west coast. Like a beacon he had offered the light of artistic, emotional, intellectual, and spiritual encouragement. With his death, Canada lost one of the era's great photographic talents and leading proponents of modernism. Vanderpant left a unique legacy: his photographs, negatives, lantern slides, and writings; and a significant contribution to the cultural development of this country. These will be a continuing source of study and a cherished treasure in Canadian history.

In his prints, Vanderpant sought to reveal the "wonderland—full of hidden beauty" that lies hidden beneath the physical exteriors of people and objects. His interpretations of that beauty give his work an "underlying vibration" that continues to stir the imagination. His influence on the west coast also went beyond the superficial and carried an underlying vibration that reverberates through our cultural history. Vanderpant's legacy is a reflection of the man and his era; his work helps us to discern the shadows of the past while reflecting on the present.

Underlying Vibrations

A Portfolio

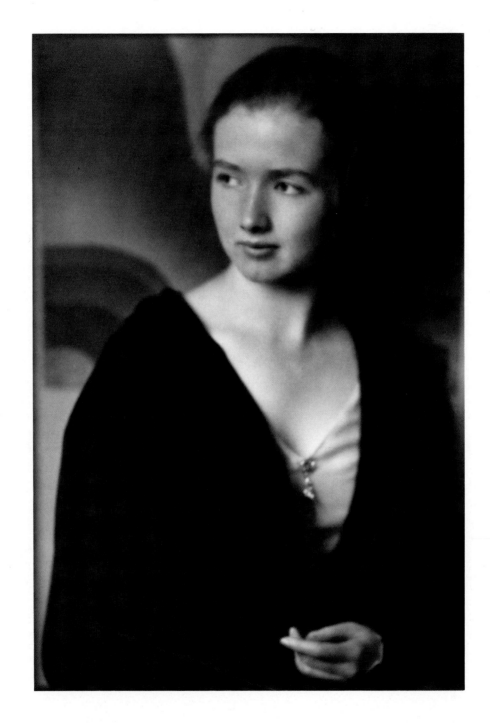

Plate 1. Untitled (thought to be a student at the V.S.D.A.A., A. Bonnycastle), n.d.

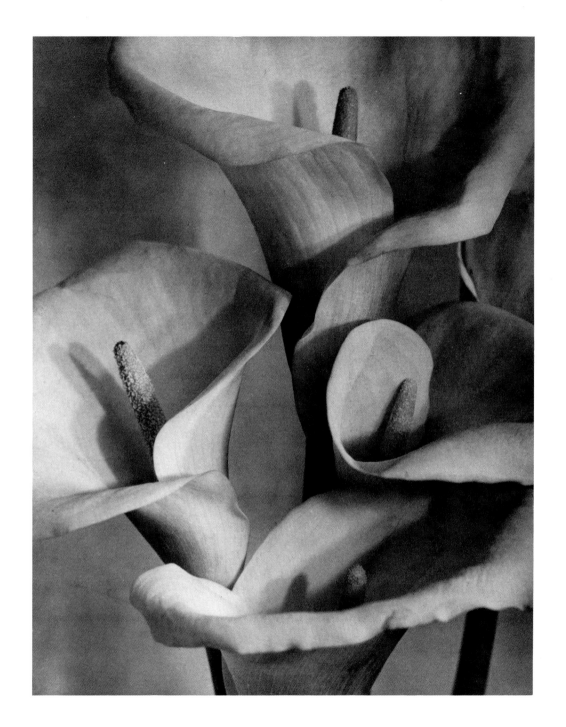

Plate 2. Floral Rhythm, 1935.

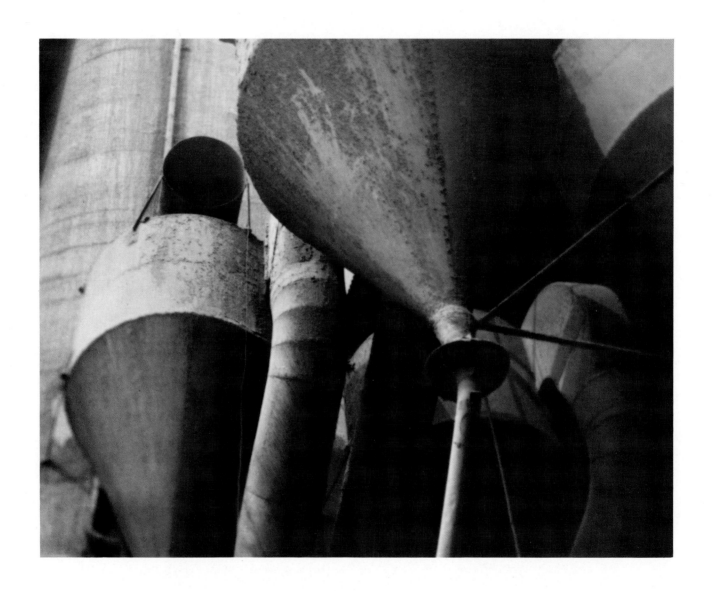

Plate 3. Essentials, 1929.

Plate 4. Grapefruit, n.d.

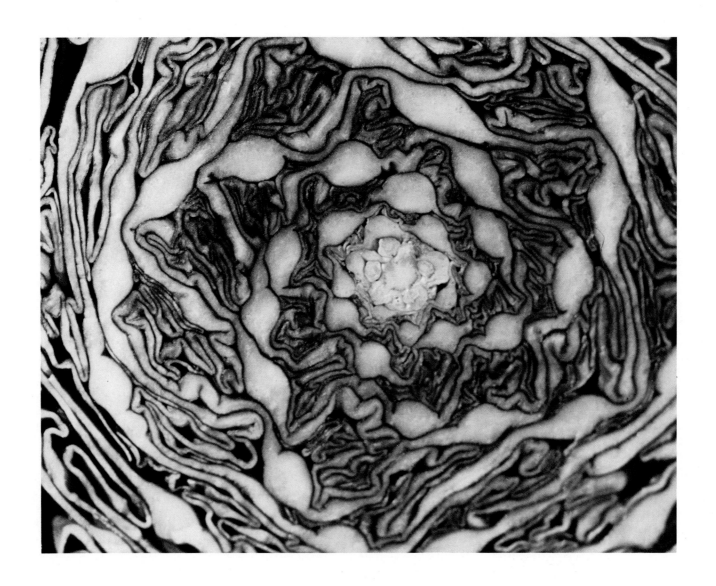

Plate 5. Heart of a Cabbage, *ca.* 1929-1930.

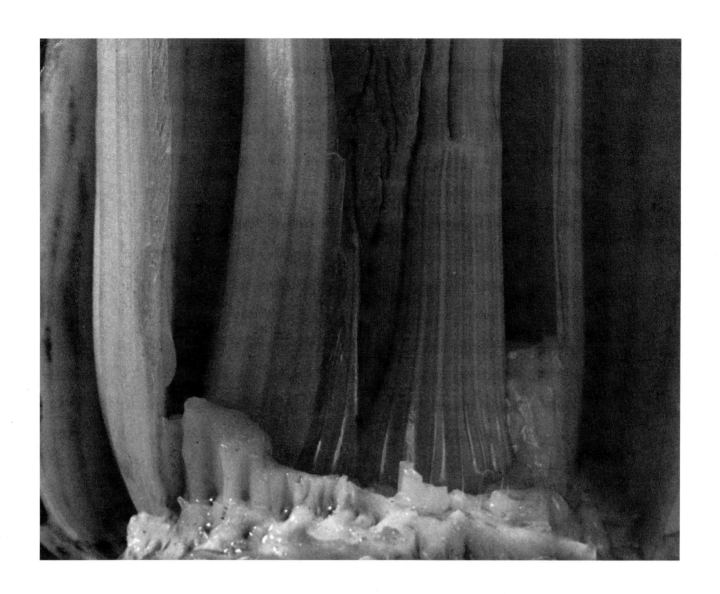

Plate 6. Mystery Stage, 1937.

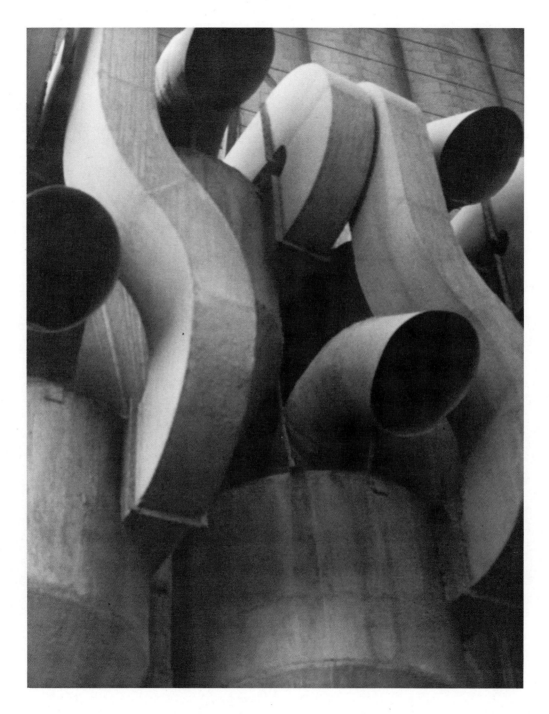

Plate 7. Untitled (cyclone ducts), n.d.

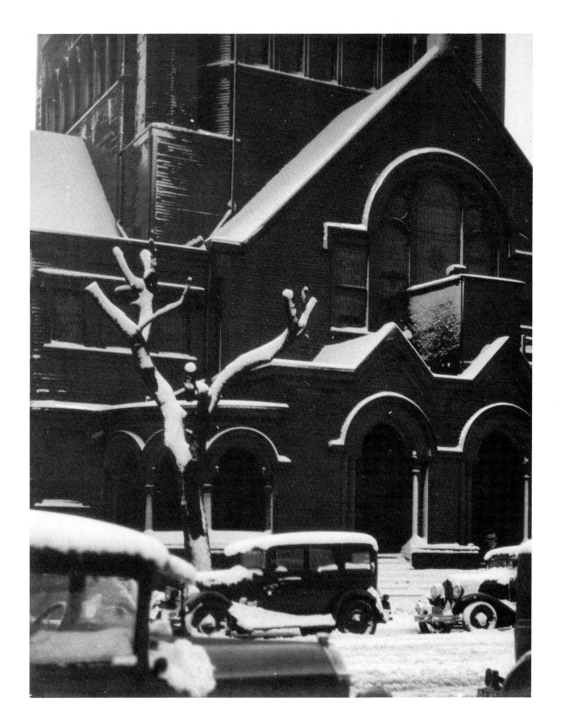

Plate 8. Untitled (variant of Winter's Design), n.d.

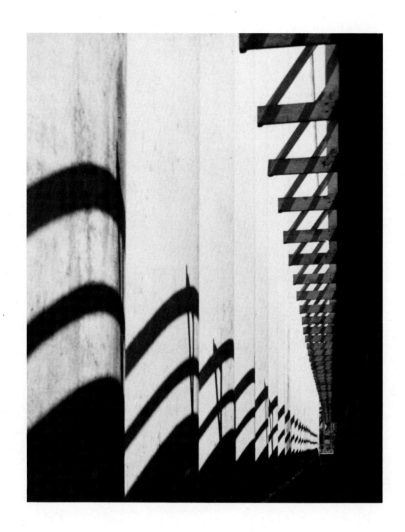

Plate 9. Curving Shadows, 1934.

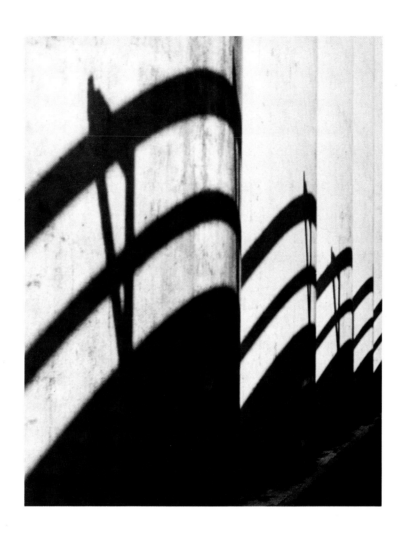

Plate 10. Untitled (Curving Shadows II), 1934.

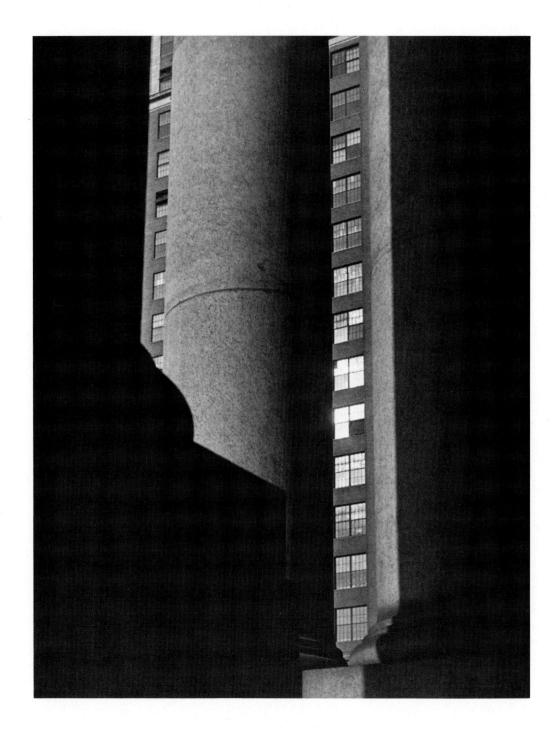

Plate 11. City Forms, 1935.

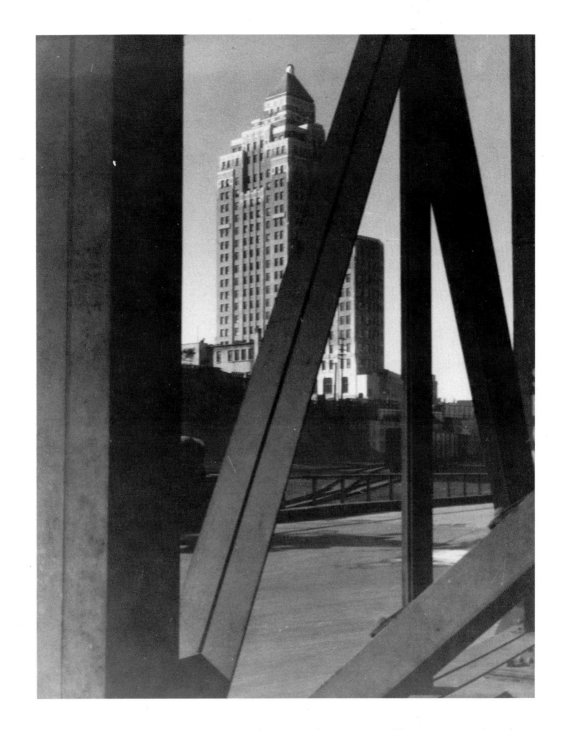

Plate 12. Untitled (variant of Steel and Stone—the Marine Building, Vancouver), n.d.

Plate 13. Winter's Stucco (view of Burrard Street Bridge, Vancouver), n.d.

Plate 14. The Fence Casts a Shadow, 1934.

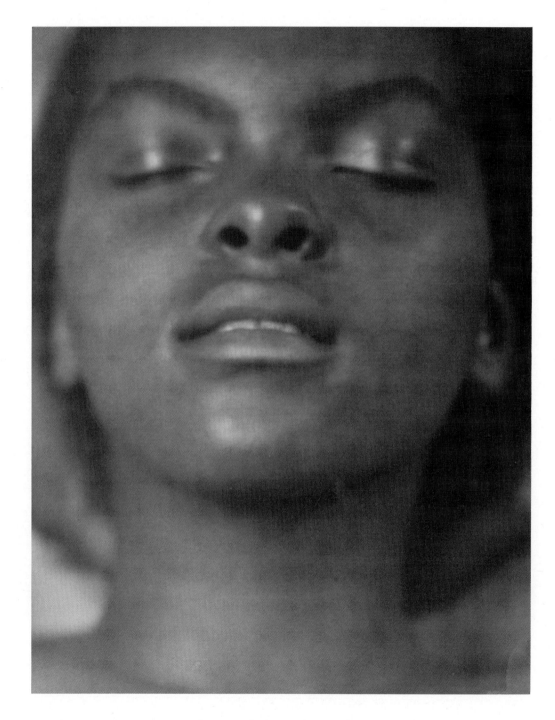

Plate 15. Ebony Mask, *ca.* 1932.

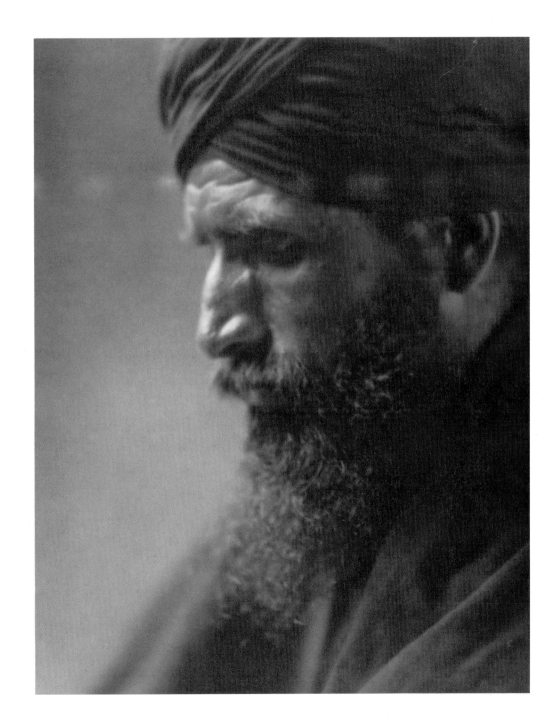

Plate 16. A Son of the East, 1924.

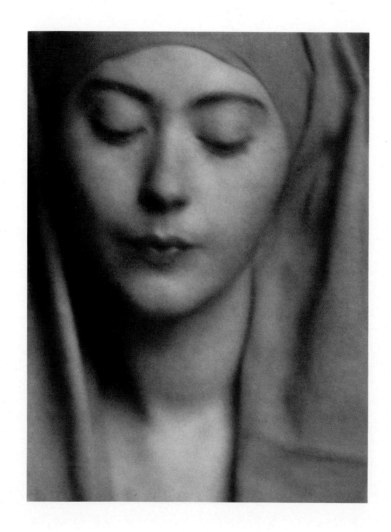

Plate 17. Vera, 1930.

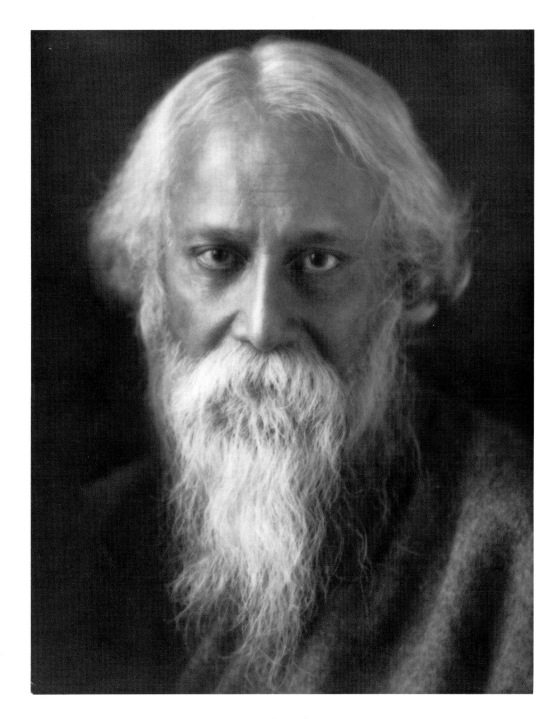

Plate 18. Rabindranath Tagore, 1929.

Plate 19. Intimate Design, 1929.

Plate 20. Curvature, n.d.

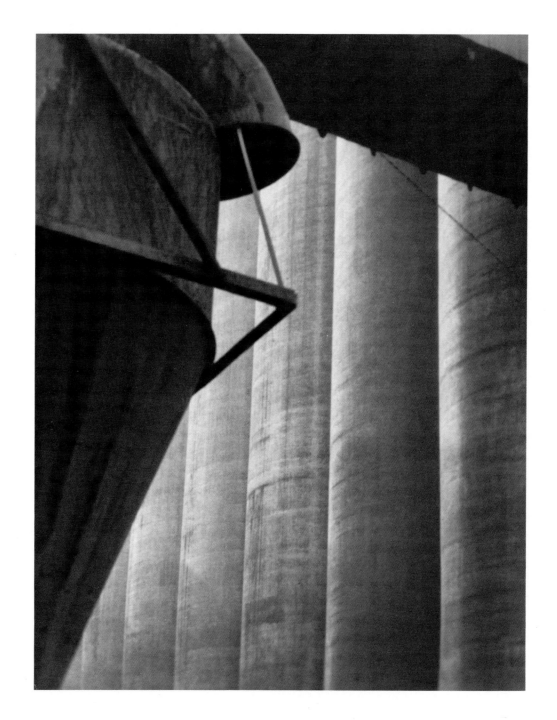

Plate 21. Towers of Today, 1929.

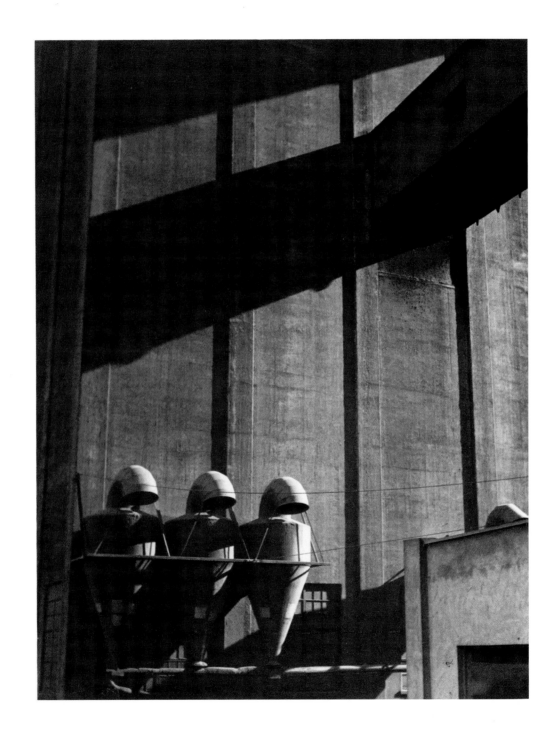

Plate 22. Three Brothers, 1929.

Plate 23. A Chat, n.d.

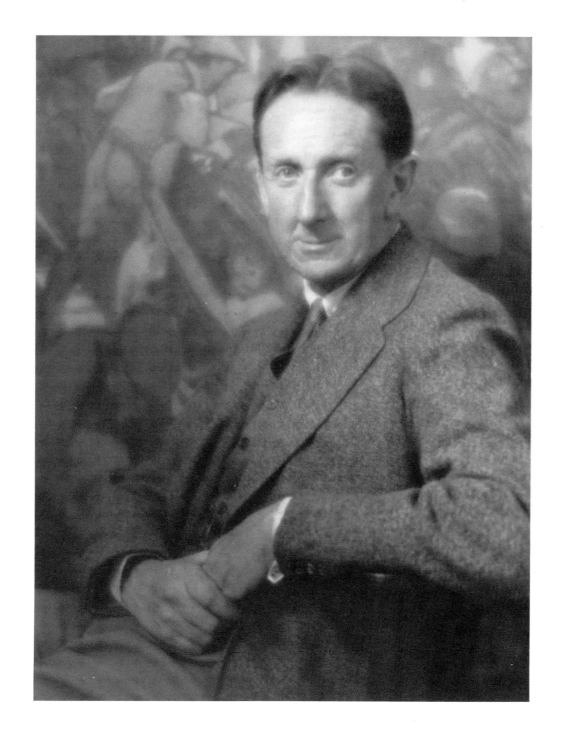

Plate 24. Eric Brown, 1927.

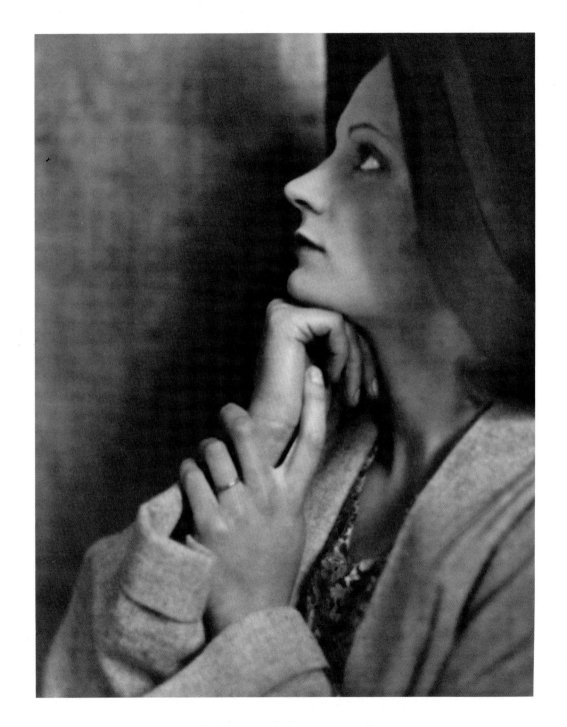

Plate 25. Untitled (portrait), n.d.

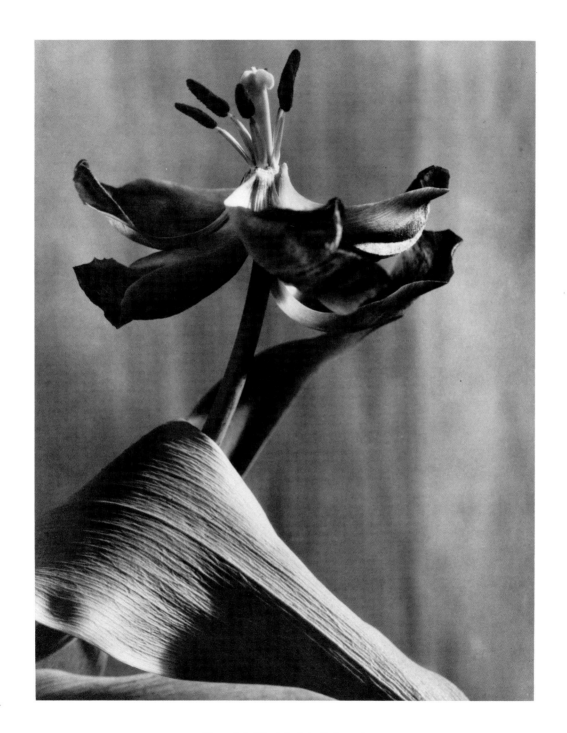

Plate 26. Untitled (tulip), n.d.

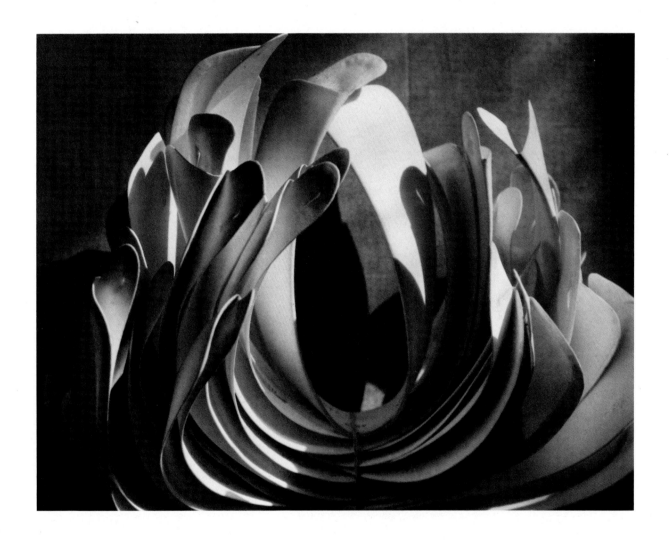

Plate 27. Expression in Form, 1931.

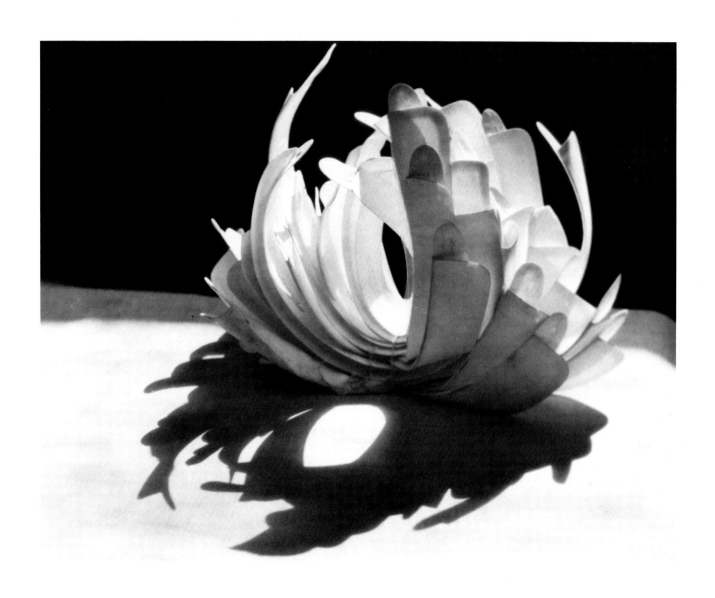

Plate 28. Cactus Collaratus, 1931.

Plate 29. Peacock Pride, n.d.

Plate 30. Untitled (curtained window), 1935.

Plate 31. Summer Riches, 1934.

Plate 32. Home Sweet Home, 1935.

Plate 33. Angles of Quebec, *ca.* 1929-1930.

Plate 34. Untitled (wire fence and elevators), *ca.* 1929-1930.

Plate 35. The Watchman, *ca.* 1934-1935.

Plate 36. Shadow Castle, *ca.* 1926.

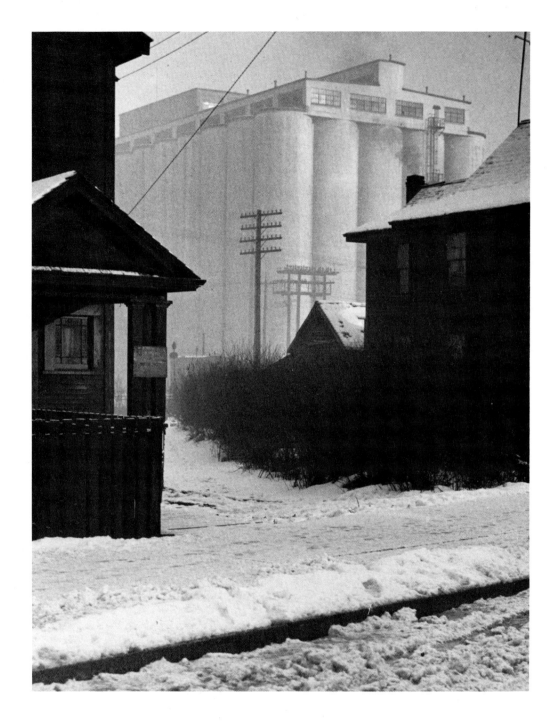

Plate 37. Untitled (houses and elevators), 1934.

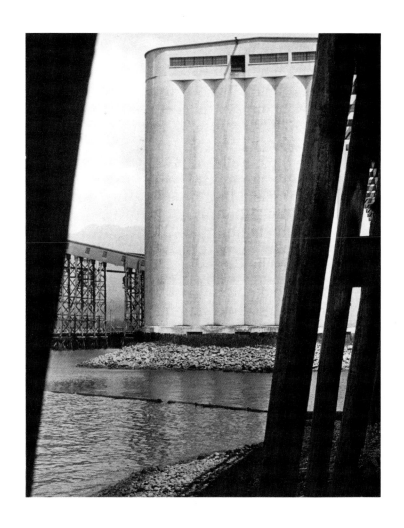

Plate 38. Modern Egypt, n.d.

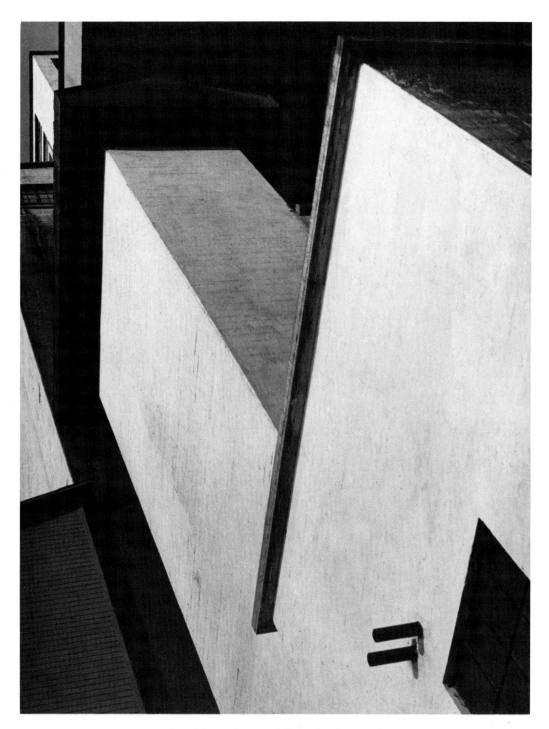

Plate 39. Angles in Black and White, n.d.

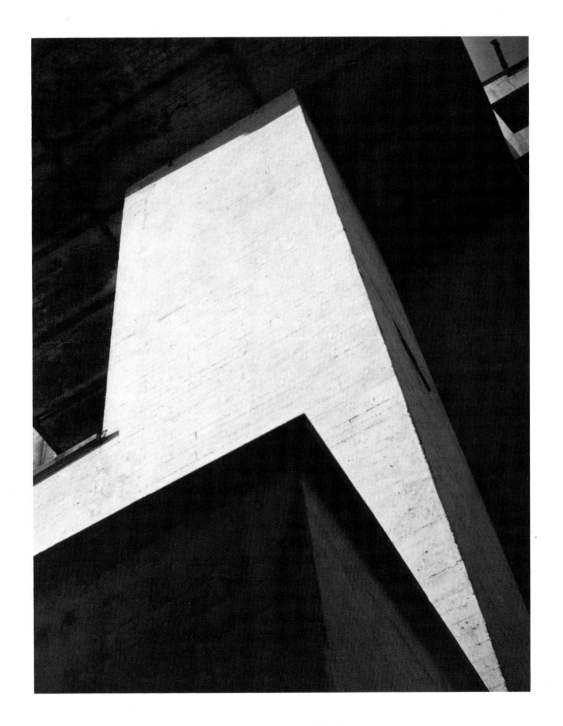

Plate 40. Strength, n.d.

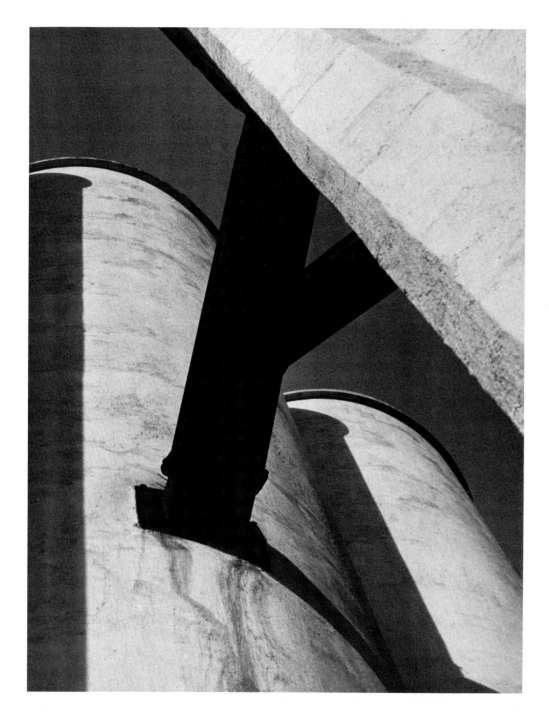

Plate 41. Concrete Power, 1934.

Plate 42. Concrete, 1934.

Plate 43. Spirit and Matter, 1935.

Plate 44. Unfair Competition, 1925.

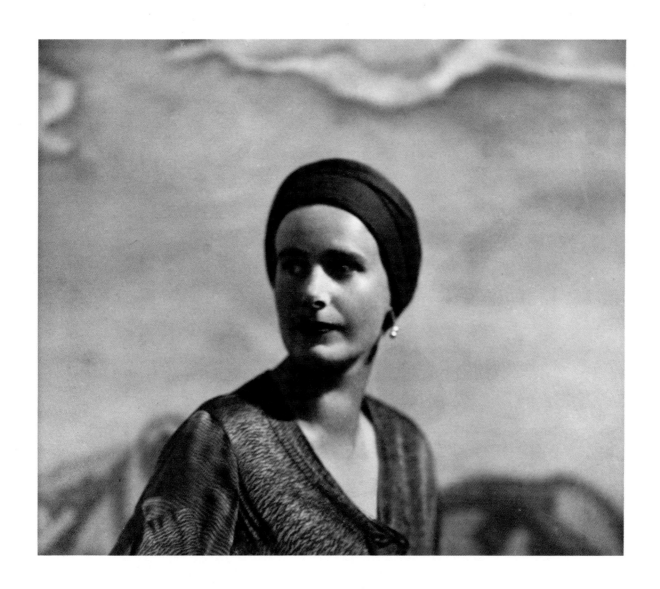

Plate 45. à la Garbo (portrait of V. Dekking), n.d.

Plate 46. A.Y. Jackson, n.d.

Plate 47. Bliss Carman, 1929.

Plate 48. Untitled (actor's profile, portrait of a Vancouver actor, thought to be M. Waring), n.d.

Plate 49. Nasturtium, n.d.

Plate 50. Raindrops, n.d.

Plate 51. Abundance, n.d.

Plate 52. Untitled (variant of Mushrooms), n.d.

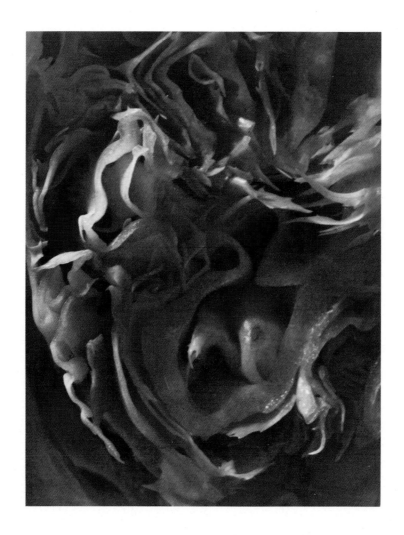

Plate 53. Agitation, 1932.

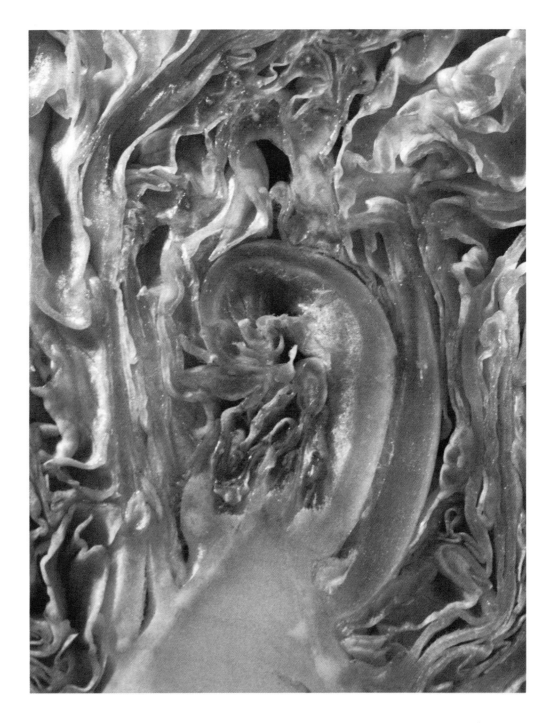

Plate 54. An Expression in Lettuce, n.d.

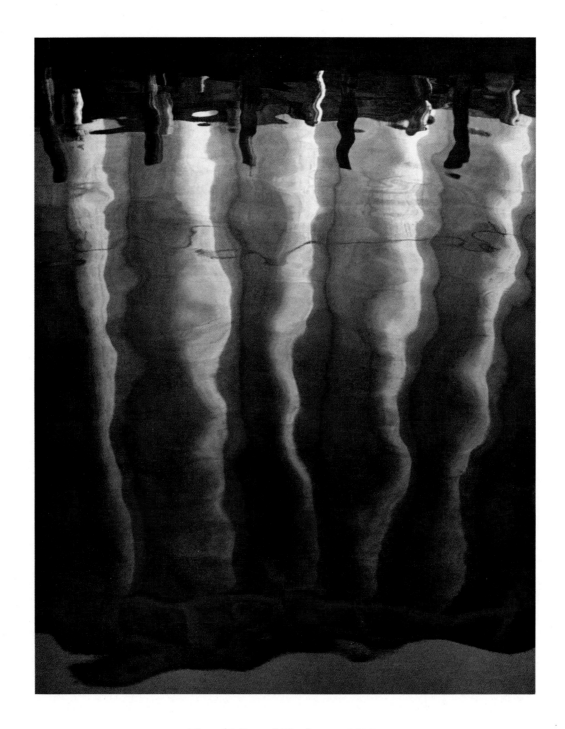

Plate 55. Liquid Rhythm, *ca.* 1934.

Plate 56. Broken Lines, 1934.

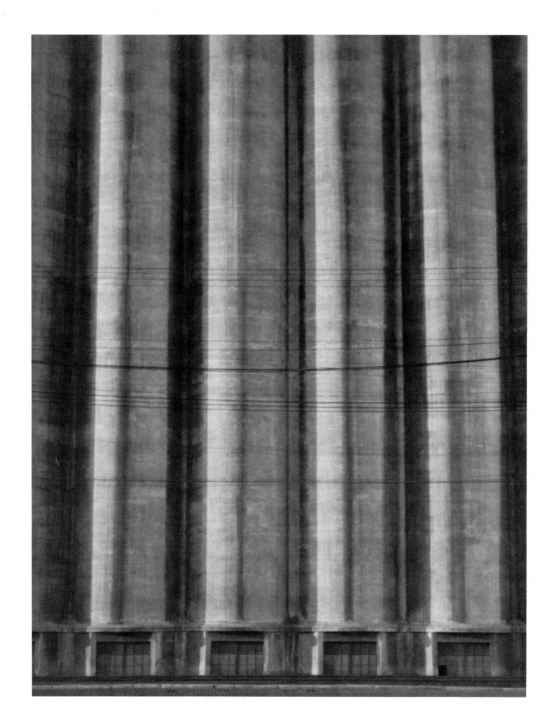

Plate 57. Cylinders, n.d.

Plate 58. Into Silences, n.d.

INDEX TO THE PLATES

Note: all photographs are silver bromide prints (Private Collection). In these dimensions of the original prints, height precedes width.

à la Garbo (portrait of V. Dekking) n.d.; 27.5 x 32.3 cm; — Plate 45.

A Chat, n.d.; 35 x 27 cm; — Plate 23.

A Son of the East, 1924; 34.9 x 27.3 cm; — Plate 16.

A.Y. Jackson, n.d.; 27.9 x 35.4 cm; — Plate 46.

Abundance, n.d.; 25.2 x 19.8 cm; — Plate 51.

Agitation, 1932; 25.3 x 19.7 cm; — Plate 53.

An Expression in Lettuce, n.d.; 35.3 x 27.5 cm; — Plate 54.

Angles in Black and White, n.d.; 45.9 x 35.2 cm; — Plate 39.

Angles of Quebec, ca. 1929-1930; 34.6 x 27 cm; — Plate 33.

Bliss Carman, 1929; 25.4 x 20.2 cm; — Plate 47.

Broken Lines, 1934; 25.1 x 20 cm; — Plate 56.

Cactus Collaratus, 1931; 27.7 x 35.1 cm; — Plate 28.

City Forms, 1935; 35.2 x 27.4 cm; — Plate 11.

Concrete, 1934; 35.2 x 25.1 cm; — Plate 42.

Concrete Power, 1934; 35.3 x 27.5 cm; — Plate 41.

Curvature, n.d.; 35 x 27.3 cm; — Plate 20.

Curving Shadows, 1934; 25 x 19.7 cm; — Plate 9.

Cylinders, n.d.; 35.2 x 27.4 cm; — Plate 57.

Ebony Mask, ca. 1932; 35.2 x 27.4 cm; — Plate 15.

Eric Brown, 1927; 35.5 x 27.9 cm; — Plate 24.

Essentials, 1929; 27.7 x 35 cm; — Plate 3.

Expression in Form, 1931; 25.5 x 33 cm; — Plate 27.

Floral Rhythm, 1935; 35 x 27.7 cm; — Plate 2.

Grapefruit, n.d.; 19.8 x 25.1 cm; — Plate 4.

Heart of a Cabbage, ca. 1929-1930; 27.5 x 35 cm; — Plate 5.

Home Sweet Home, 1935; 45.6 x 35.8 cm; — Plate 32.

Intimate Design, 1929; 25.2 x 19.8 cm; — Plate 19.

Into Silences, n.d.; 35.2 x 27 cm; — Plate 58.

Liquid Rhythm, ca. 1934; 35 x 27.6 cm; — Plate 55.

Modern Egypt, n.d.; 24.8 x 19.7 cm; — Plate 38.

Mystery Stage, 1937; 27.7 x 35.2 cm; — Plate 6.

Nasturtium, n.d.; 27.5 x 35.1 cm; — Plate 49.

Peacock Pride, n.d.; 45.8 x 35.6 cm; — Plate 29.

Rabindranath Tagore, 1929; 35.4 x 27.9 cm; — Plate 18.

Raindrops, n.d.; 27.6 x 35.3 cm; — Plate 50.

Shadow Castle, ca. 1926; 42.3 x 31.2 cm; — Plate 36.

Spirit and Matter, 1935; 35.1 x 27.4 cm; — Plate 43.

Strength, n.d.; 34.8 x 27.4 cm; — Plate 40.

Summer Riches, 1934; 35.3 x 27.6 cm; — Plate 31.

The Fence Casts a Shadow, 1934; 27.5 x 35 cm; — Plate 14.

The Watchman, ca. 1934-1935; 35.3 x 24.7 cm; — Plate 35.

Three Brothers, 1929; 35 x 27.2 cm; — Plate 22.

Towers of Today, 1929; 34.7 x 27.2 cm; — Plate 21.

Unfair Competition, 1925; 35.2 x 24.8 cm; — Plate 44.

Untitled (actor's profile, portrait of a Vancouver actor, thought to be M. Waring), n.d.; 35 x 27.4 cm; — Plate 48.

Untitled (curtained window), 1935; 35.1 x 27.5 cm; — Plate 30.

Untitled (Curving Shadows II), 1934; 25 x 19.7 cm; — Plate 10.

Untitled (cyclone ducts), n.d.; 35.1 x 27.5 cm; — Plate 7.

Untitled (houses and elevators), 1934; 35.1 x 27.5 cm; — Plate 37.

Untitled (portrait), n.d.; 35.3 x 27.7 cm; — Plate 25.

Untitled (thought to be a student at the V.S.D.A.A., A. Bonnycastle), n.d.; 34.9 x 23.8 cm; — Plate 1.

Untitled (tulip), n.d.; 35.2 x 27.6 cm; — Plate 26.

Untitled (variant of Mushrooms), n.d.; 25.2 x 19.7 cm; — Plate 52.

Untitled (variant of Steel and Stone—the Marine Building, Vancouver), n.d.; 35.4 x 27.8 cm; — Plate 12.

Untitled (variant of Winter's Design), n.d.; 35.3 x 27.8 cm; — Plate 8.

Untitled (wire fence and elevators), ca. 1929-1930; 34.9 x 27.2 cm; — Plate 34.

Vera, 1930 ; 25 x 19 cm; — Plate 17.

Winter's Stucco (view of Burrard Street Bridge, Vancouver), n.d.; 35 x 27.2 cm; — Plate 13.

NOTES TO VANDERPANT'S PHOTOGRAPHS AMONG THE FIGURES

In these dimensions, height precedes width. Unless otherwise indicated, all photographs are from a privately held collection of Vanderpant's prints. Reproductions from that collection were done by Weekes Photo Graphics (1984) Ltd. Prints acquired by the Vancouver Art Gallery in 1991 (Figures 18, 27, 33, 34, 37), were made available to the author while the prints were on loan to the National Gallery of Canada. Figures 26, 31, and 32 were made available by the Vancouver Art Gallery and reproduced by Trevor Mills.

Figure 1. Self-portrait, John Vanderpant, *circa* 1928; 24.8 x 19.4 cm.

Figure 5. "Eve Every Time" 1918; 35.2 x 27.7 cm.

Figure 6. Photographs of his family were a part of Vanderpant's early folio and were often exhibited. "Sunburned," a study of Anna, around 1918; 21.7 x 18.4 cm.

Figure 7. Miss Irene Carpenter, New Westminster's May Queen, 1922; New Westminster Historic Centre and Museum (Archives), May Day Collection, #J.J. I.H. P730600.

Figure 10. The Hart House String Quartet, (n.d.); 24.9 x 19.3 cm. From left to right: Harry Adaskin, Géza de Kresz, Boris Hambourg, and Milton Blackstone.

Figure 12. Jean Coulthard (n.d.); Special Collections Library, U.B.C., the Jean Coulthard Adams Collection, Box 13.

Figure 13. Anne le Nobel, *circa* 1931; 34.8 x 27.2 cm.

Figure 14. "Trespassers" 1926; 25.7 x 35 cm.

Figure 16. "In the Blaze of Summer" 1925, John Vanderpant; 25.4 x 34.5 cm.

Figure 17. "The First Day of Spring" *circa* 1925; a modern image reproduced from Vanderpant's lantern slide; National Archives of Canada PA 175740.

Figure 18. "Window's Pattern" *circa* 1923; 24.3 x 34.7 cm., Vancouver Art Gallery, 90.68.2.

Figure 21. "Urge" before cropping and enlarging (n.d.). A modern image reproduced from Vanderpant's negative; National Archives of Canada PA 175769.

Figure 21a. "Urge" after cropping and enlarging (n.d.); 25 x 19.6 cm.

Figure 22. "Untitled" (bok choy), before cropping and enlarging, (n.d.). A modern image reproduced from Vanderpant's negative; National Archives of Canada PA 175770.

Figure 22a. "Untitled" (bok choy), after cropping and enlarging (n.d.); 25.7 x 19.7 cm.

Figure 23. "Untitled" (drainpipes) (n.d.); 27.8 x 35.3 cm.

Figure 24. "Coated Candy" (n.d.); 27.5 x 35 cm.

Figure 26. "The Morning After" 1929; 27.8 x 35.4 cm., Vancouver Art Gallery, 90.68.22.

Figure 27. "Untitled" (Union Station I) 1930; 35.3 x 27.8 cm., Vancouver Art Gallery, 90.68.30.

Figure 29. "Shadows Over New York" 1935. A modern image reproduced from Vanderpant's lantern slide; National Archives of Canada PA 175739.

Figure 30. "Builders" 1930; 35.4 x 27.8 cm.

Figure 31. "In the Wake of the Forest Fire" 1926; 27 x 34.8 cm., Vancouver Art Gallery, 90.68.12.

Figure 32. "Elevator Pattern" 1929; 35.2 x 27.7 cm., Vancouver Art Gallery, 90.68.20.

Figure 33. "The Cylinder" 1934; 35.1 x 19.2 cm., Vancouver Art Gallery, 90.68.44.

Figure 34. "The Window" 1934; 35 x 27.3 cm., Vancouver Art Gallery, 90.68.51.

Figure 35. "Kitchen Symphony" *circa* 1935; 35.3 x 27.7 cm., John Vanderpant Collection, file II Pant 193-12, Prentenkabinet, Leiden University, Holland.

Figure 36. "Barrelaria" *circa* 1931; 27.5 x 35 cm.

Figure 37. "Untitled (Verticals)" 1934; 24.8 x 19.6 cm., Vancouver Art Gallery, 90.68.41.

Figure 38. F.H. Varley 1932; 25.1 x 19.8 cm.

Figure 39. F.H. Varley 1932; 25.1 x 19.4 cm., National Archives of Canada 1992-453.

Figure 42. "Spring on a Platter" (n.d.); 26.8 x 34.6 cm.

FOOTNOTES

Introduction

1. *The Canadian Encyclopedia*, 2d ed., s.v. "Vanderpant, John."
2. John Vanderpant, "Because of the Cause or Giving the Reason Why," *Camera Craft,* vol. 36 (December 1929): 575. The author has changed Vanderpant's "underlaying" to "underlying."
3. Vanderpant, from an untitled, undated manuscript. Unless otherwise indicated, all further citations of Vanderpant's unpublished writings, including lectures, miscellaneous manuscripts (most of which are not titled, dated, or paginated), correspondence, notebooks, and poetry, are from a collection that was made available to the author by Vanderpant's heirs (hereafter cited as Vanderpant Papers). That collection, including copies of his published writings, is now held at the National Archives of Canada, Ottawa: MG 30, D373.
4. Vanderpant, from an untitled manuscript; Vanderpant to Norman Hacking, "Cabbages and Cameras," *The Vancouver Province*, 30 November 1935.
5. Maria Tippett, *The Making of English-Canadian Culture, 1900-1939: The External Influences*, (Downsview, Ont.: York University, 1988), 2.
6. Constance Erroll, "Lens Revelations. The Story of a Camera Artist Who is Revealing the Spirit of Canada," *Maclean's Magazine*, vol. 40 (1 January 1927): 11.

7. Peter Varley, "John Vanderpant: A Memory," in Charles C. Hill's *John Vanderpant: Photographs* (Ottawa: The National Gallery of Canada, 1976 exhibition catalogue), 11-12.

Chapter One

1. "Het Werk en de Persoonlijkheid van Jan van der Pant," by A.B. [Adriaan Boer] in *Focus* (Bloemendaal), vol. 13 (6 March 1926): 115-117.
2. According to information supplied by Dr. I.Th. Leijerzapf, Conservator, Prentenkabinet Van De Rijksuniversiteit Te Leiden, the Netherlands, Vanderpant was registered as number 5196 in the Album Studiosorum. He lived in Haarlem at Du(i)venvoordestraat 94. Apparently, he did not belong to any student organizations.
3. Vanderpant to Eric Brown, 25 January 1934; 7.4-Vanderpant, J. (Lectures), National Gallery of Canada. Vanderpant worked for Willy Rooyaards in an administrative capacity.
4. A.B. [Adriaan Boer], "Het Werk," 115.
5. This information is taken from the author's interviews and correspondence (1989 to 1991) with Vanderpant's daughters, Anna Vanderpant Ackroyd and Catharina (Carina) Vanderpant Shelly. Unless otherwise indicated, all further references to Vanderpant's daughters will be noted in the text.
6. Vanderpant's print, "Type van een Portugees" (page 346 of "Setubal" in *Op de Hoogte*, June 1911), is an excellent example of Vanderpant's early portraiture: hardship, pride, and stamina are reflected in the weathered but handsome face of a Portuguese man; Vanderpant Papers.
7. These articles were titled "Brieven Uit Canada," and were published in *Stads-Editie Oprechte Haarlemsche Courant*, 14 October, 11 November, and 9 December 1911; Vanderpant Papers.
8. From *De Amsterdamer, Weekblad Voor Nederland*, 16 March 1913; copy in the Vanderpant Papers. Translation by Arista Translation Services Ltd., Edmonton, Alberta.
9. Vanderpant to Brown, 25 January 1934.
10. Author's interview with Anna Vanderpant Ackroyd.

11. Although she previously stated that her father's third studio was in Lethbridge (see Charles C. Hill, *John Vanderpant: Photographs*, 14), Anna now believes it was in Pincher Creek. A photograph in the family album is signed by Mrs. Vanderpant and reads "Pincher Creek Studio," and her dating is *circa* 1915-1916. Alberta's *Henderson's Directory* does not show Vanderpant as having had a studio in Lethbridge.

12. "People Who Do Things," *Saturday Night*, vol. 50 (26 October 1935): 16.

13. Vanderpant, "The Need for Vital Thinking," undated manuscript, Vanderpant Papers.

14. Erroll, "Lens Revelations," 11.

15. As reported in *The British Columbian*, 11 January 1924; clipping in the Vanderpant Papers.

16. *The Record of Photography*, January 1924; clipping in the Vanderpant Papers.

Chapter Two

1. Author's interview with Anna Vanderpant Ackroyd.

2. Author's interview with Sheila Watson, 6 September 1989.

3. The New Westminster Historic Centre and Museum (Archives) holds 38 Vanderpant prints. These include photographs of some of the city's May Queens (1920-1927).

4. E. Mary Ramsay, *Christian Science and Its Discoverer*, (Boston: The Christian Science Publishing Society, 1935), 55.

5. Author's interview with Carina Vanderpant Shelly.

6. DeWitt John, *The Christian Science Way of Life*, (Boston: The Christian Science Publishing Society, 1962), 107.

7. Vanderpant, "What's Wrong with the Photographic Profession?" *Camera Craft*, vol. 31 (January 1924): 3-5, 8-9.

8. Vanderpant, "Studio Ethics. A Talk Given Before the Milwaukee Convention of the Photographers' Association of America," *Abel's Photographic Weekly*, vol. 35 (10 January 1925): 34, 36, 44.

9. Vanderpant, "Studio Ethics," 36, 44.

10. "J. Vanderpant Heads Photographers' Section," unidentified newspaper clipping, dated 1934, Vanderpant Papers. A copy of the code could not be located.

11. Maurice Tuchman, "Hidden Meanings in Abstract Art," *The Spiritual in Art: Abstract Painting 1890-1985*, ed. Maurice Tuchman (Los Angeles: Los Angeles County Museum of Art exhibition catalogue, 1986), 17.

12. Anna and Carina both had prints accepted in a number of salons, including The Canadian International Salon of Photographic Art (1934-1940). After their father's death, Anna and Carina took over the Vanderpant Galleries. They pursued their photographic careers until 1941 and 1946, respectively.

13. This portrait appears on the cover of Joyce Zemans's exhibition catalogue, *Jock Macdonald: The Inner Landscape/A Retrospective Exhibition* (Art Gallery of Ontario, 1981), and on the National Gallery of Canada's Canadian Artists Series 9 (1985), *Jock Macdonald*, also written by Zemans. In both cases the portrait is incorrectly attributed to John Vanderpant. Carina states that she took the portrait, and her name is on the negative's envelope.

14. Erroll, "Lens Revelations," 46.

15. *Ibid.*, 11.

16. Yousuf Karsh, *In Search of Greatness: Reflections of Yousuf Karsh* (Toronto: University of Toronto Press, 1962), 94.

17. Melissa K. Rombout, National Archives of Canada, correspondence with the author, 25 January 1993.

18. James Borcoman, "The Art of the Portrait," in *Karsh: The Art of the Portrait* (Ottawa: The National Gallery of Canada in collaboration with the National Archives of Canada, 1989), 69.

19. *Ibid.*, 82.

20. Walt Whitman, *The Complete Writings of Walt Whitman*, eds. Richard Maurice Bucke, Thomas B. Harned, and Horace L. Traubel (New York: G.P. Putnam's Sons, 1902) as quoted by Ann Davis in *The Logic of Ecstasy: Canadian Mystical Painting 1920-1940* (Toronto: University of Toronto Press, 1992), 84.

21. At the time of the author's research, 103 portraits were listed in the private collection of Vanderpant's work and an undetermined number of those were duplicates or proofs; there was also an uncatalogued collection of family portraits that was not available to the author.

22. Mary Baker Eddy, *Science and Health with Key to the Scriptures* (Boston: Published by the Trustees under the Will of Mary Baker G. Eddy, 1934), 284; 296.

23. *Ibid.*, 305.

24. Rabindranath Tagore, *The Religion of Man*, (London: Unwin Paperbacks, 1961), 14; 34.

25. *Ibid.*, 65; 127.

26. Charles C. Hill, *John Vanderpant: Photographs* (Ottawa: The National Gallery of Canada, exhibition catalogue, 1976), 19.

27. Ann Davis, *The Logic of Ecstasy: Canadian Mystical Painting 1920-1940* (Toronto: University of Toronto Press, 1992), ix.

28. Vanderpant used the "à la Garbo" print in a 1935 advertising brochure. Titled "!" or "?," the accompanying write-up stated, "The name VANDERPANT is photographically respected from coast to coast. Have it under your portrait. Decide on the "!"

29. Undated letter from G.F. Levenston to Charles C. Hill, the National Gallery of Canada.

30. From the author's correspondence and telephone conversations with Anne le Nobel, 28 October and 5 November 1991.

Chapter Three

1. Wassily Kandinsky, *On the Spiritual in Art*, ed. Hella Rebay, (New York: The Solomon R. Guggenheim Foundation, for the Museum of Non-Objective Painting, 1946) 95; 94.

2. Victoria *Daily Colonist*, 27 May 1956. Knight is now noted for the 3,000 prints and 30,000 negatives that are held at the Victoria City Archives. His work is valued as a record of Victoria's early history and citizens.

3. The sign for Knight's studio, 715 Fort Street, bore a knight in armour (a pun on his name) holding a shield imprinted with the letter K and advertised "Camera Portraits and Camera Sketches."

4. Lilly Koltun, "Art Ascendent/1900-1914," in *Private Realms of Light: Amateur Photography in Canada/1839-1940*, ed. Lilly Koltun (Toronto: Fitzhenry & Whiteside, 1984), 32.

5. Erroll, "Lens Revelations," 11.

6. Vanderpant, "Pictorial Photography," *Abel's Photographic Weekly*, vol. 36 (1 August 1925): 98.

7. Helga Pakasaar, "Formulas for the Picturesque: Vancouver Pictorialist Photography 1930-1945," in *Vancouver Art and Artists 1931-1983*, (Vancouver: The Vancouver Art Gallery, exhibition catalogue, 1983), 51.

8. *The Canadian Encyclopedia*, 2d ed., s.v. "Knight, Harry Upperton." Vanderpant's 1924 print, "The Stone Cutters" (p. 36 of Hill's *John Vanderpant: Photographs*) is one example of his early work that captures "pictorial moodiness" and an interaction of forms.

9. Author's interview with Lottie Kaiser, 7 September 1989.

10. Another letter from Knight to Vanderpant, dated 15 January 1934, is in the National Gallery of Canada Archives, 7.4-Vanderpant, J. (Lectures).

11. Vanderpant made at least two Veltex prints: "Curvature" (the study of a swan) and "A Son of the Earth." Both were exhibited by the Royal Photographic Society of Great Britain in 1924.

12. Knight to Vanderpant, 12 February 1924, Vanderpant Papers.

13. Vanderpant, "Pictorial Photography," 100.

14. Victoria *Daily Colonist*, 27 May 1956; from Lawrence Sabbath's taped interview with F.H. Varley, Sept. 1960, Agnes Etherington Art Centre, Queen's University, transcript, 9.

15. Amédée Ozenfant, *Foundations of Modern Art*, trans. John Rodker (New York: Dover Publications, Inc., 1931), 60; Walt Whitman, *Complete Poetry and Collected Prose*, ed. Justin Kaplan (New York: The Library of America, 1982), 13.

16. Vanderpant, "Pictorial Photography," 98.

17. Ramsay Cook, "'Nothing Less Than a New Theory of Art and Religion': The Birth of a Modernist Culture in Canada," in Ann Davis's 1990 exhibition catalogue, *The Logic of Ecstasy*, 18.

18. Joan M. Schwartz, "Helders, Johan Anton Joseph," in *Private Realms of Light*, 313.

19. The Vancouver Public Library holds 31 of Helders's original prints; a second copy of "Evening" is held at the National Gallery of Canada; and "Castle of Light" is to be found at the National Archives of Canada in the Camera Club of Ottawa Collection.

20. Johan Helders, "How I Make My Exhibition Prints," *The Amateur Photographer & Cinematographer*, vol. 95 (21 October 1931): 385; copy in the Vanderpant Papers.

21. *Ibid.*

22. *Ibid.*

23. Author's interview with John Helders, 11 May 1990.
24. Schwartz, "Helders, Johan Anton Joseph," *Private Realms of Light*, 313.
25. F.H. Varley to Vanderpant, "Easter Monday," [1936], Vanderpant Papers.
26. Helders to Vanderpant, 20 May 1936, Vanderpant Papers.
27. *Ibid.*, 14 September 1937.
28. *Ibid.*, 22 September 1936.
29. Schwartz, "Salon Crescendo/1930-1940," *Private Realms of Light*, 112.
30. Andrew C. Rodger, "So Few Earnest Workers/1914-1930," *Private Realms of Light*, 77.
31. Vanderpant, "Pictorial Photography," 99-100; the names of the magazines are not known. Vanderpant belonged to an unnamed "local association" as well as the Vancouver Photographers' Association, the Photographers' Association of the Pacific Northwest, the Pictorial Photographers of America, and the Royal Photographic Society of Great Britain.
32. Weston to Vanderpant, 8 May 1931, Vanderpant Papers.
33. Vanderpant, "The Danger of the Photographic Salon," *Camera Craft*, vol. 33 (November 1926): 511-512.
34. Rodger, "So Few Earnest Workers/1914-1930," *Private Realms of Light*, 81-83.
35. C.M. Johnston to Wm. Howard Gardiner, 5 November 1935; MG 30, D165, volume 1, Photographic Salons: 1935, Manuscript Division, National Archives of Canada.
36. F.R. Fraprie to C.M. Johnston, 2 October 1935; MG 30, D165, volume 1, Manuscript Division, National Archives of Canada.
37. Vanderpant to C.M. Johnston, 8 November 1935; MG 30, D165, Photographic Salons: 1935, Manuscript Division, National Archives of Canada.
38. *The British Columbian*, May 1925; clipping in the Vanderpant Papers.
39. "That First Day of Spring," *The Christian Science Monitor*, 13 April 1934.
40. *L'Avenier de Calais*, 10 October 1925; clipping in the Vanderpant Papers.
41. J.D.C. [J. Dudley Johnston] "Exhibitions at Russell Square: Prints by J. Vanderpant," *The Photographic Journal*, vol. 65 (September 1925): 440.
42. Erroll, "Lens Revelations," 11.
43. Hill, *John Vanderpant: Photographs*, 26. Dating Vanderpant's work can be problematic: often negatives and prints are undated and, as is the case with "Eve Every Time," many prints were not exhibited or reproduced for a year or more after being taken. Vanderpant's daughters believe that their father may have taken studies of grain elevators as early as 1924. Based on their recollections, the author stated in "Fine Grain," *Vancouver* (1990), that Vanderpant began photographing the grain silos in 1924. However, 1926 is the earliest date that can be referenced to a print or a negative of a grain elevator study.
44. "Fine Prints Shown by Photographer in Art Lecture," *The Gateway* (University of Alberta), 12 March 1937.
45. Hacking, "Cabbages and Cameras," *The Vancouver Province,* 30 November 1935,
46. "MacSymon's Commentaries: A Series on the World's Greatest Photographers. No. 7: John Vanderpant, A.R.P.S., Canada," *American Photography*, vol. 21, no. 11, (November 1927): 605-613.
47. *The Vancouver Sun*, 29 May 1926; clipping in the Vanderpant Papers.
48. *Ibid.*
49. "Gave Lectures in Milwaukee: New Westminster Photographer Is Honoured at Great Gathering in American City," *The British Columbian* 18 August 1924; clipping in the Vanderpant Papers.
50. In *John Vanderpant: Photographs*, 16, Charles C. Hill notes that Vanderpant resigned from the art committee in 1927. However, Vanderpant's resignation was publicly announced on page 2 of *The British Columbian*, 5 September 1928, when he stated that 1928's was "the last exhibition at which he would be … chairman of the Fine Arts Committee."
51. *The British Columbian*, 29 September 1920.
52. "Effective Art Display at the Royal City Fair," *The Daily Province*, 12 September 1923.
53. *The British Columbian*, 14 September 1921.
54. *Ibid.*, 8 September 1927.
55. *New Westminster, Provincial Exhibition, Fine Art Gallery*, 1922, exhibition catalogue; copy in Vanderpant Papers.

56. A thorough discussion of the history and philosophy of the Group of Seven is given by Ann Davis in her unpublished Ph.D. thesis, "An Apprehended Vision: The Philosophy of the Group of Seven" (York University 1973).

57. Vanderpant lecture, "Art in General; Canadian Painting in Particular," 1933.

58. Vanderpant, "Art and Criticism," letter to the editor, *Vancouver Daily Province*, 17 August 1928.

59. Vanderpant, "Appreciates the Art Exhibition," (letter to the editor) *Vancouver Daily Province*, 18 August 1927.

60. "Fine Prints Shown by Photographer in Art Lecture," *The Gateway*, 12 March 1937.

Chapter Four

1. *Catalogue of Paintings, Etchings, and Photographs at the Opening Exhibition of the Vanderpant Galleries*, March 15-20, inclusive, 1926, Vanderpant Papers. The prints that Mortimer-Lamb and Vanderpant exhibited are not listed in the catalogue.

2. Koltun, "Art Ascendent/1900-1914," *Private Realms of Light*, 50.

3. Jack Shadbolt, "The Thousandth Exhibition at the Vancouver Art Gallery," June 1952; copy in the Mortimer-Lamb file at the Vancouver Public Library.

4. In her article, "Who 'Discovered' Emily Carr?," *Journal of Canadian Art History*, vol.1, no.2, (Fall 1974): 30-34, Maria Tippett noted that Mortimer-Lamb wrote the National Gallery in 1921 and urged Eric Brown to "take cognizance" of Carr's work (31). In 1933 Mortimer-Lamb published an article on Carr, "A British Columbia Painter," in *Saturday Night* (14 January): 26-27.

5. Newspaper articles on the Fine Arts section of the Provincial Exhibition indicate that Mortimer-Lamb exhibited prints in Vanderpant's New Westminster Salon; some years he helped to judge the entries.

6. Shadbolt, "An Artist Isolated by Disillusion," *The Vancouver Sun*, 29 May 1971.

7. Mortimer-Lamb to Lismer, 28 January 1926; Arthur Lismer Papers, MG 30, D184, 85/007, vol.1, Correspondence Lamb, Mortimer H. 1926, National Archives of Canada.

8. "Agreement of Partnership between H. Mortimer-Lamb and J. Vanderpant," Vanderpant Papers.

9. Mortimer-Lamb to Lismer, 8 March 1926; Arthur Lismer Papers, MG 30, D184, 85/007, vol.1, Correspondence Lamb, Mortimer H. 1926, National Archives of Canada.

10. *Catalogue of Paintings, Etchings, and Photographs at the Opening Exhibition of the Vanderpant Galleries*, March 15-20, inclusive, 1926, Vanderpant Papers.

11. Mortimer-Lamb to Lismer, 16 June 1926; Arthur Lismer Papers, MG 30, D184, 85/007, vol.1, Correspondence Lamb, Mortimer H. 1926, National Archives of Canada.

12. *Ibid.*, 21 July 1926.

13. According to Vanderpant's daughters, the assistant's name was Zoe (Kirk) Stewart; they recall that she sometimes modelled for Vanderpant. Due to Mrs. Stewart's failing health, it was not possible for the author to interview her. From late 1927 to 1931, Vanderpant's assistant was Maude Bain; she could not be located.

14. From 1969 to January 1995, the building that housed the Vanderpant Galleries was a Vancouver landmark known as the Côte d'Azur restaurant; the building was demolished shortly after the restaurant's closure.

15. In the exhibition catalogue *First Class: Four Graduates from the Vancouver School of Decorative and Applied Arts, 1929*, (Vancouver: Women in Focus Gallery, 1987), Letia Richardson described Vanderpant, Frederick Varley, and Mortimer-Lamb as "a catalytic force which fueled the exuberance of the visual arts [in Vancouver] in the early 1930's" (14). From the 1940s to his death, Mortimer-Lamb's home was a meeting place for many Vancouver artists such as Jack Shadbolt. Mortimer-Lamb's role in the Vancouver arts scene has yet to be fully documented.

16. Vancouver City Archives, Mss 168, vol. 5.

17. *Ibid.*

18. *Ibid.*, vol. 2.

19. Vanderpant to Brown, 25 January 1934.

20. *International Master Salon of Pictorial Photography*, held under the auspices of the B.C. Pictorialists (exhibition catalogue, Vancouver: Vanderpant Galleries, 1927), Vanderpant Papers. This salon was held at the Vanderpant Galleries from 23 June to 9 July 1927 (9:00 a.m. to 9:00 p.m.).

21. Reta W. Myers, "In the Domain of Art," *Vancouver Daily Province*, 12 April 1931.

22. William Wylie Thom, "The Fine Arts in Vancouver, 1886-1930: An Historical Survey," (M.A. thesis, University of British Columbia, 1969), 159.

23. Vanderpant to Brown, 13 April 1931, 7.1-Vanderpant, J., National Gallery of Canada Archives.

24. Thom, "The Fine Arts in Vancouver," 151.

25. From the 21 January 1930 executive meeting minutes of the British Columbia Society of Fine Arts, as quoted in Thom, "The Fine Arts in Vancouver," 154.

26. Jean Barman, *The West Beyond the West: A History of British Columbia* (Toronto: University of Toronto Press, 1991), 245.

27. *Ibid.*, 245-246.

28. Neither the Imogen Cunningham Trust, nor her collection at the Smithsonian Institution (Washington. D.C.), has information on any Canadian exhibitions for Cunningham prior to 1931. In 1914, Weston exhibited ten prints (#405-414) with the Toronto Camera Club.

29. Cunningham to Vanderpant, 7 May 1931, Vanderpant Papers.

30. Weston to Vanderpant, 8 May 1931, Vanderpant Papers.

31. Myers, "In the Domain of Art," *Vancouver Daily Province*, 20 September 1931.

32. From a list of prints (dated 10 September 1931) that Cunningham sent to Vanderpant; a copy of the list was provided by the Imogen Cunningham Trust, California. In her letter of 1 September 1931, Cunningham wrote that she was "sure Weston will be sending you at least fifty things [prints]."

33. Weston to Vanderpant, 3 September 1931, Vanderpant Papers.

34. *Ibid.*

35. *Ibid.*, 25 October 1931.

36. Cunningham to Vanderpant, 7 May 1931.

37. Margery Mann in the Introduction to *Imogen Cunningham: Photographs* (Seattle: University of Washington Press, 1970), 8.

38. *Ibid.*, 10.

39. Vanderpant, "Because of the Cause," 571.

40. Margaretta Mitchell in the Introduction to *After Ninety: Imogen Cunningham* (Vancouver: J.J. Douglas Ltd., 1977), 11.

41. Weston to Vanderpant, 8 May 1931, Vanderpant Papers.

42. Nancy Newhall, ed., *The Daybooks of Edward Weston*, vol. 2, (New York: Horizon Press in collaboration with The George Eastman House, 1961), 240; 221.

43. Peter C. Bunnell, ed., *Edward Weston on Photography*, (Salt Lake City: Gibbs M. Smith, Inc., Peregrine Smith Books, 1983), 27; 55.

44. Erroll, "Lens Revelations," 11.

45. Hill, *John Vanderpant: Photographs*, 23.

46. "Vanderpant at Camera Club," *The Vancouver Sun*, 5 March 1934; clipping in the Vanderpant Papers.

47. Vanderpant, "Because of the Cause," 576.

Chapter Five

1. Vanderpant lecture, "Art and Canadian Life," n.d., Vanderpant Papers.

2. Robert P. Welsh, "Sacred Geometry: French Symbolism and Early Abstraction," *The Spiritual in Art*, 65.

3. Vanderpant lecture, "Art and Canadian Life."

4. It is likely that Vanderpant read the major mystical texts of the day as well as the writings of Ralph Waldo Emerson, Henry David Thoreau, and Walt Whitman. Vanderpant's daughters recall that he particularly enjoyed the work of A.E. Housman. Notations in his papers indicate that he read the poetry of T.S. Eliot, and Edna St. Vincent Millay, and that he was familiar with the writings of the British mathematician and astrophysicist, Sir James Hopwood Jeans.

5. A privately published collection of Vanderpant's poems, 114 pages, titled *Lyrica*, is held at the National Archives of Canada.

6. *The Vancouver Poetry Society Programme 1935-1936*; in the Kate Eastman Inventory, Special Collections Library, University of British Columbia.

7. Vancouver City Archives, Mss 294, Vol. 1.

8. Minutes of the Vancouver Poetry Society, Vancouver City Archives, Mss 294, Vol. 1.

9. *Ibid.*

10. Vanderpant's address on the topic was outlined in a draft of the paper, "Are traditional forms of poetry adequate to the expression of Canadian Scene?," and dated 24 April 1937; a copy is held in the Vanderpant Papers.

11. Vanderpant lecture, "Art in General; Canadian Painting in Particular."

12. Bess Harris and R.G.P. Colgrove, eds., *Lawren Harris* (Toronto: MacMillan of Canada, 1969), 76.

13. In *The Logic of Ecstasy* (1990), Ann Davis states that mystically inspired teachings were the key to the modernism of Brooker's and Harris's paintings. Both artists also wrote poetry which, while not distinguished, offers insights into the development of modern poetry in Canada. For a discussion of Brooker's poetry see Birk Sproxton, ed., *Sounds Assembling: The Poetry of Bertram Brooker* (Winnipeg: Turnstone Press, 1980); for a discussion of Harris's see David Arnason, "Canadian Poetry; the Interregnum," *Contemporary Verse II* (1975): 28-32.

14. Tuchman, "Hidden Meanings in Abstract Art," *The Spiritual in Art*, 36.

15. From an interview with the author conducted on 8 December 1989. Vito Cianci (1907-1994) was a student at the V.S.D.A.A. from 1926 to 1929. He became an art teacher and worked in the B.C. education system for 40 years. He also pursued his interests in photography; in 1976 65 of his prints were exhibited at the Open Space Gallery in Victoria, B.C. Unless otherwise indicated, all further references to Cianci will be noted in the text.

16. From an interview with the author conducted on 7 December 1989. Irene Hoffar Reid (1908-1994) enrolled at the V.S.D.A.A. in 1925 and was a member of the first graduating class in 1929. She taught at the Vancouver School of Art from 1933 to '37 and since 1931 has had canvases exhibited in numerous exhibitions. Unless otherwise indicated, all further references to Hoffar Reid will be noted in the text.

17. F.H. Varley, *The Paint Box* (annual publication of the students of the Vancouver School of Decorative and Applied Arts), vol. 3 (1928): 12, Fine Arts Library, University of British Columbia.

18. *Ibid.*, 12; Vanderpant, "Artery," 55.

19. Lawren Harris was a theosophist whose ideas influenced the Group of Seven and, for a time, Emily Carr. For a discussion of the spiritual inspiration in Harris's work see Ann Davis's 1990 exhibition catalogue, *The Logic of Ecstasy: Canadian Mystical Painting 1920-1940* and her 1992 book of the same title.

20. F.H. Varley, *The Paint Box*, vol. 3 (1928): 12.

21. From F.H. Varley's 28 January 1928 letter to Dr. A.D.A. Mason, in Christopher Varley's, *F.H. Varley*, (Ottawa: National Gallery of Canada, 1979), 17.

22. Over the years others, including Lawren Harris, were also to host musical evenings; however, Vanderpant's appear to have been the first, to have been the longest running, to have attracted the largest audiences, and to have been the greatest stimulant to the community.

23. John Becker, *Discord: The Story of the Vancouver Symphony Orchestra*, (Vancouver: Brighouse Press, 1989), 6.

24. Vanderpant's daughter, Anna, recalls that her father's homemade system "had a heavy wood frame with a twelve to fifteen inch opening … in which was mounted a speaker identical to gramophone speaker. He set the gramophone speaker in one corner of the room, and set the other speaker in an opposite corner. Both speakers were about three feet off the floor. The tone was fantastic."

25. From an interview with Margaret Williams, conducted by Ann Pollack, 1969, and held in the Archives of the National Gallery of Canada.

26. Ada F. Currie, "The Vanderpant Musicales," *The Paint Box*, (1928): 48.

27. Ivan Denton, "Surely in a Room Like This, Something Interesting Must Take Place," *West End Breeze*, vol. 1 (13 April 1933); copy in the Vanderpant Papers.

28. Dorothy Tisdall, "The President's Retiring Message," *The Paint Box*, vol. 5 (1930): 13, Fine Arts Library, University of British Columbia.

29. Vanderpant, undated black notebook, Vanderpant Papers.

30. *Ibid.*

31. *Ibid.*

32. Peter Varley, "Memories of Father," *Frederick H. Varley*, (Toronto: Key Porter Books, 1983), 26.

33. Richard M. Steele, *The Stanley Park Explorer*, (North Vancouver: Whitecap Books, 1985), 129.

34. Catharina J. Vanderpant, "Biographical Data for History of the Vancouver Poetry Society" (typescript), Vanderpant Papers. The dates on which the Club started and ended are not known; but former members think that the first meetings

were held some time in the 1920s, and that the last occurred toward the end of the 1930s. Harold Mortimer-Lamb has also been credited as being one of the Club's founders (Koltun, *Private Realms of Light*, 321); however, none of the individuals interviewed could remember him ever being in attendance.

35. This information was given to the author in a letter from John C. Lort, 8 February 1990.
36. T. Lort, in a telephone conversation with the author, 6 November 1989.
37. Frank Taylor, in a telephone conversation with the author, 6 November 1989.
38. F.H. Varley to H.O. McCurry, 22 May 1929, the National Gallery of Canada Archives, 7.1-Vanderpant, J.
39. *Vancouver Daily Province*, 2 July 1929. Vanderpant's daughters do not recall such an exhibition taking place, and the author could not locate any reviews. It is possible that the exhibition was too small "in size" for the local media to give it attention. Vanderpant's daughters do recall that over the years paintings by individual members of the Group were exhibited at the Vanderpant Galleries.
40. Brooker to Vanderpant, 21 August 1936, Vanderpant Papers.
41. Hill, *John Vanderpant: Photographs*, 19.
42. Three telegrams from Macleans Stenning to Vanderpant, 11 September 1930; Vanderpant Papers.
43. Hill, *John Vanderpant: Photographs*, 20.
44. "Vanderpant Reveals Art of Photographer," *The Vancouver Sun*, 26 May 1932. The exhibition ran from 11 May to 29 May 1932; a complete listing of the works exhibited is in the Vanderpant Papers.
45. According to the Vancouver Art Gallery's 1932 catalogue of Vanderpant's exhibition (copy in the Vanderpant Papers), neither "Spring on a Platter" nor any of the "Honesty" series were exhibited. Cianci must have seen those prints at the Vanderpant Galleries or at Vanderpant's 1937 solo exhibition at the Vancouver Art Gallery.
46. Larry Cross, *The Seattle Times*, May 1934; June 1934; clippings in the Vanderpant Papers.
47. Vancouver City Archives, Mss 294, vol. 1.
48. *Ibid.*

49. *Ibid.* The lecture was also titled "Art in General; Canadian Painting in Particular."
50. "Vanderpant at Camera Club," *The Vancouver Sun*, 5 March 1934; clipping in the Vanderpant Papers.
51. "Speaker Discovers Artistic Subjects in Grain Elevators," *The Ubyssey*, 29 January 1935.
52. "Interesting Lecture on Pictorial Photography," *The Ottawa Citizen*, 4 October 1935; clipping in the Vanderpant Papers.
53. "Vanderpant Ends Lecture Tour," unidentified newspaper clipping in the Vanderpant Papers.
54. "Aesthetic Value Found in Photos," *The Montreal Gazette*, 10 October 1935; clipping in the Vanderpant Papers.
55. Hill, John Vanderpant: Photographs, 26.
56. "Elevators Topic of Club Address," *The Fort William Daily Times-Journal*, 27 September 1935; clipping in the Vanderpant Papers.
57. "Beauty of Elevators," *The Port Arthur News-Chronicle*, 27 September 1935; clipping in the Vanderpant Papers.
58. "People Who Do Things," *Saturday Night*, vol. 50 (26 October 1935): 16.
59. Hacking, "Cabbages and Cameras," *The Vancouver Province*, 30 November 1935.

Chapter Six

1. A.B. [Adriaan Boer], "Het Werk," 117. Vanderpant also mentioned that he was inspired by the work of Pirie MacDonald, a lesser-known American photographer.
2. Erroll, "Lens Revelations," 47.
3. Mike Weaver, *Alvin Langdon Coburn Symbolist Photographer, 1882-1966: Beyond the Craft*, (New York: Aperture Foundations Inc., 1986), 18. The Symbolist influences in Vanderpant's work are yet to be explored.
4. John, *The Christian Science Way of Life*, 112.
5. "MacSymon's Commentaries," 605.
6. Frederick Colin Tilney, "Prints by J. Vanderpant, F.R.P.S.," *The Photographic Journal*, vol. 68 (June 1928): 243; copy in the Vanderpant Papers.
7. "The John J. [*sic*] Vanderpant and J. Harold Leighton Exhibitions" *The Photographic Journal*, vol. 68 (July 1928): 291-292; copy in the Vanderpant Papers.

8. Vanderpant, "Tradition in Art," *The Photographic Journal*, vol. 68 (November 1928): 449; copy in the Vanderpant Papers.

9. From the *Group of Seven* exhibition catalogue, Art Gallery of Toronto 7 May-27 May 1920, as quoted in Ann Davis, "An Apprehended Vision: The Philosophy of the Group of Seven," (Unpublished Ph.D. thesis, York University, 1973), 106; 286.

10. Erroll, "Lens Revelations," 11.

11. Vanderpant, "Because of the Cause," 575-576.

12. *Ibid.*, 572.

13. Vanderpant, undated notes, verso of letter from Walter F. Isaacs, University of Washington, Seattle, to Vanderpant, 31 May 1934.

14. Bertram Brooker, "Elevator Pattern by J. Vanderpant," *Yearbook of the Arts in Canada*, (1928/1929): 302.

15. Rosemary Donegan, *Industrial Images*, (Hamilton: Art Gallery of Hamilton, 1987), 96.

16. Vanderpant, "Because of the Cause," 572-573.

17. Vanderpant, undated notes, verso of letter from Walter F. Isaacs.

18. F.H. Varley, *The Paint Box*, vol. 3, (1928): 12.

19. Le Corbusier, as quoted in Reynar Banham, *A Concrete Atlantis: U.S. Industrial Buildings and European Modern Architecture 1900-1925*, (Boston: MIT Press, 1986), 223-224.

20. Ann Davis, *The Logic of Ecstasy* (1990), 7.

21. Ralph Waldo Emerson, "Nature," *The Selected Writings of Ralph Waldo Emerson*, ed., Brooks Atkinson (New York: The Modern Library, 1940), 41.

22. William Blake, "Auguries of Innocence," *The Complete Prose and Poetry of William Blake*, Newly Revised Edition, ed. David V. Erdman, commentary by Harold Bloom, (Berkeley and Los Angeles: University of California Press, 1982), 490.

23. Vanderpant, "Because of the Cause," 576.

24. Vanderpant, "Tradition in Art," 448.

25. Pakasaar, "Formulas for the Picturesque," *Vancouver Art and Artists 1931-1983*, 52.

26. Christopher Varley, *F.H. Varley*, 20.

27. As a boy, Peter Varley visited the Vanderpants at their Drummond Drive home and at their studio-home on Robson Street.

28. Peter Varley, "John Vanderpant: A Memory," *John Vanderpant: Photographs*, 9-11.

29. Vanderpant, "Because of the Cause," 571.

30. Vanderpant, undated notes, verso of letter from Walter F. Isaacs.

31. Peter Varley, *Frederick H. Varley*, 63.

32. *Passionate Canadians*, National Film Board of Canada, 1977.

33. F.H. Varley to Vera Weatherbie, letter dated 1944, Edmonton Art Gallery.

34. *Ibid.*, 26 February 1937, second part of the letter which is dated "Sunday night now."

35. *Ibid.*, 7 January 1941.

36. Letia Richardson, *First Class*, 18. Richardson states that Weatherbie's exhibitions with the Exhibition of B.C. Artists received no reviews or special mention in the local press. Richardson also notes that after Vera's marriage to Mortimer-Lamb in 1942, Vera "continued to work, [but] it is not known to what extent, what media she used or what subjects she painted" (18). When Vera died in 1977 her papers and art work were bequeathed to the Art Gallery of Greater Victoria, B.C.

37. F.H. Varley to Vera Weatherbie, 9 November 1931, Edmonton Art Gallery.

38. Varley and his family were impoverished after 1933. Philip Surrey remembers visiting the family in their "small, ugly, bungalow in North Vancouver," and that when Mrs. Varley "confided … that there was no food in the house," he purchased a watercolour of Varley's for $10.00 to provide some income. ("Biography of Philip Surrey," unpublished manuscript by Margaret Surrey, Philip and Margaret Day Surrey Papers, MG 30, D368, National Archives of Canada, vol. 1, 47.) H.U. Knight's stepdaughter, Lottie Kaiser, remembers calling on the family with the Vanderpants. She recalls that wooden boxes comprised most of the furniture in the house (L. Kaiser, interview with the author, 7 September 1989).

39. Vanderpant to Eric Brown, 6 January 1931; 7.1-Vanderpant, J., National Archives of Canada. Vera's portrait of Varley is now in the collections of the Vancouver Art Gallery (86.178).

40. Reta W. Myers, "In the Domain of Art," *Vancouver Daily Province*, 12 April 1931.

41. Vera's pose is sphinx-like and conveys a sense of sensual intrigue. The brochure advertised "Distinguished Portraiture," a "Partial List of Gold Or Silver Awards" awarded to Vanderpant's work, and 16 reviews of his photographs from Canadian and international newspapers and magazines; Vanderpant Papers.

42. Christopher Varley, *F.H. Varley*, 19.

43. This information was given to Letia Richardson during a 1987 interview with Irene Hoffar Reid; see note 74, page 27, of *First Class*.

44. F.H. Varley to Vera Weatherbie, 7 January 1941, Edmonton Art Gallery.

45. *Ibid.*, 26 February 1937, second part of the letter which is dated "Sunday night now."

46. Richardson, *First Class*, Note 74, 27.

47. Charles C. Hill, *John Vanderpant: Photographs*, 19.

48. Joyce Zemans, *Jock Macdonald: The Inner Landscape/A Retrospective Exhibition* (Toronto: The Art Gallery of Ontario, 1981), 23.

49. J.W.G. Macdonald, "Reflections on a trip to the Canadian International Seminar in Breda," *Highlights* 9:1 (March 1950), 6, as quoted in Zemans, *The Inner Landscape*, 43.

50. Macdonald to John Varley, 19 January 1937, copy in the Burnaby Art Gallery.

51. Vanderpant to H.O. McCurry, 5 March 1937, The National Gallery of Canada Archives, 7.4-Vanderpant, J. (Lectures).

52. Macdonald to H.O. McCurry, April 1938, 22 July 1938, and 10 May 1943; 7.1-Macdonald, J.W.G., National Gallery of Canada Archives.

53. Zemans, *The Inner Landscape*, 65.

54. Emily Carr, *Hundreds and Thousands: The Journals of Emily Carr*, (Toronto: Clarke, Irwin & Company, 1966), 29; 85.

55. Emily Carr, MG 30, D215, Volume 3, National Archives of Canada. This entry was included on page 63 of *Hundreds and Thousands: The Journals of Emily Carr*, but Vanderpant and Knight's names were excluded from the entry.

56. Victoria City Archives, H.U. Knight Collection, Emily Carr Series, 4257 1-18.

57. Carr to Cheney, 25 October 1935; Carr to Cheney, postmarked 25 January 1938. Copies of these letters are in the Nan Lawson Cheney Papers, Special Collections Library, University of British Columbia.

58. On page 190 of *Emily Carr: A Biography*, (Toronto: Oxford University Press, 1979), Maria Tippett states that Carr sold "a few paintings … at the Vanderpant Galleries."

59. Emily Carr, *Hundreds and Thousands*, 23; 54.

60. *Ibid.*, 260.

61. Philip Surrey, "Diary Excerpts 1921-1964," Philip and Margaret Day Surrey Papers, MG 30, D368, National Archives of Canada.

62. Margaret Surrey, "Biography of Philip Surrey," (unpublished manuscript), Philip and Margaret Day Surrey Papers, MG 30 D368, National Archives of Canada, 53.

63. *Ibid.*, 43; 51.

64. In a letter from Livesay, 9 May 1937, she thanks Vanderpant for his "generosity" in allowing the New Frontier Club (a literary group) to meet at the Galleries. She also notes that many in attendance remarked on "how interested they were in the views put forward by you, as one who is a creator himself"; Vanderpant Papers.

65. Philip Surrey to Vanderpant, 23 April 1937, Vanderpant Papers.

66. R. Ann Pollack and Dennis R. Reid, Retrospective Exhibition and Catalogue *Jock Macdonald* (Ottawa: National Gallery of Canada, 1969-1970), 4.

67. F.H. Varley to Vera Weatherbie, letter dated 1940, Edmonton Art Gallery.

68. A collection of James Crookall's prints is held at the Vancouver City Archives. Among that collection nine prints are listed as studies of Vancouver grain elevators, *circa* 1930. In the extant collection of Johan Helders (Vancouver Public Library) are two studies of grain elevators, "Pool No.1" (1937) and "Light and Shadow" (1937). The former bears a striking resemblance to Vanderpant's 1934 print, "Tracks"; the latter is similar to Vanderpant's "Untitled" (Concrete, 1934).

69. Melissa K. Rombout, correspondence with the author, 25 January 1993. See page 93 of *Karsh & Fisher see Canada* (Toronto: Thomas Allen, 1960) for Karsh's untitled print.

70. Vanderpant, "Artery," *The Paint Box*, vol. 3, (1928): 55.

Chapter Seven

1. Prior to the Vanderpants' move to Robson Street, Bill and Betty Blythe had occupied the studio quarters. They put out and gathered chairs, and set out cups and made coffee for the numerous functions held at the Vanderpant Galleries. A tape-recorded interview with the Blythes, conducted by Peter Varley, is held in his Varley Inventory but was unavailable at the time of the author's research.
2. Vito Cianci and Jessie Binning (interviewed by the author on 8 December 1989 and 17 June 1990, respectively), who occasionally accompanied her mother to tea with Mrs. Vanderpant, have remarked that the house was "different" and "unusual." Vancouver homes of the period did not tend to have large windows or vaulted ceilings.
3. Anne le Nobel, in a telephone conversation with the author, 5 November 1991.
4. Verso of letter to Vanderpant from The Manufacturer's Life Insurance Company, 8 December 1934, Vanderpant Papers.
5. Vanderpant to McCurry, 2 October 1934; 7.4-Vanderpant, J., (Lectures) National Gallery of Canada Archives.
6. Grace Melvin (1890-1977) was hired to teach illumination, embroidery, and pottery at the V.S.D.A.A. in 1927. She headed the Design Department after Macdonald's departure, and did so until her retirement from the Vancouver School of Art (as it was later called) in 1952. A comment from Varley in a May 1937 letter to Vera Weatherbie (Edmonton Art Gallery), indicates that Melvin was at odds with Macdonald and Varley: "If it wasn't for the blighted Grace M. in Vancouver & the slimy ways of the blasted school I should be tempted to commence again in Vancouver."
7. F.H. Varley to the Vancouver School Board, 1933; 7.1-Varley, F., National Gallery of Canada Archives. For a thorough study of V.S.D.A.A. and the B.C. College of Arts, see Letia Richardson's forthcoming Ph.D. thesis (Simon Fraser University), "The Social History of the Vancouver School of Art, 1925-1952."
8. Shadbolt, "A Personal Recollection," *Vancouver Art and Artists 1931-1983*, 36. An article on page 10 of the 12 April 1931 issue of the Vancouver *Province*, "Viennese Artist Will Give Lecture," establishes that Täuber was in Vancouver as early as 1931. To date, publications on Varley and Macdonald and the history of the B.C. College of Arts have incorrectly stated that Täuber arrived in 1932.
9. Täuber to Anne Hillier McMenoman, 3 November 1935; 7.4.C-Vancouver School of Art, National Gallery of Canada Archives.
10. Beatrice Lennie in a tape-recorded interview with Ann Pollack, 1968; Macdonald, J.W.G., National Gallery of Canada Archives.
11. This information was given to Lorna Farrell-Ward in a 25 April 1983 interview with Isabell Wintemute, as quoted in "Tradition/Transition: The Keys to Change," *Vancouver Art and Artists 1931-1983*, (Vancouver: Vancouver Art Gallery), 18.
12. Beatrice Lennie to Ann Pollack, 1968.
13. Gerald Hall Tyler, in a tape-recorded interview with Ann Pollack, 1969; Macdonald, J.W.G., National Gallery of Canada Archives.
14. Margaret Williams in a tape-recorded interview with Ann Pollack, 1969; Macdonald, J.W.G., National Gallery of Canada Archives.
15. Shadbolt, "A Personal Recollection," *Vancouver Art and Artists 1931-1983*, 37-38.
16. F.H. Varley, "Closing Ceremonies, May 17th, 1935."
17. F.H. Varley to H.O. McCurry, 16 April 1934, 7.1-Varley, F., National Gallery of Canada Archives.
18. *Ibid.*, 21 May 1935, 7.4-Carnegie Corporation, B.C. College of Art, National Gallery of Canada Archives.
19. F.H. Varley to E.S. Nutt, 7.1-Varley, F., National Gallery of Canada Archives.
20. Vanderpant photographed a still-life class at the College, and the print was used to accompany H.E. Torey's article, "Where East Meets West," *Saturday Night*, 21 April 1934. He also photographed the College's 1934-1935 graduation ceremonies; one print shows the painter Paul Goranson receiving his diploma.
21. Beatrice Lennie to Ann Pollack, 1968.
22. Gerald Hall Tyler to Ann Pollack, 1969. Mr. Tyler could not recall the exact date of the luncheon but indicated that it was sometime between 1937 and 1939.

23. Rowena Morell, diary entry 25 May 1933; copy in the Burnaby Art Gallery.

24. From an interview with Pindy Barford, 19 June 1990. Binning later studied under Amédée Ozenfant and Henry Moore. In 1955 Binning founded the Fine Arts Department at the University of B.C.

25. Gerald Hall Tyler to Ann Pollack, 1969.

26. According to Joyce Zemans, *Jock Macdonald: The Inner Landscape*, in 1936 Macdonald took a part-time position at the Canadian Institute of Associated Arts; from 1938-1939 he taught at Templeton Junior High School; and in September 1939 he began teaching at the Vancouver Technical High School. He complained, "Why the devil has one to hang on to mentally stagnating jobs in order to exist?" (Letter to John Varley, 9 September 1939, National Gallery of Canada Archives, as quoted on page 96 of Zemans, *The Inner Landscape*.)

27. J.W.G. Macdonald, "Vancouver," *F.H. Varley, Paintings and Drawings 1915-1954* (Toronto: Art Gallery of Ontario, 1954-57), as quoted in Zemans, *The Inner Landscape*, 22.

28. F.H. Varley to McCurry, 23 February 1936; 7.1-Varley, F., National Gallery of Canada Archives.

29. Vanderpant to Brown, 23 February 1936; 7.1-Vanderpant, J., National Gallery of Canada Archives.

30. Varley painted a portrait of Vanderpant and completed a sketch of Mrs. Vanderpant; both are in a private collection. The portrait of Mortimer-Lamb is held at the National Gallery of Canada.

31. Vanderpant to McCurry, 21 March 1936; 7.1-Vanderpant, J., National Gallery of Canada Archives.

32. McCurry to Vanderpant, Canadian National Telegraphs, 24 March 1926, Vanderpant Papers; Vanderpant to McCurry, 25 March 1936; 7.1-Vanderpant, J., National Gallery of Canada Archives.

33. F.H. Varley to Vanderpant, letter dated "Easter Monday," Vanderpant Papers.

34. *Ibid.*, 5 November 1937, Vanderpant Papers.

35. McCurry to Vanderpant, 27 April 1936; 7.1- Vanderpant, J., National Gallery of Canada Archives.

36. F.H. Varley to Philip Surrey, 6 November 1937; the Philip and Margaret Day Surrey Papers, MG 30, D368, vol. 1, Manuscript Division, National Archives of Canada.

37. F.H. Varley to Vanderpant, 5 November 1937.

38. The Vancouver Art Gallery has one print (77.66), the sketch of a young male, which bears Varley's thumbprint on the sketch and another thumbprint, noted as Vanderpant's on the matte. The sketches, "Marie," 1934, and "Study for Dhârâna," 1932, are also known to have been part of the set.

39. From the author's interview with L. Kaiser, 7 September 1989.

40. F.H. Varley to Vanderpant, 13 January 1937, Vanderpant Papers.

41. *Ibid.*, 6 April 1938.

42. Brown to Vanderpant, 2 July 1936, Vanderpant Papers.

43. Helders to Vanderpant, 20 May 1936; 18 November 1936, Vanderpant Papers.

44. F.H. Varley to Vanderpant, 13 January 1937.

45. *Ibid.*, 12 June 1936.

46. Macdonald to John Varley, 8 December 1936; copy in the Burnaby Art Gallery.

47. F.H. Varley to Vanderpant, 13 January 1937.

48. F.H. Varley to Philip Surrey, 6 November 1937; Philip and Margaret Surrey Papers, MG 30, D368, National Archives of Canada.

49. F.H. Varley to Vanderpant, 6 April 1938.

50. Vanderpant to F.H. Varley, 17 April 1938, unfinished letter; private collection.

51. Charles C. Hill, *Canadian Painting in the Thirties* (Ottawa: National Gallery of Canada, 1975), 15.

52. Vanderpant to F.H. Varley, 17 April 1938, unfinished letter.

53. Gerald Hall Tyler to Ann Pollack, 1969.

54. Author's interview with Anna Vanderpant Ackroyd, 29 November 1989.

55. Vanderpant to McCurry, 12 January 1934, 7.4-Vanderpant, J., (Lectures) National Gallery of Canada Archives.

56. *Ibid.*, 6 January 1936; 7.4-Vanderpant, J. (Lectures) National Gallery of Canada Archives.

57. Vanderpant to F.H. Varley, 17 April 1938, unfinished letter.

58. McCurry to Vanderpant, 27 April 1936, Vanderpant Papers.

59. Brown to John Murray Gibbon, 21 January 1931, 7.1-Vanderpant, J., National Gallery of Canada Archives.

60. Macdonald to John Varley, 8 December 1936.

61. Vanderpant to McCurry, 21 March 1936; 7.1-Vanderpant, J., National Gallery of Canada Archives.

62. Vanderpant's 1937 Alberta tour, sponsored by the University of Alberta, took him to Edmonton, Calgary, Camrose, and Lethbridge.

63. Vanderpant to McCurry, 12 September 1936; 7.4-Vanderpant, J., (Lectures), National Gallery of Canada Archives.

64. In *J.W.G. Macdonald The Western Years: 1926-1946* (Burnaby Art Gallery, March 1969), 14, Judi Francis, research assistant for Dennis Reid and Ann Pollack, states that Macdonald's canvases and one by W.P. Weston were "the only choices of western Canadian works to be presented" at the exhibition.

65. Vanderpant to McCurry, 5 March 1937; 7.4-Vanderpant, J. (Lectures), National Gallery of Canada Archives.

66. *Ibid.*, 5 March 1937.

67. *Ibid.*, 12 September 1936.

68. John Vanderpant to Catharina Vanderpant, 6 July 1936; 6 July 1939; private collection.

69. Author's interview with L. Kaiser, 7 September 1989; she could not remember the name of the facility.

70. Author's interview with Anna Vanderpant Ackroyd.

71. Nan Cheney to Eric Brown, 1 December 1938; the letter is published in *Dear Nan: Letters of Emily Carr, Nan Cheney, and Humphrey Toms*, ed. Doreen Walker (Vancouver: University of British Columbia Press, 1990), 140.

SELECTED BIBLIOGRAPHY

Banham, Reynar. *A Concrete Atlantis: U.S. Industrial Buildings and European Modern Architecture 1900-1925*. Boston: MIT Press, 1986.

Barman, Jean. *The West Beyond the West: A History of British Columbia*. Toronto: University of Toronto Press, 1991.

Boer, Adriaan. "Het Werk en de Persoonlijkheid van Jan van der Pant," *Focus* (Bloemendaal). vol. 13 (6 March 1926): 115-118, 123-130.

Brooker, Bertram, ed. *Yearbook of the Arts in Canada*. Toronto: Macmillan, 1929; 1936.

Bunnell, Peter C., ed. *Edward Weston on Photography*. Salt Lake City: Gibbs M. Smith, Inc., 1983.

Carr, Emily. *Hundreds and Thousands: The Journals of Emily Carr*. Toronto: Clarke, Irwin Company Limited, 1966.

Currie, Ada F. "The Vanderpant Musicales," *The Paint Box*. Vancouver: Vancouver School of Decorative and Applied Arts,(1928): 48.

Davis, Ann. "An Apprehended Vision: The Philosophy of the Group of Seven." Unpublished Ph.D. thesis, York University, 1973.

—— *The Logic of Ecstasy: Canadian Mystical Painting 1920-1940*. Toronto: University of Toronto Press, 1992.

Eddy, Mary Baker. *Science and Health with Key to the Scriptures*. Boston: Published by the Trustees under the Will of Mary Baker G. Eddy, 1934.

Erroll, Constance. "Lens Revelations. The Story of a Camera Artist Who is Revealing the Spirit of Canada," *Maclean's Magazine*. vol. 40 (January 1927): 11, 20, 22, 46.

Francis, Judi. *J.W.G. Macdonald The Western Years: 1926-1946*. Burnaby Art Gallery, March 1969.

Hacking, Norman. "Cabbages and Cameras," *The Vancouver Province*. (30 November, 1935).

Harris, Bess and Colgrove, R.G.P. eds. *Lawren Harris*. Toronto: Macmillan of Canada, 1969.

Helders, Johan. "How I Make My Exhibition Prints," *The Amateur Photographer & Cinematographer*. vol. 95 (21 October 1931): 385.

Hill, Charles C. *Canadian Painting in the Thirties*. Ottawa: National Gallery of Canada, 1975.

John, DeWitt. *The Christian Science Way of Life*. Boston: The Christian Science Publishing Society, 1962.

Johnston, Dudley C. "Exhibition at Russell Square: Prints by J. Vanderpant," *The Photographic Journal*. vol. 65 (September 1925): 440-442.

Kandinsky, Wassily. *On the Spiritual in Art*. ed., Hella Rebay. New York: The Guggenheim Foundation, for the Museum of Non-Objective Painting, 1946.

Karsh, Yousuf. *In Search of Greatness: Reflections of Yousuf Karsh*. Toronto: University of Toronto Press, 1961.

Karsh, Yousuf and John Fisher. *Karsh & Fisher see Canada*. Toronto: Thomas Allen, 1960.

Koltun, Lilly, ed. *Private Realms of Light: Amateur Photography in Canada/1839-1940*. Toronto: Fitzhenry & Whiteside, 1984.

"MacSymon's Commentaries: A Series on the World's Greatest Photographers. No. 7: John Vanderpant, A.R.P.S., Canada," *American Photography*. vol. 21, no. 11 (November 1927): 605-613.

Mann, Margery, Intro. *Imogen Cunningham: Photographs*. Seattle: University of Washington Press, 1970.

Mitchell, Margaretta, Intro. *After Ninety: Imogen Cunningham*. Vancouver: J.J. Douglas Ltd., 1977.

Newhall, Nancy, ed. *The Daybooks of Edward Weston*. New York: Horizon Press & The George Eastman House, 1961.

Ozenfant, Amédée. *Foundations of Modern Art*. New York: Dover Publications, Inc., 1931.

Ramsay, E. Mary *Christian Science and Its Discoverer*. Boston: The Christian Science Publishing Society, 1935.

Tagore, Rabindranath. *The Religion of Man*. London: Unwin Paperbacks, 1961.

The Paint Box. Annual publication of the Vancouver School of Decorative and Applied Arts, 1925-'30.

Thom, William Wylie. "The Fine Arts in Vancouver, 1886-1930: An Historical Survey." Unpublished M.A. thesis, University of British Columbia, 1969.

Tilney, Frederick Colin. "Appreciations J. Vanderpant's Picture: 'Castles of Commerce'," *The New Photographer*. (1 November 1926): 116-117.

— "Prints by J. Vanderpant, F.R.P.S." *The Photographic Journal*. vol. 68 (July 1928): 243-244.

— *The Principles of Photographic Pictorialism*. Boston: American Photographic Publishing Co., 1930.

Tippett, Maria. "Who 'Discovered' Emily Carr?" *Journal of Canadian Art History*. vol.1, no.2 (Fall 1974): 30-34.

— *Emily Carr: A Biography*. Toronto: Oxford University Press, 1979.

— *The Making of English-Canadian Culture, 1900-1939: The External Influences*. Downsview, Ont.: York University, 1988.

Vanderpant, Catharina J. "Biographical Data for History of the Vancouver Poetry Society," typescript.

van der Pant, Jan. "Vijver," "Bloei," *Overdruk uit Onze Ecuw*. (7 January 1907).

— *Verzen*. Typ. H.J. Boogards, Oude Gracht; B/D Zijlstr, Haarlem (1908).

— "Haar Verdriet," De Oranje Serie no. 27 Stoomdrukkerij van J.K. Kak Te Kampen (1908).

— "Kinderliedje," "Kermis," "Zwanen," "Maaiday," *Nieuwe Gids*. (8 August, 1908).

— "Strand," "Badman," *1 Revisie*. (12 November 1910).

— "Setubal," *Op de Hoogte*. (June 1911): 345-348.

— "Messina," *Op de Hoogte*. (July 1911): 393-397.

— "Van De Veluwe," *Op de Hoogte*. (October 1911): 578-582.

— "Brieven Uit Canada," *Stads-Editie Oprechte Haarlemsche Courant*. (14 October, 11 November, 9 December 1911).

— "Iets Over Italië," *Op de Hoogte*. (November 1911): 645-650.

— "Op Reis Naar Canada," *Op de Hoogte*. (January 1912): 72-77.

— "Uit Westelijk Canada," *Op de Hoogte*. (December 1912): 673-680.

— "Feuilleton - De Zware Taak," *De Amsterdamer Weekblad Voor Nederland*. (16 February 1913): 2-3.

— "Canada en de enmigratie," *De Amsterdamer Voor Nederland*. (16 March, 1913): 6.

— "Land En Landbouw in Westelijk Canada," *Op de Hoogte*. (April 1913): 190-197.

— "Krabbels over Canada," *Op de Hoogte*. (May 1914): 253-260.

— "De Internationale Fotografische Tentoonstelling te New Westminster, B.C. Canada," *Focus* (Bloemendaal). vol. 10 (1 November 1923): 569.

— "De Internationale Tentoonstelling van Fotografieën te New Westminster, B.C. Canada," *Lux Amsterdam*. (1 November 1923): 416.

Vanderpant, John. "What's Wrong with the Photographic Profession," *Camera Craft*. vol. 31 (January 1924): 3-9.

— "The New Westminster Salon of Pictorial Photography," *Camera Craft*. vol. 31 (December 1924): 582-584.

— "The New Westminster Salon of Pictorial Photography," *Camera Craft*. vol. 32 (January 1925): 15-17.

— "Studio Ethics," *Abel's Photographic Weekly*. vol. 35 (January 1925): 34, 36-44.

— "Pictorial Photography," *Abel's Photographic Weekly*. vol. 36 (1 August 1925): 98-100.

— "The Danger of the Photographic Salon," *Camera Craft*. vol. 33 (November 1926): 510-512.

— "Appreciates the Art Exhibition," (letter to the editor), *Vancouver Daily Province*. (18 August 1927).

— "Artery," *The Paint Box*. vol. 3 (1928): 46; 55.

— "Art and Criticism," (letter to the editor), *Vancouver Daily Province*. (17 August 1928).

— "Tradition in Art," *The Photographic Journal*. (November 1928): 447-451.

— "Because of the Cause or Giving the Reason Why," *Camera Craft*. vol. 36 (December 1929): 570-577.

— "Art in General; Canadian Painting in Particular," lecture manuscript dated 27 November 1933.

— "The Art Gallery," *West End Breeze*. (13 June 1935): 1, 3.

Varley, Christopher. *F.H. Varley*. Ottawa: National Gallery of Canada, 1979.

Varley, Peter. *Frederick H. Varley*. Toronto: Key Porter Books, 1983.

Walker, Doreen, ed. *Dear Nan: Letters of Emily Carr, Nan Cheney, and Humphrey Toms*. Vancouver: University of British Columbia Press, 1990.

Weaver, Mike. *Alvin Langdon Coburn Symbolist Photographer, 1882-1966: Beyond the Craft*. New York: Aperture Foundations Inc., 1986.

Whitman, Walt. *Complete Poetry and Collected Prose*. ed. Justin Kaplan. New York: The Library of America, 1982.

Zemans, Joyce. *Jock Macdonald*. Canadian Artists Series 9, ed. Dennis Reid. Ottawa: National Gallery of Canada, 1985.

Exhibition Catalogues and Illustrated Monographs

Catalogue of Paintings, Etchings, and Photographs at the Opening Exhibition of the Vanderpant Galleries, March 15-20, inclusive, 1926.

First Class: Four Graduates from the Vancouver School of Decorative and Applied Arts, 1929. Catalogue and text by Letia Richardson. Women in Focus Gallery, 1987.

Het Fotografsch Museum van Auguste Grégoire. Text by Dr. Ingeborg Th. Leijerzapf. Prentenkabinet Rijksuniversiteit Leiden/SDU Uitgeverij's Gravenhage, 1989.

Industrial Images. Catalogue and text by Rosemary Donegan. Art Gallery of Hamilton, 1987.

Jock Macdonald. Catalogue and text by R. Ann Pollack and Dennis R. Reid. National Gallery of Canada, 1969-1970.

Jock Macdonald: The Inner Landscape/A Retrospective Exhibition. Catalogue and text by Joyce Zemans. Art Gallery of Ontario, 1981.

John Vanderpant: Photographs. Catalogue and text by Charles C. Hill. National Gallery of Canada, 1976.

Karsh: The Art of the Portrait. ed. James Borcoman. National Gallery of Canada in collaboration with the National Archives of Canada, 1989.

The Logic of Ecstasy: Canadian Mystical Painting 1920-1940. Catalogue and text by Ann Davis. London Regional Art and Historical Museum, 1990.

The Spiritual in Art: Abstract Painting 1890-1985. ed. Maurice Tuchman. Los Angeles County Museum of Art, 1986.

Vancouver Art and Artists 1931-1983. Vancouver Art Gallery, 1983.

INDEX

Ackroyd, Anna Vanderpant 2, 3, 5, 7, 8, 10, 13, 14, 17, 24, 32, 38, 39, 52, 53, 56, 62, 63, 65, 69, 70-72
Adaskin, Harry 11, 56
Amess, Fred 26, 35
B.C. College of Arts 36, 37, 56, 64, 65, 68, 69
Barford, Pindy 65
Becker, John 36
Besant, Annie 55, 58
Binning, Bertram C. 65
Blake, William 50
Blavatsky, H.P. 55. 64
British Columbia Art League 20, 25
Brooker, Bertram 10, 34, 40, 41, 49
Brown, Eric 1, 12, 26, 56, 64, 66-68, 70
Carman, Bliss 10, 33, 41
Carpenter, Irene 6
Carr, Emily 13, 23, 26, 27, 44, 58, 59, 69, 70, 71
Cheney, Nan 27, 59, 72
Christian Science 4, 6, 7, 10, 13, 14, 32, 47, 66, 71, 77
Cianci, Vito 35-38, 42, 52, 53, 63
Clark, A.F.B. 33, 40
Coburn, Alvin Langdon 46
Coulthard, Jean 12
Crookall, James 60

Cross, Larry 42
Cunningham, Imogen 27-29
Currie, Ada F. 37
Denton, Ivan 38
Dilworth, Ira 33
Donegan, Rosemary 49
Emerson, Ralph Waldo 50
f/64 Group 28, 29
Fewster, Ernest 33
Fraprie, F.R. 18
Group of Seven 10, 20-24, 35, 40, 47, 48
Hacking, Norman 45
Hambidge, Jay 55
Harris, Lawren 11, 34, 36, 60
Hart House String Quartet 10, 39
Helders, Johan 16-18, 20, 67, 68
Helders, John 17
Hill, Charles C. 10, 29, 42
Industrial Images 49
Jackson, A.Y. 12, 23, 24, 40
Johnston, C.M. 17, 18
Kaiser, Lottie 13, 42
Kandinsky, Wassily 55
Karsh, Yousuf 9, 41, 60, 61, 71
Knight, Harry Upperton 13-16, 23, 42, 58, 59
Le Corbusier 48, 50
le Nobel, Anne 12, 63
Leadbeater, Charles W. 55, 58
Lennie, Beatrice 64
Lismer, Arthur 23, 24
Livesay, Dorothy 33, 60
Lort, John C. 40
Lort, Ross 40
Lort, Tony 40
Macdonald, J. W. G. 8, 13, 26, 27, 35, 52, 53, 58, 60, 61, 63-66, 68-71
McCurry, H.O. 40, 63, 64, 66, 67, 69, 70
Malkin Bowl 39
Maynard, M. S. 26
Melvin, Grace 63, 64

Metcalfe, Bruce 17, 18
Morell, Rowena 65
Mortimer-Lamb, Harold 20, 21-25, 27, 56, 65, 67
Myers, Reta W. 27
New Westminster Provincial Exhibition 20, 21
Ouspensky, P.D. 55, 64
Ozenfant, Amédée15, 55, 60
Reid, Irene Hoffar 26, 27, 35, 37, 56, 60, 65
Rombout, Melissa K. 60
Scott, Charles H. 26, 27, 35, 63-65, 69
Sedgewick, Garnett G. 27, 33
Shadbolt, Jack 23, 64
Sheeler, Charles 28
Shelly, Carina Vanderpant 2, 4, 8, 13, 32, 52, 53, 58, 62, 70
Steichen, Edward 28, 46
Steiner, Rudolph 55, 60
Stieglitz, Alfred 25, 28
Stone, Henry 26
Strand, Paul 28
Surrey, Philip 59-61, 67, 68
Tagore, Rabindranath 10, 41
Täuber, Harry 60, 64-66
Taylor, Frank 40
Tilney, F.C. 47
Tyler, Gerald Hall 64-66
Vancouver Arts and Letters Club 39, 40, 69, 70
Vancouver Poetry Society 33, 43
Vancouver School of Decorative and Applied Arts 10, 25, 36-38, 56, 57, 60, 61, 63-65
Vanderpant, Catharina over de Linden 1-3, 8, 38, 39, 42, 51, 59, 62, 63, 71
Vanderpant Galleries 22-25, 26, 28, 33, 35-37, 39, 40, 53, 59, 60, 62, 70

Vanderpant, John à la Garbo 11; A Son of the Earth 20; A Son of the East 10, 19; Agitation 51; An Expression in Lettuce 51; Angles in Black and White 30; Birth 51; Broken Lines 55; Cactus Collaratus 42, 52; Coated Candy 34; Colonnades of Commerce 41, 48; Concrete 30, 31; Concrete Power 18, 30; Curvature 20; Cylinders 32; Ebony Mask 10; Elevator Pattern 41, 48, 49, 55; Eve Every Time 4, 5; Expression in Form 41, 52; Floral Rhythm 18; Heart of a Cabbage 51; Honestly, Honesty 42; In the Wake of the Forest Fire 48; Intimate Design 51; Into Silences 32; Liquid Rhythm 55; Mystery Stage 51, 55; Peacock Pride 18, 30; Shadows Over New York 44, 45; Spirit and Matter 18, 44; Spring on a Platter 42, 72; Summer Riches 31; Symphony of the Sun 19; Temples by the Seashore 48, 61; The Fence Casts a Shadow 34; The First Day of Spring 18, 41; The Morning After 41; The Watchman 49; The Window 50; Towers of Today 49; Trespassers 15, 41; Untitled (bok choy) 29, 31; Untitled (drainpipes) 32; Untitled (Verticals) 55; Urge 18, 29, 30; Variations on a Theme 18; Window's Pattern 19
Varley, F.H. ix, 10-13, 15, 17, 21, 26, 27, 35, 36, 39, 40, 44, 50-69, 71
Varley, John 68, 69
Varley, Peter ix, 39, 53, 68
Watson, Sheila 6
Weatherbie, Vera 10, 26, 56, 57, 60, 61, 65, 66
Weston, Edward 17, 27-29, 43
Weston, W.P. 26
White, Clarence 46
Whitman, Walt 9, 15
Williams, Margaret 37, 64
Yearbook of the Arts 41